THE REAL AND THE SPIRITUAL

*Nineteenth-Century French Drawings
from the Musée des Beaux-Arts de Lyon*

Dominique Brachlianoff
Conservateur au Musée des Beaux-Arts de Lyon

With an Introduction by
Philippe Durey
Conservateur du Musée des Beaux-Arts de Lyon

Translations by Anne Bertrand
Edited by DeCourcy E. McIntosh

THE FRICK ART MUSEUM, PITTSBURGH

THE REAL AND THE SPIRITUAL:
Nineteenth-Century French Drawings
from the Musée des Beaux-Arts de Lyon
was organized and circulated by
The Frick Art Museum, Pittsburgh.

THE FRICK ART MUSEUM
Pittsburgh, Pennsylvania June 13, 1992–August 16, 1992

SMITH COLLEGE MUSEUM OF ART
Northampton, Massachusetts September 15, 1992–November 15, 1992

Design by Robert L. Bowden
Typography by Hamilton Phototype, Pittsburgh
Printed by Geyer Printing Company, Inc., Pittsburgh

Cover illustration: Pierre-Henri Révoil, Bonaparte Rebuilding the City of Lyon
(detail), black chalk heightened with white chalk, 0.445 × 0.575 m. Signed at
lower left: "P. Révoil Lugdunensis." Inscription at lower center: "Lyon relevée par le
premier consul." Musée des Beaux-Arts de Lyon inventory number A 3014. (no. 79).

CONTENTS

FOREWORD

A brief article in the May, 1990, issue of *Apollo* planted the seed for this exhibition. In "The Renovation of the Musée des Beaux-Arts in Lyon," Barbara Scott reported on the extensive work underway at the museum, tantalizingly described the museum's distinguished collections, and noted in conclusion that the new director, Philippe Durey, had "developed an imaginative policy for joint exhibitions with museums abroad."[1]

Always on the lookout for interesting loan exhibition possibilities, we wrote Mr. Durey, and soon received a warm, encouraging response. Before long, an American version of the 1989 Lyon exhibition, *De Géricault à Léger, Dessins français des XIX^e et XX^e siècles dans les collections du Musée des Beaux-Arts de Lyon,* had become a real possibility. Later, the original invitation to select sixty drawings from the 1989 checklist expanded generously, and we were offered ninety drawings, many unpublished. As a result, we have been able to emphasize the origins and achievements of the Lyon School without compromising the idea of the 1989 Lyon exhibition, which balanced Lyonnais drawings with works by many of the great names of nineteenth-century French art in order to demonstrate the breadth and quality of the Lyon museum's holdings in French drawings of the nineteenth century.

It is our fervent hope that the thrills of discovery that we have experienced in preparing this exhibition, particularly as relate to Lyonnais painters, will be shared by visitors in Pittsburgh and Northampton. The exhibition could perform no greater service than to spark further interest, especially on the part of American students of art history, in the echoes of Dutch and Flemish naturalism, in the romance of Troubadour painting, in the intensity of religious expression, or in the lyricism of landscape painting to be found in Lyon.

To Mr. Durey goes our deep gratitude for granting the loan of the exhibition and for contributing an informative Introduction to the catalogue. Likewise, we wish to convey unlimited thanks to Dominique Brachlianoff, Curator at the Musée des Beaux-Arts de Lyon and author of the 1989 catalogue, for functioning as guest curator of this exhibition, in which capacity she wrote all of the supplemental entries and oversaw details of preparing the drawings for shipment to America. Both Mr. Durey and Ms. Brachlianoff are to be admired for tolerating the demands of this exhibition while under the stress of a total renovation at their own institution. Murielle Valle-Busby of the museum's photographic library also merits consideration for adding the demands of the exhibition to her regular responsibilities.

Abundant gratitude is due Anne Bertrand, the Judy Cheteyan Intern at The Frick Art Museum, who, though she came to this project merely as translator, evolved quickly into indispensible assistant, advisor and jack-of-all-trades. Her command of scholarly custom no doubt spared us untold embarrassment, while her sensitivity to nuances of meaning in both English and French will benefit all who read this catalogue. Ms. Bertrand's intelligence, diligence, and courage hold great promise for any future project that may attract her attention.

From the moment of first contact, our dealings with the Smith College Museum of Art have been pleasurable. Charles Parkhurst, Interim Director, and Suzannah J. Fabing, Director of the museum as of August 1, 1992, are to be thanked for their hospitality to the exhibition. The enthusiasm of Ann H. Sievers, Associate Curator of Prints, Drawings, and Photographs, is a tonic to the chronically worried exhibition organizer; she and David Dempsey, the Museum's Preparator/ Conservation Technician, are producing an especially thoughtful presentation at Smith, where owing to splendid holdings in nineteenth-century French art, the exhibition could hardly be more at home.

Professor Aaron Sheon of the Frick Fine Arts Department of the University of Pittsburgh read the translated catalogue manuscript in two successive drafts, offering many helpful suggestions. L. Denis de Cazotte assisted with translation at a critical, early point in the project. Professor Frank

Anderson Trapp of Amherst College, Director Emeritus of the Mead Art Museum, provided friendly advice and useful information at times when they were most needed. Louis-Antoine Prat's support and endorsement were invaluable. The sagacity of John Ittmann, freely and tactfully shared whenever sought, and the erudition of Dita Amory, Mark Brady, Eric Carlson, and Robert Kashey benefited this exhibition in subtle ways and are much appreciated.

A graphic designer can make no greater sacrifice for his client than to produce a design that pleases by its very lack of conspicuousness. Robert L. Bowden agreed to such a sacrifice in accepting the present commission and realized a discrete and handsome design with customary good cheer, a balm to the nerves of all who work with him.

We were not the first American institution to approach the Musée des Beaux-Arts de Lyon about the loan of a selection of drawings. Mr. Durey's response to our initial inquiry indicated that the American Federation of Arts had manifested a similar interest. Although the project eventually proved impractical for the AFA, the present exhibition owes much to the groundwork of Marie-Thérèse Brincard, AFA Senior Exhibition Coordinator. The selflessness of Lynn Kahler Berg and Joseph Saunders of Art Services International in answering our numerous questions related to logistics reminds us once again of our good fortune in having such friends.

The Frick Art Museum is the creation of Miss Helen Clay Frick, who at the time of its opening in 1970 placed it in the care of the foundation that bears her name. Two decades later, The Helen Clay Frick Foundation established the Clayton Corporation to operate the museum and Clayton, a house museum that was the original Henry Clay Frick residence in Pittsburgh. On the eve of the opening of Clayton in 1990, the Clayton Corporation organized the Friends of Clayton to encourage voluntary support for the museum and Clayton. The response to the appeals of the Friends of Clayton has been heartwarming. All programs of the Clayton Corporation have benefited, including the present exhibition. To the Friends of Clayton, then, we owe continued gratitude.

Many members of the staff of the Clayton Corporation have contributed to this project. Especially noteworthy has been the care with which Ruth Ferguson, Administrative Assistant, has typed parts of the manuscript and maintained records pertaining to all aspects of the exhibition. In matters related to budgets and insurance, John R. Thomas, Director of Finance and Administration, has performed beyond the call of duty. Responsibility for the registration of the exhibition in Pittsburgh, the production of labels and explanatory texts, and the Pittsburgh installation, has fallen, as usual, to the capable Nadine Grabania, Assistant Curator of The Frick Art Museum. Ms. Grabania has been ably assisted by Jeanne Brown. John Wolfendale, Superintendent of Buildings and Grounds, and his maintenance and security staff comprise the infrastructure upon which the Clayton Corporation depends.

Finally, it is to the munificence of the Trustees of The Helen Clay Frick Foundation and the beneficence of the Directors of the Clayton Corporation that everything occurring at The Frick Art Museum ultimately is owed. One can only hope that the realization of this exhibition in some small way rewards their effort, contributed magnanimously over many years.

DeCourcy E. McIntosh
Executive Director, The Helen Clay Frick Foundation
and the Clayton Corporation
June, 1992

[1]*Apollo*, vol. CXXXI, No. 339, p.336.

INTRODUCTION

"Entre les vieilles pierres charmantes du Palais, autour d'un jardin paisible dont les feuillages dessinent sur les murs des ombres pleines de grâce et de majesté, les Musées de Lyon développent un ensemble de galeries d'une richesse, d'une harmonie particulièrement significatives et rares. L'histoire de l'antique cité est là, et aussi le résultat d'un long effort, d'un goût passionné pour les arts."[1]

These few lines by Henri Focillon (1881-1943) may be the best way to introduce the Musée des Beaux-Arts de Lyon to an American audience. Among its claims to fame, the two-hundred-year-old museum is proud to have had as its director for eleven years (1913-1924) one of the greatest French art historians, the famous author of **Vie des formes**, Henri Focillon. Appointed Visiting Professor at Yale in 1933, Focillon invested tremendous energy in establishing good relations between historians and museums on both sides of the Atlantic.

Like Focillon in his time, the visitor to the Musée des Beaux-Arts de Lyon today is struck by the dignified grandeur of the site. The former Abbaye Royale des Dames de Saint Pierre, a Benedictine convent located at the heart of the peninsula formed by the Saône and Rhône Rivers, at the foot of Croix-Rousse hill, preserves to this day the original, monumental facade conceived around 1660 by the architect François Royer de la Valfenière (1575-1667). This facade forms one entire side of the Place des Terreaux and creates with the majestic Hôtel de Ville a superb Baroque architectural ensemble. From those days of splendor and "grand goût," the only interiors in the building to survive are the refectory and the main staircase, decorated by the painter and architect, Thomas Blanchet (1614-1689).

The history of the Musée des Beaux-Arts de Lyon begins with the upheavals of the Revolution and Empire. The former contributed the site and the concept, the latter the organization and realization. As early as 1789, the nationalization of clerical property placed the large buildings of the Abbey at the disposition of the municipality. Very soon was born the idea to create a museum, a museum whose function would be to encourage public education, especially that of future draftsmen employed in the silk factories upon which rested the prosperity of Lyon. In 1799, the State sent to Lyon for use as models several paintings of flowers. Soon, the municipality was completing this project by acquiring, on the one hand, works by Old Masters who specialized in flower painting (Van Huysum, Van Dael) and, on the other, the initial output of the nascent Lyon school of painting (Berjon and Bony). These paintings constituted the origin of the famous "Salon des Fleurs," installed shortly after the opening of the Musée des Beaux-Arts de Lyon in 1803.

The Imperial administration would strengthen and enlarge upon the initial concept. Given highest priority in the 1801 Decree that established museums in fifteen provincial cities, Lyon received, in three successive shipments (1803, 1805 and 1811), nearly 110 paintings, which taken together constituted the largest of the state's permanent loans. Works of the first rank by Perugino, Veronese, Tintoretto, Guercino, Rubens, Jordaens and Champaigne gave immediate stature to the museum of a city whose wounds had to be healed and whose

industry urgently needed restoration. Simultaneously, the first curator, François Artaud (1767-1838), undertook a second mission, the creation of a gallery of archaeology, by assembling the first collections of bas-reliefs, mosaics and bronzes from Lyon's prestigious past as the capital of Gaul.

Between 1815 and 1878, the rooms reserved for paintings were enriched by works from the School of Lyon, a school that Baudelaire would somewhat wickedly describe as "the penal colony of painting, the place in all the world where one paints best that which is infinitely small." If it is true that artists like Révoil, Richard, Grobon and Bellay possessed a very precise and minute technique, greatly influenced by Dutch Masters of the Golden Age, then their aspiration reveals no less a real sense of poetry and a delicate feeling for Nature. At the same time, Orsel and Janmot represent an artistic current very different, one characterized by both austerity and mysticism and stimulating comparisons with certain tendencies of the German Nazarenes or the British Pre-Raphaelites.

In 1879 there emerged what may be called the "Golden Age." This was a particularly ambitious period in the life of the museum, an era whose decline if not whose end coincided with the outbreak of the First World War. New goals were set as major renovations of the buildings occupied by the museum began (these included the great Puvis de Chavannes mural, *Sacred Wood*, painted in 1883-1886 for the upper portion of the monumental staircase installed by the architect Hirsch). The objective was to become one of the great museums of Europe. To accomplish this, it was necessary to acquire Italian Renaissance paintings and sculptures, Greek vases and bronzes, Medieval ivory and enamel works. At the instigation of Jean-Baptiste Giraud, one of the directors, a new section devoted to decorative objects was opened. The museum also began to collect Modern Art before most other French museums. Hence, in 1901 and 1902, the first Impressionist paintings of Renoir, Monet and Manet were acquired from Durand-Ruel. In 1910, Degas' famous *Café-concert des Ambassadeurs* entered the collection, followed in 1913 by Gauguin's *Nave Nave Mahana*, the first painting by this artist to be purchased by a French public collection. Thereafter, such brilliant personalities as Edouard Aynard, Doctor Tripier, the Marquise Arconati-Visconti, Raymond Koechlin, Tony Garnier and Henri Focillon applied their diverse talents to the further development of the museum.

A third phase in the museum's existence, the period between the two World Wars, continued, in a slightly diminished way, the dynamism of the previous period. By 1926, Léon Rosenthal, who succeeded Focillon, was able to devote a gallery to modern Decorative Arts, containing works by Marinot, Lalique, Ruhlman and Linossier, among others. However, with the Second World War came very difficult times due to transfers and financial restrictions. Despite the energy deployed in the 1950s, there followed a period of relative apathy resulting in an overall withdrawal that lasted until the end of the 1960s.

As the museum approaches the end of the second century of its existence, how can we assess the balance sheet? On the negative side, the Musée des Beaux-Arts de Lyon is

twenty years behind in museology, in development of facilities for visitors and in operating systems. On the positive side are the extreme diversity and richness of the museum's holdings, the true basis of its identity. It is no exaggeration to say that the Musée des Beaux-Arts de Lyon is the most complete of the "small Louvres" that large French cities tried to create in the nineteenth century. A general renovation cofinanced by the City of Lyon and the Secrétariat d'Etat aux Grands Travaux began last year and will be completed in 1996. This project marks the beginning of a new era whose goals are not only to overcome the deficits mentioned earlier but also to reorganize the installation of the galleries, where the displays are now somewhat anarchical, in order to emphasize the diversity of the collection.

When the entire paintings collection is assembled in the thirty-five galleries of the third floor, space will be liberated on the second floor for the installation of the departments of Antiquities and Decorative Arts. The eighteen galleries of Antiquities will illustrate the Ancient Mediterranean world (excluding Gaul which now has its own museum, the Musée de la Civilisation Gallo-romaine, at Fourvière). Its highlights will be the Egyptian and the equally beautiful Greek and Etruscan collections. The Decorative Arts Department, whose realm extends from the Christian and Islamic Middle Ages (the Islamic collection being the most important outside Paris) through the Art Nouveau and Art Deco periods, also includes a collection of some 40,000 medals. The sculptures (more than 600) are varied and range from the Romanesque to Maillol.

From the Department of Drawings, the Musée des Beaux-Arts de Lyon is pleased to present, for the first time in the United States, a selection from a rich collection, due to the hospitality of The Frick Art Museum of Pittsburgh. The Department includes about 4000 sheets from the Italian, Northern, and especially, the French schools. The nineteenth century is extremely strong, especially the School of Lyon. Some artists are represented by definitive holdings: 130 sheets by Puvis de Chavannes (given by the artist's family in 1899), 200 by Chenavard (given in 1877) and 500 by Fleury Richard (acquired in 1988). Apart from several specific gifts (His de la Salle in 1877, Aynard in 1884, Tripier in 1917, Gruyer in 1921) the recent enrichment of the collection results principally from permanent loans from or exchanges with the Bibliothèque Nationale.

The drawings assembled here include several masterly sheets by the greatest names in French art of the past century: Géricault, Delacroix, Courbet and Rodin. This body of drawings also contains works by artists less known, especially in the United States, notably artists from Lyon. We are certain that these will arouse the curiosity of our American friends and inspire in them a desire to visit the city of Lyon to discover not only its native School but also its masterpieces from all periods and places.

Philippe Durey
Conservateur du Musée des Beaux-Arts de Lyon

[1]"Within the Palace's charming old stone walls, walls that enclose a peaceful garden with leaves casting graceful and majestic shadows, a series of galleries unfolds in a richness and harmony particularly rare and significant. The history of the ancient town is there, as is the product of a lengthy effort, of a passion for the arts."

Color Plates

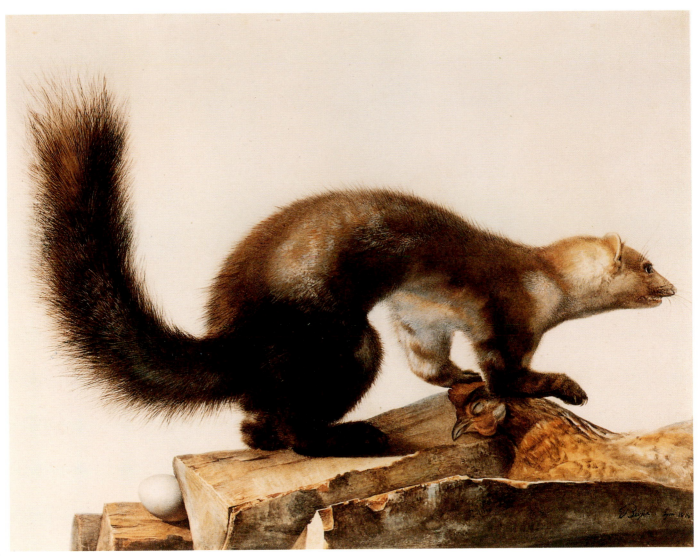

ANTOINE BERJON, *A Stone Marten* (No. 7)

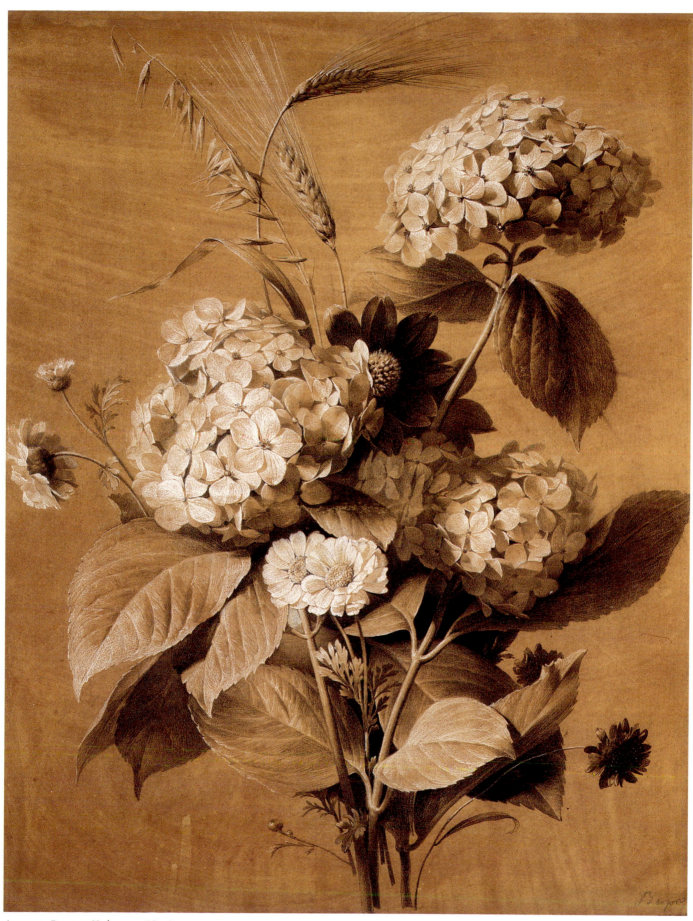

ANTOINE BERJON, *Hydrangeas* (No. 8)

THÉODORE GÉRICAULT, *Louis XVIII Reviewing Troops on the Champ-de-Mars* (No. 39)

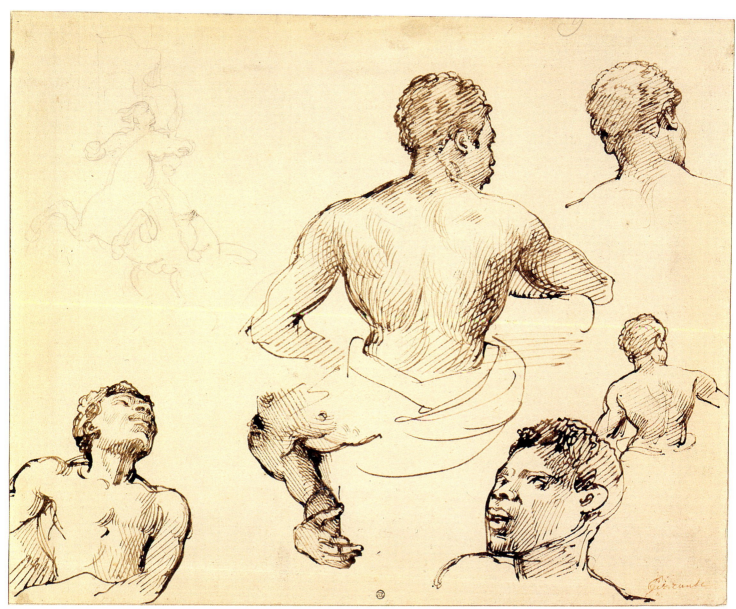

THÉODORE GÉRICAULT, *Five Studies of a Negro* (No. 40)

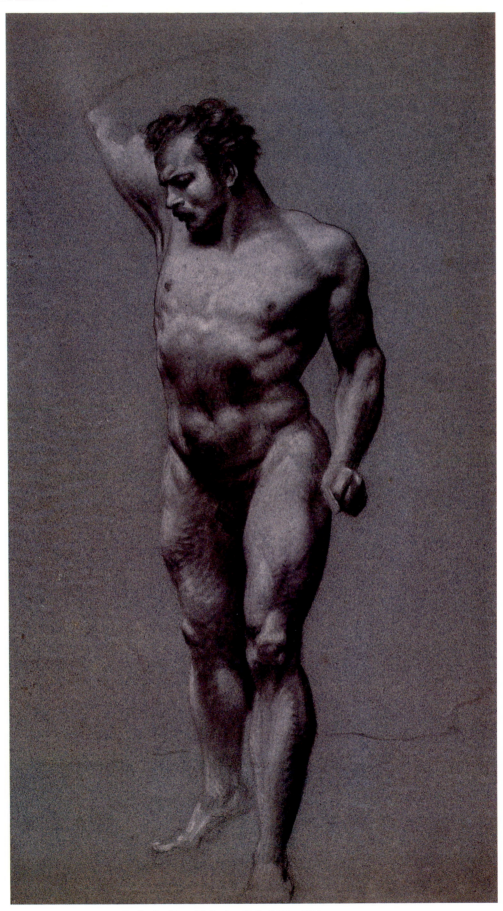

PIERRE-PAUL PRUD'HON, *Study of a Man, Right Arm Raised* (No. 68b)

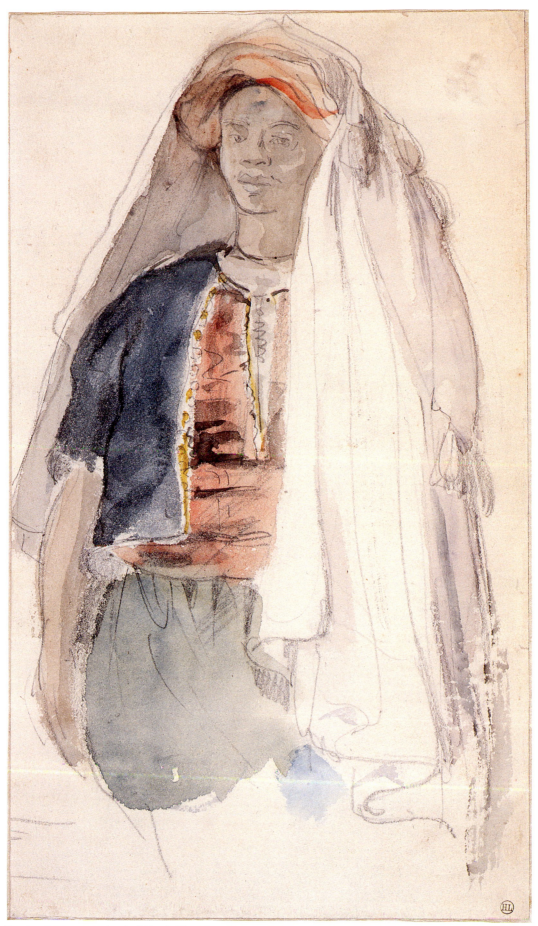

EUGÈNE DELACROIX, *An Arab Youth* (No. 28)

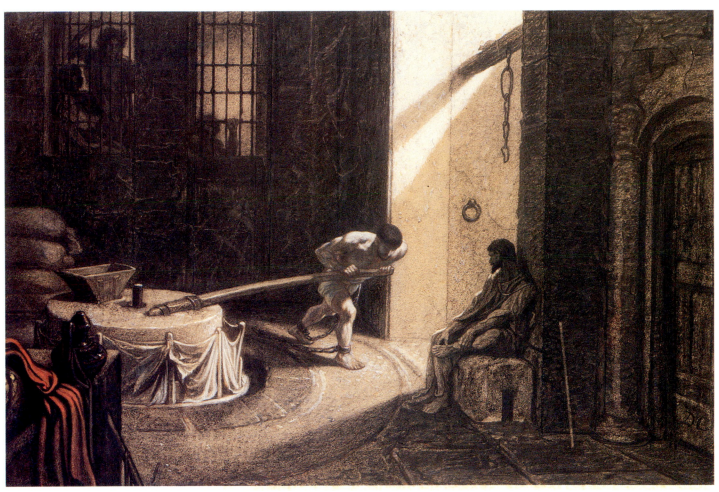

GABRIEL-ALEXANDRE DECAMPS, *Samson Turning the Millstone* (No. 24)

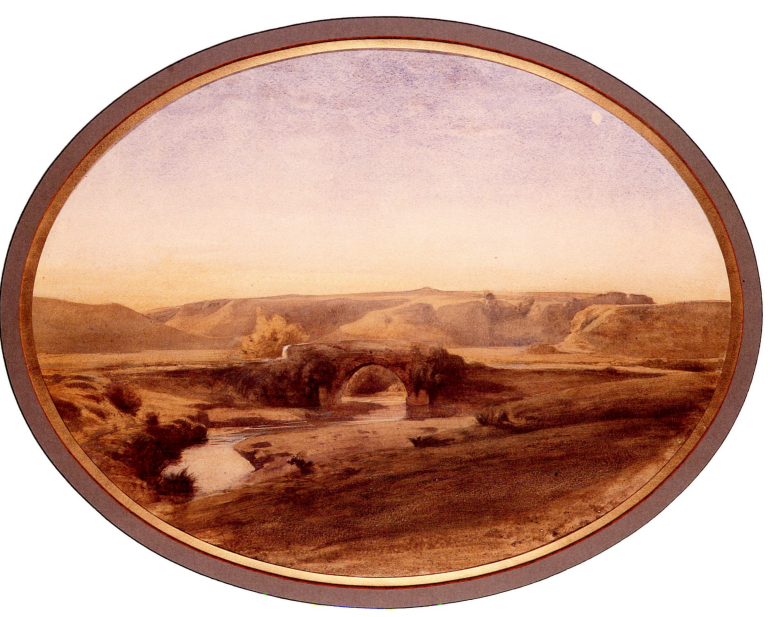

FRANÇOIS-AUGUSTE RAVIER, *View of the Roman Campagna* (No. 75)

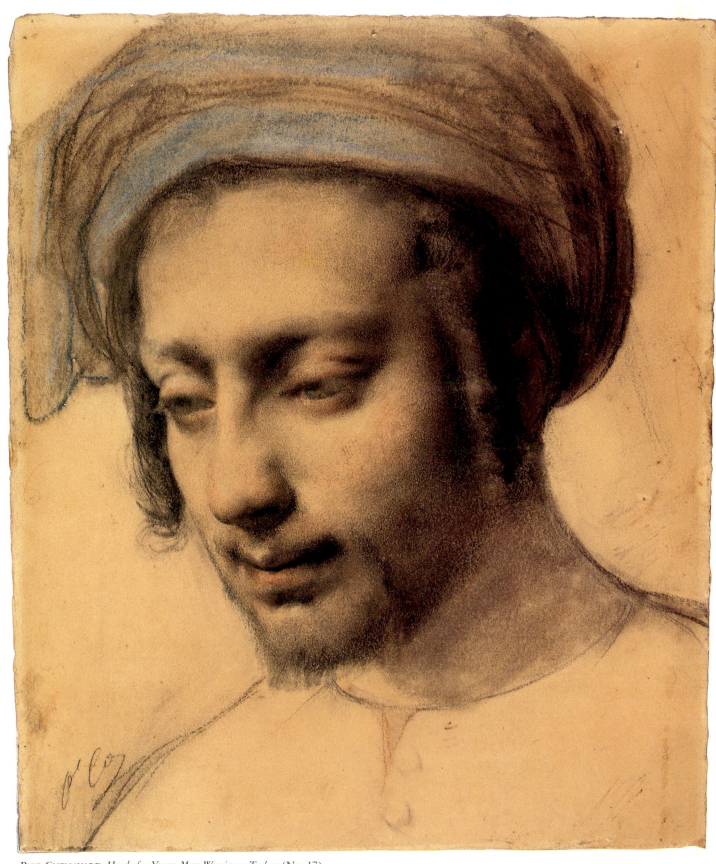

PAUL CHENAVARD, *Head of a Young Man Wearing a Turban* (No. 17)

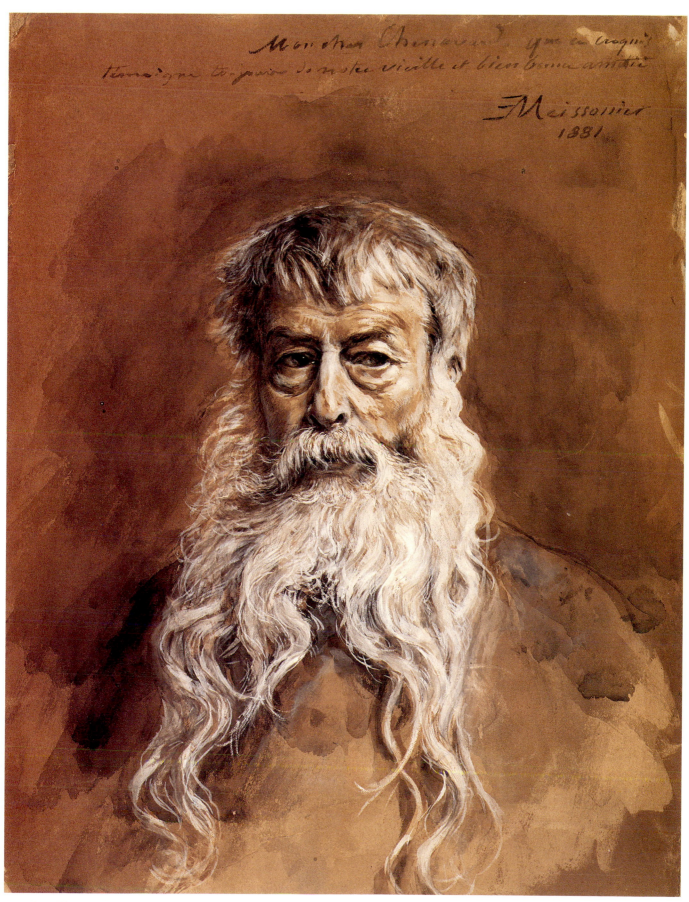

Jean-Louis-Ernest Meissonier, *Self-Portrait* (No. 58)

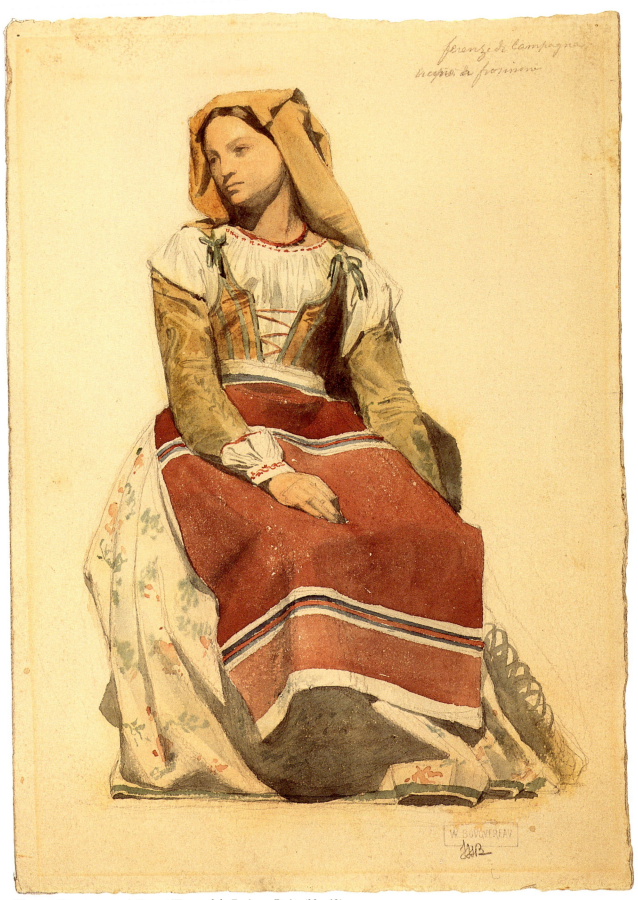

WILLIAM BOUGUEREAU, *A Peasant Woman of the Frosinone Region* (No. 13)

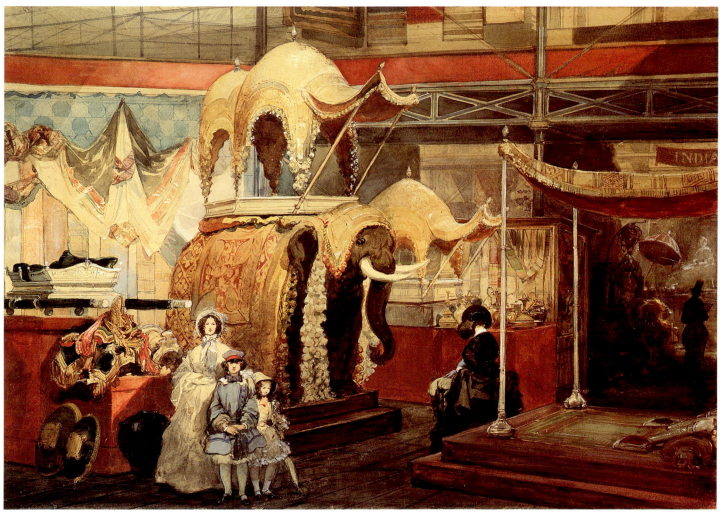

EUGÈNE LAMI, *The Indian Section of the Crystal Palace Exposition, London, 1851* (No. 55)

MICHEL DUMAS, *Eurydice* (No. 32)

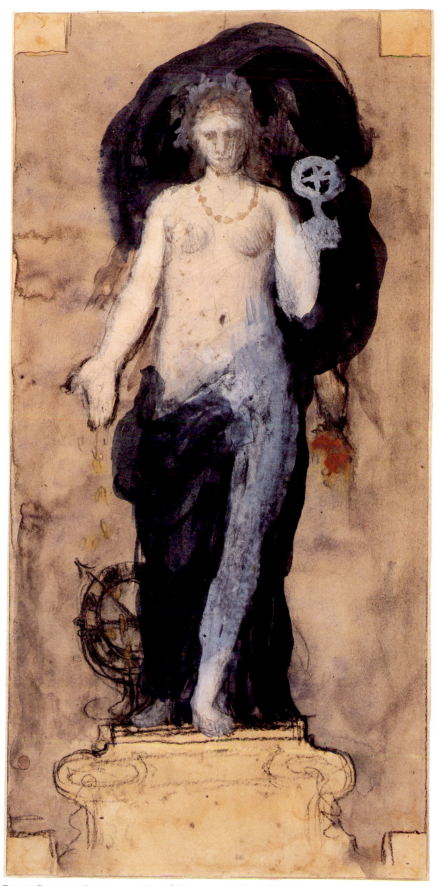

PIERRE PUVIS DE CHAVANNES, *Draped Woman on a Pedestal* (No. 71)

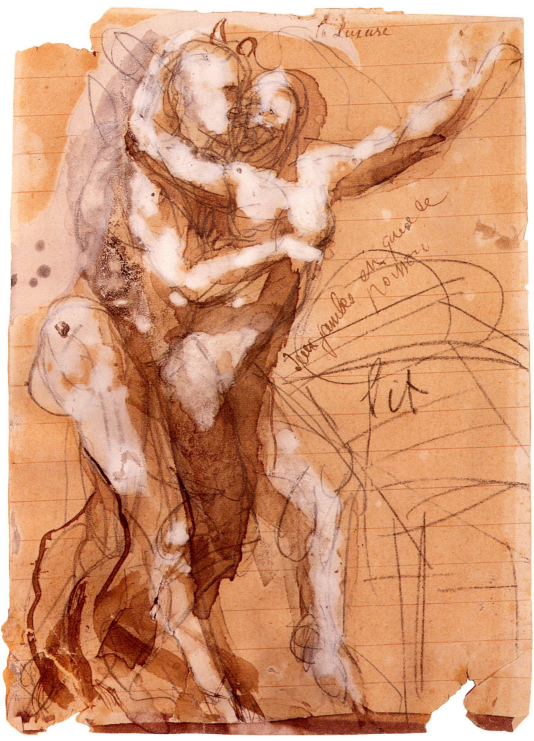

AUGUSTE RODIN, *Lust* (No. 85)

CATALOGUE

Measurements are given in meters. Catalogue numbers 27, 37, and 88 are reproduced to actual size.

The catalogue is arranged alphabetically by last name of the artist.

Théodore Caruelle d'Aligny

Chaumes, 1798–Lyon, 1871

1 View of Meyringen

Pen and brown ink. Height: 0.665;
width: 0.490. Signed, dated and
annotated in pen and ink at lower left:
"T.A. Meyringen-Oberland bernois.
1832."
Inventory number: X840-2

Provenance: Deposited by the State
in 1873.
Catalogue: See Lyon (1989): 17, no.1.

The rigorous precision of this drawing evokes the economy of an engraving, especially in the strictly paralleled hatching used to indicate shadows. (It is worth noting that, in 1845, the artist engraved the illustrations of his *Views of the Most Celebrated Ancient Greek Sites*).

This austere technique, wherein line predominates, recalls nearly contemporary drawings made at Rocca San Stefano. In these works, too, intricate, cubic forms of massed rocks contrast sharply with the sinuosity of trees. The grandeur of this drawing, whose synthetic rigor is not without a certain dryness, allows us to distinguish the draftsmanship of Aligny from the more suggestive, allusive style of Corot.

Several works in the Aligny sale of 1874 originated in the artist's 1832 travels in the Bernese Oberland: ***Laar Spring, near Bern (Switzerland)*** (no.18), ***Brientz Lake (Switzerland)*** (no.22), ***The Watterhorn (Bernese Oberland)*** (no.26), purchased by Corot, and ***View From the Bernese Oberland*** (no.48), also bought by Corot.

One of the drawings in the Louvre that Aligny executed in the Bernese Oberland is entitled ***At Meyringen, Switzerland*** (R.F.831).[1]

1 Aubrun (1988): 239 (D148).

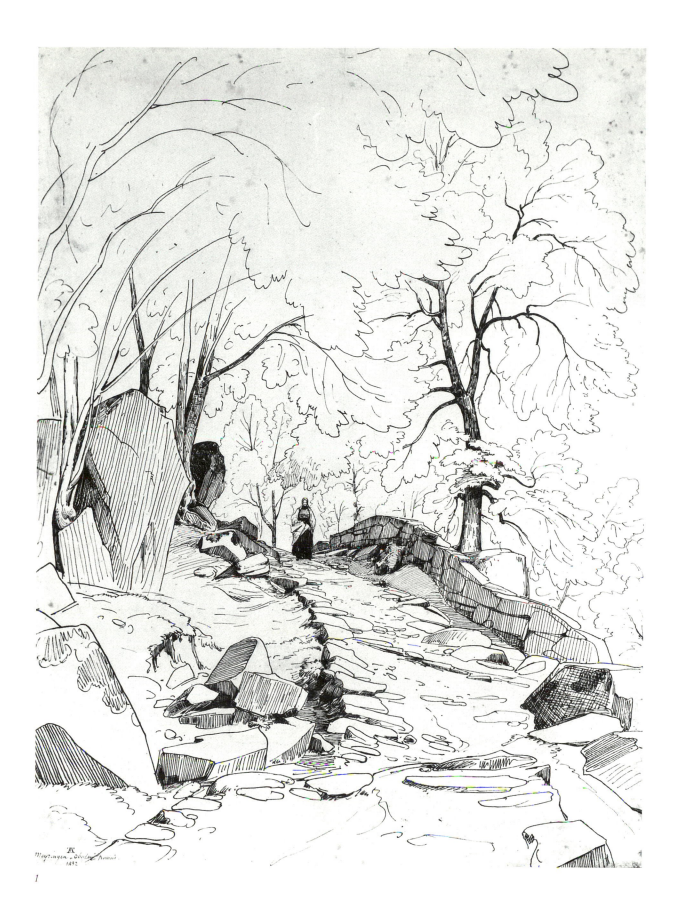

Meyr.nyen "Oberfar Kerwei.
1832

1

THÉODORE CARUELLE D'ALIGNY

2 View of Olevano

Pen and brown ink. Height: 0.480; width: 0.636. Signed, dated and annotated in pen and ink at lower right: "Olevano (état Romain) le 3 septembre 1835. TA." Inventory number: X840-1

Provenance: Deposited by the State in 1873.
Catalogue: See Lyon (1989): 18, no.2.

During his two stays in the countryside around Rome and Naples, 1822-1827 and 1834-1835, Aligny produced numerous sketches which formed a body of motifs he used later in paintings.

Of the two Italian periods, we know most about the second, during which Aligny executed this drawing. Numerous studies have survived of Amalfi, Corpo di Carva, Sorrento, Capri, Genazzano, Rocca San Stefano, Civitella, Serpentara, Olevano, and other Italian sites.

The remote village of Olevano Romano, dominated by the ruins of the thirteenth-century Colonna castle, is perched on the slope of Mount Céleste in the Sabine Mountains fifty kilometers east of Rome. Discovered by the painter Joseph Anton Koch in 1804, it attracted many French and, especially, German, artists and is where Aligny met the Nazarene painters. From the tall houses of this medieval village, squeezed together in passageways that resemble staircases more than streets, one can admire a breathtaking panorama of the surrounding mountains. In 1827, Aligny was in Olevano with Corot, who went there three times in all. Both artists travelled the roads north of the village that lead to Civitella or Rocca San Stefano, near the Serpentara, a famous oak forest that Corot called "the enchanted forest," where he often painted with his friend. A drawing very similar to the one exhibited here, *View of Olevano in the Roman States* appeared in the *Magasin Pittoresque*.[2] The viewpoint is similar but the figures represented are missing in this drawing. There is a heliogravure after the drawing in Lyon.[3]

The two sales after the artist's death included several paintings depicting this village and its surroundings. In the 1874 sale were: *View of Serpentara (Roman States)* (no.14), *Olevano, in the Outskirts of Rome* (no.29), *The Serpentara, in the Outskirts of Rome* (no.30) and *View from Olevano* (no.44).[4] The paintings in the sale of 1878 were *Plevano* (sic) *Roman States* (no.20), *Rocky Grounds (Olevano)* (no.112) and *Study of Mountains at Olevano* (no.153). Of the drawings in the sale, the 1979 exhibition (Orléans, Dunkerque, Rennes) displayed one, *Olevano* (no.41),[5] to which may be joined two others: *On the Road From Olevano* (location unknown) and *At Olevano*.[6]

Drawing was Aligny's favorite medium. Even while working ceaselessly through motifs, he demonstrated tireless attention to composition. This imposing and precisely executed drawing shows not only the artist's concern for spatial clarity, but also his elegant linear style, particularly in the festooned lines evoking foliage. The rigorous terracing of the successive planes—from the closest tree trunk on the left, to the intermediate group of trees to the right, to the mountains on the horizon—and the framing of the main motif by two planes wedging the composition—are consistent with Neo-classical landscape principles in use since the days of Pierre Henri de Valenciennes.

2 *Magasin Pittoresque* (June 1848): 201.

3 Aubrun (1988): 263 (G.217A).

4 Nos.14, 30 and 44 were purchased by Corot.

5 No.41 (private collection); Aubrun (1988): D.227.

6 At Olevano (private collection); Paris, Galerie du Fleuve (1974): no.33. Aubrun (1988): D.226.

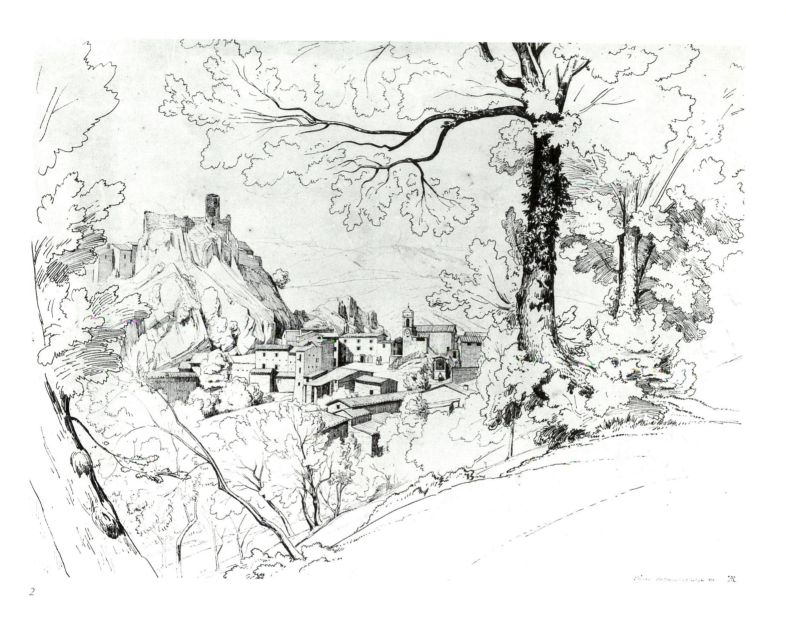

2

ADOLPHE APPIAN

Lyon, 1818–Lyon, 1898

3 The Lock at Rossillon

Charcoal heightened with white chalk.
Height: 0.395; width: 0.515. Signed
at lower right: "Appian."
Inventory number: 1989-19

Provenance: Gift of Jacques Gruyer,
relative of the artist, in 1989.
Bibliography: *Bulletin des Musées
et Monuments Lyonnais* (1990): 85,
nos.1-2.

Rossillon-en-Bugey, located east of Lyon,
along with Morestel and Crémieu, was
one of the favorite meeting places of the
Lyonnais landscape painters during the
second half of the nineteenth century. In
1866-1867, Appian settled in Rossillon
and explored its surroundings.

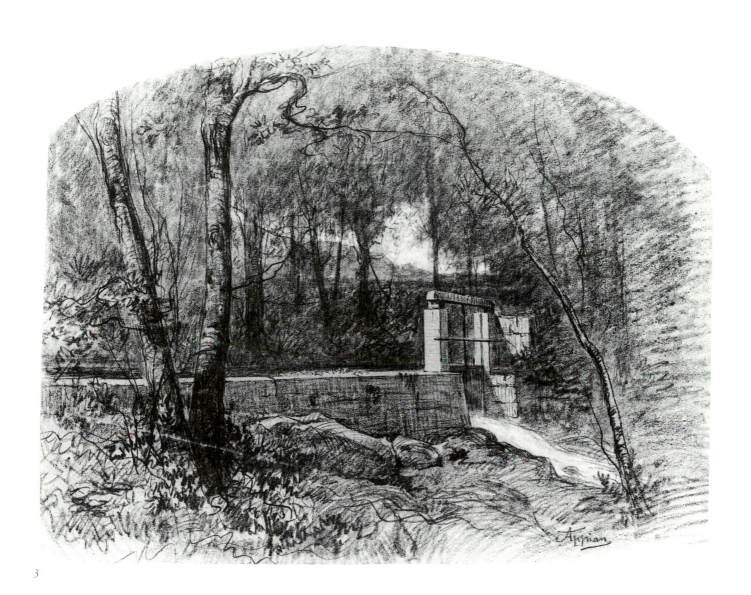

3

FRANÇOIS ARTAUD

Avignon, 1767–Orange, 1838

4 Self-Portrait

Black chalk heightened with white chalk. Height: 0.298; width: 0.277. Signed and dated at lower right: "Semetipse Del. F. Artaud 1801." Inventory number: A 233

Provenance: Gift of the artist in 1838. Bibliography: Bruyère (1986)

As the first bona fide curator of the Musée des Beaux-Arts de Lyon, François Artaud played a major role in determining the museum's destiny.

Upon arrival in Lyon around 1787 as an apprentice draftsman on silk, Artaud began walking and sketching in the environs of Lyon with his friend, Jean-Michel Grobon. A discovery of Roman pottery shards spawned a passion for archaeology. Artaud entered the workshop of Pierre Toussaint Dechazelle, a painter, draftsman and silk weaver, and after the Revolution started to paint, specializing in miniatures. After travel in 1803 in Italy, including a special visit to Herculaneum and Pompeii, he renounced his vocation as a silk designer to fully indulge his passion for archaeology.

On October 3, 1806, after the publication of a brilliant work on the ***Mosaic of the Circus Games***, a very important Roman mosaic found at Lyon, Artaud was appointed Inspector of the Conservatory of Arts and "Antiquaire" for the city. Only in 1812, however, when the museum's collegial form of administration was changed, was he granted the title of director and given complete authority to organize the museum.

Beginning in 1807, all the inscriptions and stone monuments which had been dispersed throughout the city and the surrounding areas were assembled under the arches of the cloister of the Palais Saint Pierre.[7] In 1810, the newly created Cabinet of Antiquities received the collection of antique bronzes and medals which had been kept since the eighteenth century at the City Library. Soon after, the Cabinet benefited from numerous astonishing acquisitions such as the collection of the Marquis de Migieu—one of the oldest collections of antiquities in France—and the Tempier collection, including the famous ***Attic Kore***, an archaic Greek figure that remains one of the highlights of the museum. No less remarkable were the above-mentioned ***Mosaic of the Circus Games*** and the equally famous ***Tables Claudiennes***, both of which entered the museum at this stage.

As much by force of personality as through passion for archaeology, Artaud laid the foundations of the Musée des Beaux-Arts de Lyon as an encyclopedic museum.[8]

7 Between 1965 and 1970, when the "Musée de la Civilisation Gallo-romaine" of Lyon was created, all Roman objects with a gallic provenance, except for those whose origins were foreign or uncertain, left the Musée des Beaux-Arts to enter the new institution.

8 We owe thanks to Gérard Bruyère for his extensive study (1986) of Artaud's rich personality and life.

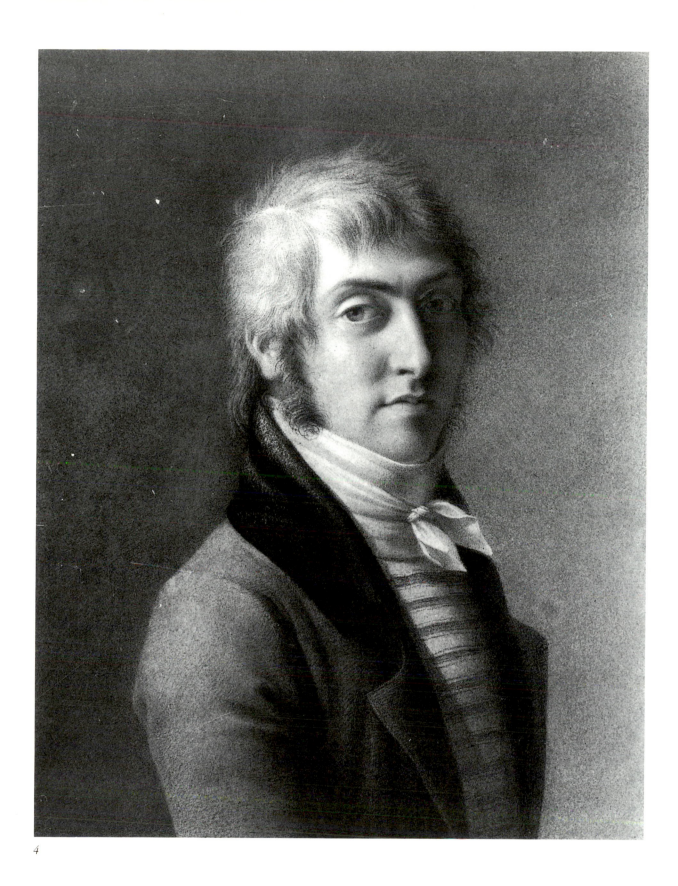

4

JEAN-FRANÇOIS BELLAY

Chalamont, 1789–Rome, 1858 (?)

5 Study for a Peasant's Jacket

Black chalk heightened with white chalk. Height: 0.215; width: 0.134. Inventory number: B344-4

Provenance: Gift of M. Bellay, son of the artist, in 1883.

Bellay, student first of Grobon, then of Révoil, at the Ecole des Beaux-Arts de Lyon, became a specialist in genre scenes in the manner of minor seventeenth-century Dutch masters: barn or stable interiors, farmyards, post taverns, animals, carriages, landscapes and some portraits. This study perfectly exemplifies Bellay's ability to translate the humblest realities of the peasant's world. Even if this drawing, in which a raked light delicately models the folds of the jacket, is not a direct preparatory study, it can be related to the figure of the peasant, who with his hands joined together, listens to the charlatan in the painting entitled the **Market at the Place des Minimes, Lyon** (1819) in the Musée des Beaux-Arts de Lyon.

6 Study of a Horse

Black chalk heightened with white chalk. Height: 0.124; width: 0.185. Inventory number: B344-5

Provenance: Gift of M. Bellay, son of the artist, in 1883.

This drawing is a preparatory study for the white unharnessed horse in the painting the **Market at the Place des Minimes, Lyon**. As in the painting, the hindquarters and the back of the horse are illuminated by a low sunlight which casts the flank in shadow. Pariset speaks about Bellay's specialization as a horse painter, and of a style closely related to that of Wouwermans.

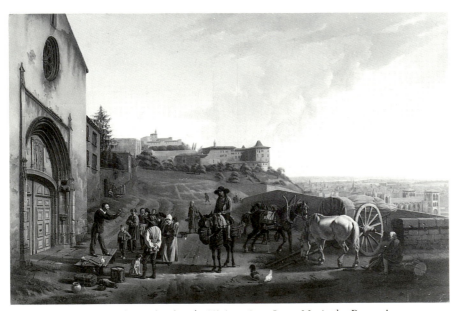

Jean François Bellay, *Market at the Place des Minimes, Lyon*, Lyon, Musée des Beaux-Arts.

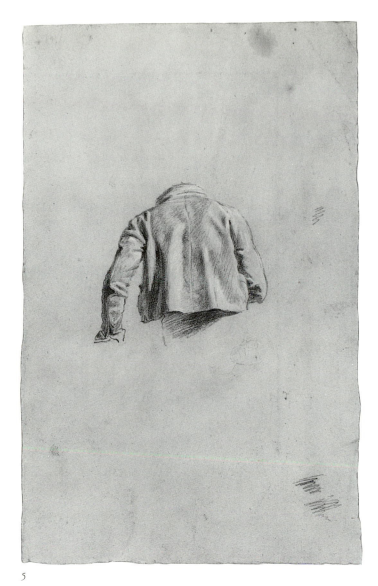

5

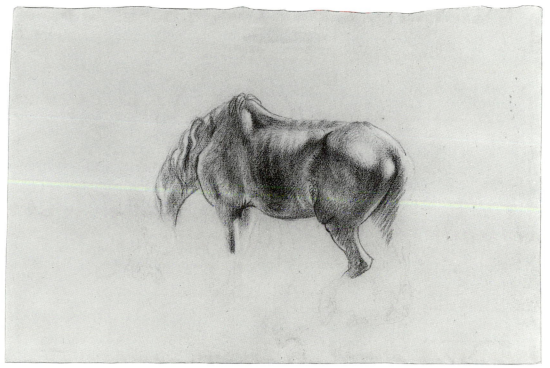

6

ANTOINE BERJON

Lyon, 1754–Lyon, 1843

7 A Stone Marten

Watercolor and gouache on cardboard.
Height: 0.450; width: 0.578. Signed
and dated in pen and ink at lower
right: "Berjon. Lyon. 1818."
Inventory number: B 406

Provenance: Acquired from P. Roche
in 1887.
Catalogue: See Lyon (1989): 19, no.3.

This imposing drawing, accompanied by a lost pendant representing a pheasant, failed to interest the artistic commission in charge of acquisitions for the Musée des Beaux-Arts de Lyon after Berjon's death.

Berjon probably used a stuffed animal for a model. The difficulties he encountered in staging the animal manifest themselves in the stiffness of the pose, the improbability of the front legs, and the obvious clumsiness of the motif of a dead hen wedged between logs. The placement of the natural elements against an abstract white background lends further artificiality to the drawing.

Berjon made a better choice in two impressive drawings from 1810 in which a hare and a rooster each hang by one leg against a totally neutral background. Both drawings belong to the collection of the Musée des Beaux-Arts de Lyon and were shown in the 1989 exhibition *Les artistes à Lyon sous la Révolution et l'Empire*. Nevertheless, in the *Stone Marten*, the artist not only demonstrated his capability as a miniaturist, but also successfully adapted to a rare format. This can be seen in the rendering of the marten's fur, particularly on the tail, where attention to minute detail recalls the work of Flemish primitives.

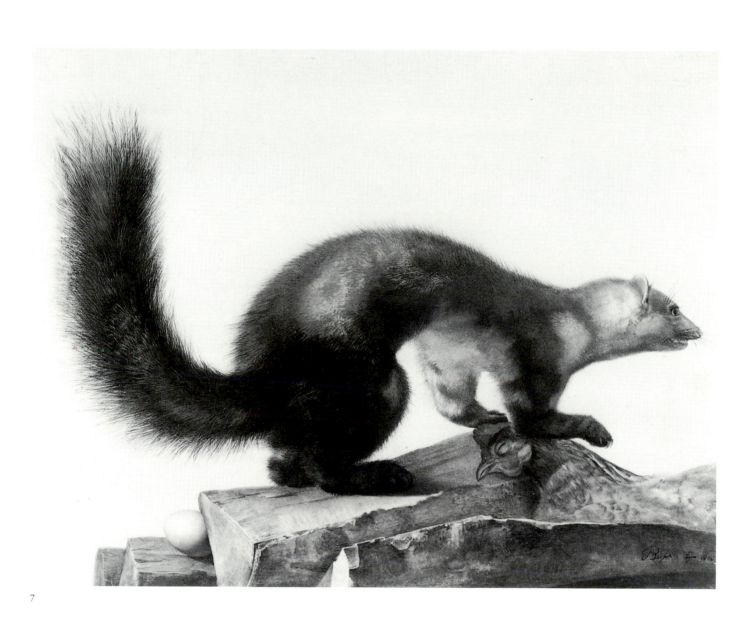

7

ANTOINE BERJON

8 Hydrangeas

Black chalk with white chalk on paper prepared with brown wash. Height: 0.580; width: 0.445. Signed, in graphite, at lower right: "Berjon." Inventory number: A 1772

Provenance: Acquired from the heirs of the artist in 1844 (no.62 of the inventory after his death which occurred on November 6, 1843). Catalogue: See Lyon (1989): 20, no.4.

This signed drawing, ambitious in format, was probably the ***Bouquet of Hydrangeas*** exhibited at the Salon of Lyon in 1822 (no.10). Berjon chose a challenging composition, mingling the rather stiff and voluminous hydrangeas with smaller flowers and delicate stems of barley and oats. The virtuosity achieved with two different kinds of chalk is remarkable. Berjon analyzed the complete structure of every flower, each composed of a multitude of small elements individually studied and rendered in their exact form and pose. Yet, this intense observation of physical detail detracts from neither the general layout nor the overall unity of the composition. For the sake of emphasis, this bouquet, as in most by the artist, is presented in front of a simple background and in a neutral spatial environment. A rigorous choice of material produces a sober effect, limited to subtle tonal nuances and without the intervention of color, which is characteristic of Berjon as a draftsman.

In 1822, Berjon's position as Professor of the "Classe de la Fleur" at the Ecole des Beaux-Arts in Lyon was threatened. Power struggles tearing apart the Ecole and personal conflicts between François Artaud, the director, and Berjon eventually resulted in the latter's dismissal along with Fleury Richard in 1823. According to Custodero (if this is indeed the drawing Berjon sent to the Salon of 1822), the drawing was intended to display the artist's technical mastery and suggest the unjust nature of the sanction pending against a man capable of such an accomplishment.[9]

Germain praised this drawing, giving it the evaluation of "étude par excellence," a compliment he also gave to the better-known drawing, ***The Peonies***, also in the Musée des Beaux-Arts de Lyon.[10] Berjon himself observed: "It is in vain that we pursue Nature for she always escapes. One should draw constantly, without respite, with a positive line and a wise hand, to unravel outward appearance and find the bone structure, to search for the justification of the slightest contour, and the secrets of all its aspects."[11]

9 Custodero (1985): 1401 and 1941.
10 Germain (1907): 173.
11 Custodero (1985): 40.

9 Medlars

Black chalk and pastel. Height: 0.230; width: 0.300.
Inventory number: A 1773

Provenance: Acquired from the artist's heirs in 1844.
Bibliography: Germain (1907): 174; Germain (1911): 21; Chaudonneret (1982): 60; Custodero (1985): 1417.

This study — which on account of both subject and size is less important than the preceding works — was chosen as a model for students in the "classe de la Fleur" of the Ecole des Beaux-Arts. J. Custodero mentions a pastel copy at the Musée des Arts Décoratifs de Lyon.

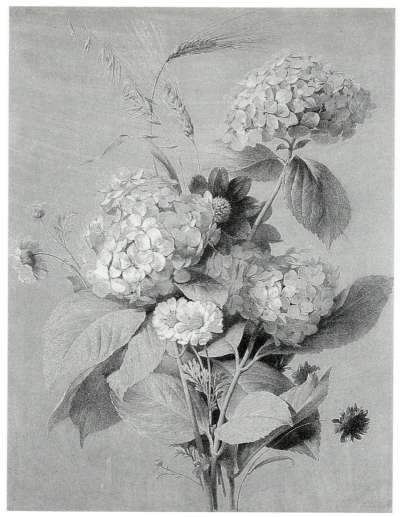

8

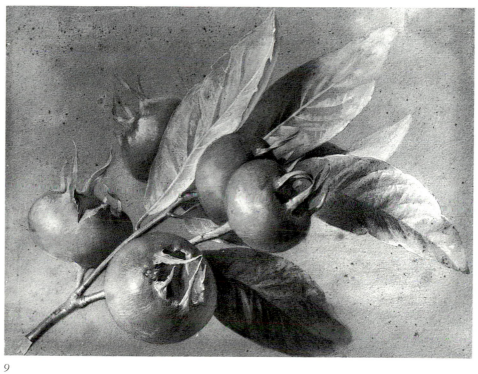

9

ALBERT BESNARD
Paris, 1849–Paris, 1934

10 Study for the Portrait of Vice Admiral Sir John Edmund Commerell

Charcoal heightened with white chalk. Height: 0.320; width: 0.240. Signed and dated at lower left: "A. Besnard 1882."
Inventory number: B 1368
Provenance: Gift of the Baron Vitta in 1925.
Bibliography: Brachlianoff (1989-4): 26.

The facial features of Vice Admiral Sir John Edmund Commerell appear very close in this drawing to the painted image of the Vice Admiral seated in a bark holding the tiller against a difficult sea. The painting was donated to the Musée des Beaux-Arts de Lyon by Baron Vitta, along with this preparatory study.

Albert Besnard, husband of Charlotte Dubray, the daughter of the sculptor Gabriel-Vital Dubray and a sculptor in her own right, followed his wife to London sometime shortly after 1879. Through the large, aristocratic clientele of his wife he obtained several important portrait commissions, including the portrait of the Vice Admiral. For some unknown reason this portrait did not remain long in the Commerell family; as early as 1904, it was shown in France at the Salon de la Société Nationale des Beaux-Arts.[12]

Edmund Commerell (1829-1901) pursued a brilliant naval career and was promoted to Admiral of the Fleet in 1892.

12 The painting is reproduced in the *Gazette des Beaux-Arts* I (1904): 367.

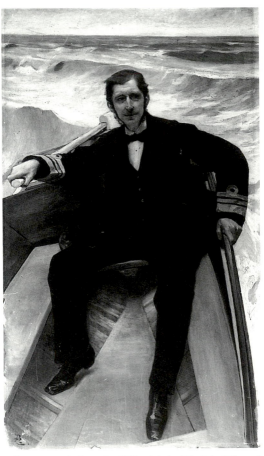

Albert Besnard, *Portrait of Vice Admiral Sir John Edmund Commerell,* Lyon, Musée des Beaux-Arts.

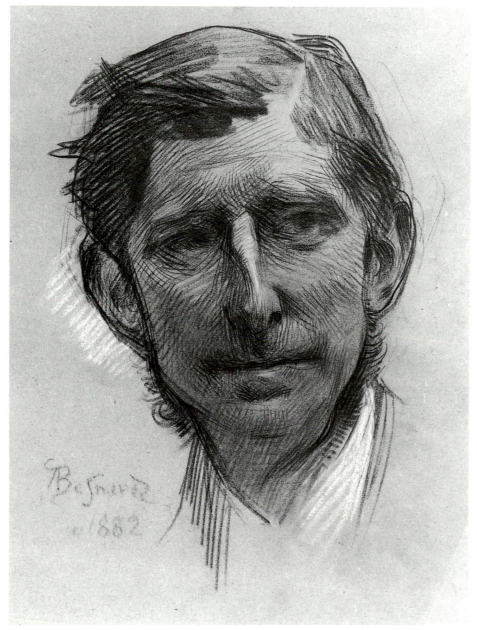

10

PAUL BOREL

Lyon, 1828–Lyon, 1913

11 A Guardian Angel

Charcoal, China ink wash and white gouache. Height: 0.890; width: 0.760.

Provenance: Entered the Collection at an unknown date.
Bibliography: Thiollier (no date): plate no.AA.

This imposing angel is a preparatory study for the decoration of the Dominican chapel at Oullins, near Lyon. For the right side of the nave, above the windows of the chapel, Borel had designed five quatrefoils representing pilgrim angels holding a pilgrim's staff; on the left side, he placed five guardian angels holding the scale of the Archangel Michael. This preparatory drawing was made for one of the five guardian angels.

Borel, by using the architectural motif of the quatrefoil, presents the winged angel as though emerging from an opening on which rests his left hand and which hides the lower part of his tunic. Borel's work at Oullins is probably one of his best decorative accomplishments.

The Dominican school at Oullins, established by Lacordaire, welcomed the artist and his brother after they had been orphaned at an early age. Probably for this reason, Borel remained affectionately and spiritually tied throughout his life to the order that had cared for him. He decorated the chapel of the College of St. Thomas Aquinas at his own expense. Pierre Bossan, with whom Borel had already worked at the church of Ars, undertook construction of the chapel around 1861. The friendship between the two began with their first meeting in 1844 — when Borel was working in Janmot's studio — and remained firm until the death of the architect.

Borel, who laid out the decorative program around 1869, started to work on it as soon as construction began. Nevertheless, it took him twenty years of work — as the numerous preparatory drawings he made testify — to complete this vast decorative cycle, which includes twenty-five compositions for the chapel.

These illustrate, in the choir, the most famous episodes of the lives of the Saints of the Dominican Order, and in the nave, the concordance of the Old and New Testaments.

The enthusiasm of Huysmans for the work of this mystic artist, especially for his creation at Oullins, is a matter of record. In an article for the *Echo de Paris* (November 24, 1897) later nearly completely reprinted in *La Cathédrale* (1898), Huysmans writes: "The most astonishing religious paintings were there; they had been created without the pastiche style of the Primitives, without the tricks of the awkward bodies enclosed in wire, without trompe-l'oeil and affectation."

However, Huysmans's admiration for Borel was not blind. Among his comments while visiting Oullins, one summed up his reservations: "[He] could do very well or execrably."[13] Nevertheless, Huysmans is the writer who speaks most accurately about both the painter and his work. In one sentence, he captured the genius of Borel: "How filled with the joy of God had to be the artist who could paint such a work!"

13 Hardouin-Fugier (1980): 21.

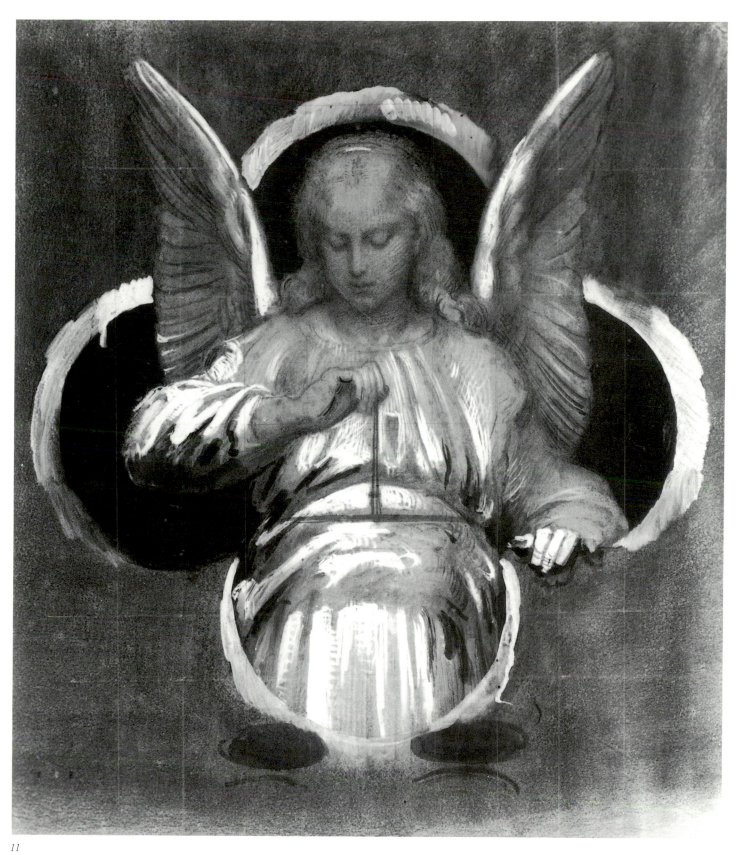

11

WILLIAM BOUGUEREAU

La Rochelle, 1825–La Rochelle, 1905

12 View of Seiano

Watercolor over pen and China ink. Height: 0.395; width: 0.335. Stamp on lower right: "W. Bouguereau." Inventory number: 1948-50

Provenance: Gift of M. Vincens-Bouguereau in 1948.
Catalogue: See Lyon (1989): 27, no.9.

In December 1850, Bouguereau, who had won second place in the Premier Grand Prix de Rome, left Paris for Italy, where he spent a little more than three years. A diary begun on February 7, 1851, allows us to trace the artist's travels very precisely. In Italy, he not only produced numerous works modelled after Old Masters and the Antique, but worked relentlessly to create a considerable body of detailed studies of the environs of Rome, Tuscany, the Veneto, Umbria and the outskirts of Naples. This view of the village of Seiano was done while the artist was sojourning near Naples from April to October 1851. From his diary, we know that he was in Seiano in June of that year. The abundant freshness, spontaneity and elegance of this watercolor are characteristic of works executed while he was in the company of Alfred Curzon, a close friend who had won the Prix de Rome for landscape and who probably played an important role developing Bouguereau's interest in landscape painting.

13 A Peasant Woman of the Frosinone Region

Watercolor over graphite. Height: 0.273; width: 0.190. Annotated, in graphite, at upper right: "ferenze di campagna-nupio (?)." Stamp on lower right: "W. Bouguereau." Inventory number: 1948-52

Provenance: Gift of M. Vincens-Bouguereau in 1948.
Catalogue: See Lyon (1989): 27, no.10.

During his stay in Italy, Bouguereau interested himself not only in landscape but also in the various folk cultures witnessed while travelling extensively across the country. He produced numerous subtly observed studies of peasant women in their traditional costumes. The picturesque treatment of detail here deprives the figure of none of its nobility. During his entire career, Bouguereau remained faithful to the ideal of feminine beauty that he identified in young Italian peasant women.

12

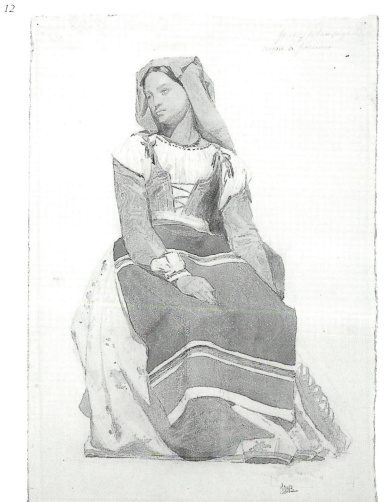

13

JEAN-MICHEL CAZIN
Paris, 1869–Paris, 1917

14 Portrait of Puvis de Chavannes

Red chalk. Height: 0.360; width: 0.260. Monogram M/C on lower right.
Inventory number: B 1632

Provenance: Gift of M. Tempelaere in 1929.

Jean-Michel Cazin designed the medal presented to Puvis de Chavannes on January 16, 1895, in honor of his seventieth birthday. Here the facial features of Puvis de Chavannes, seen in profile, are rendered in a detailed and precise manner that suggests the art of the engraver.

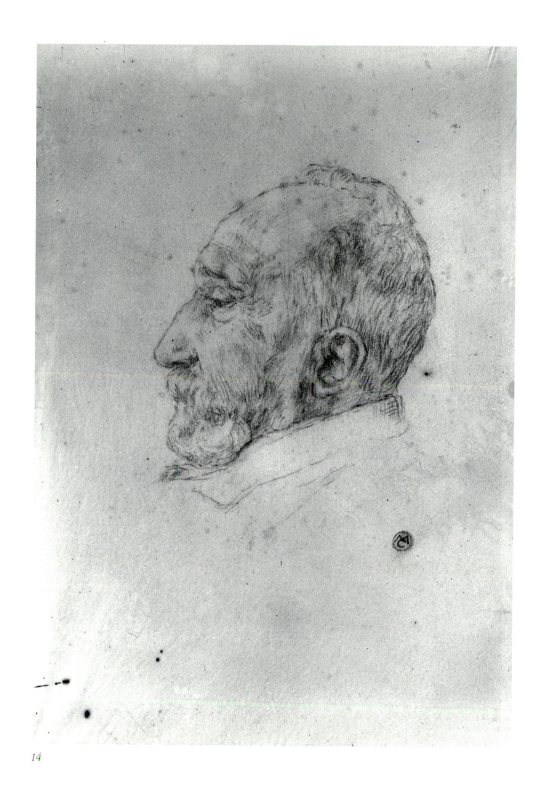

14

PAUL CHENAVARD
Lyon, 1807–Paris, 1895

15 Italian Woman's Head, Three-Quarter Right Profile

Charcoal and red chalk, heightened with white chalk, on oiled tracing paper. Height: 0.298; width: 0.212. Annotated, with black chalk, at lower left: "Via dei Fossi-4017. piano interto. St Pellegro Lazarini."
Inventory number: H 1857

Provenance: Gift of the artist (unspecified date).
Catalogue: See Lyon (1989): 30, no.15.

The inscription on this drawing, doubtless the address of the model who posed for the study, permits us to date the work to one of Chenavard's Italian sojourns, perhaps the first, 1827-1829. The artist later used this study for his *Judith*, a painting in the museum at Lyon. Both the position of the head and the determining role of light — which powerfully models the neck, illuminates the tip of the nose, and relegates the eyes to shadow — reappear in the painting. Yet, the sensuous, mysterious beauty represented here becomes, in the painting, a rather heavy, classical coldness. A study of the entire nude figure of Judith is also preserved at Lyon (inv. A3146-1).

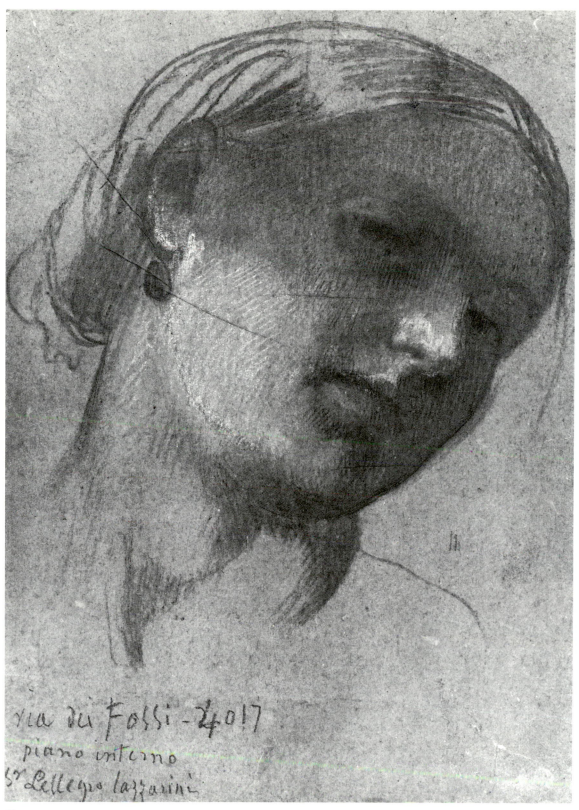

via di Fossi - 4017
piano interno
Sr Pellegro lazzarini

15

PAUL CHENAVARD

16 Bust of a Woman Smiling

Charcoal and pastel. Height: 0.430;
width: 0.290.
Inventory number: B 352ter 13

Provenance: Gift of E. Aynard in 1884.

The artist has modelled this face, which wears a smile distantly recalling the *Mona Lisa*, with superb confidence, the draftsmanship reflecting a strong influence of Italian quattrocento painting, to which Chenavard would have been exposed initially in the Musée des Beaux-Arts de Lyon, where Perugino's *Ascension of Christ* (1496-1498) had been received as a gift from Pope Pius VII in 1816, and later during his sojourns in Italy, especially the first (1827-29).

Joseph Sloane, in his monograph on Chenavard, notes that although Chenavard lost the notebooks he filled with drawings after Leonardo and other masters on his first Italian sojourn, he could never escape the vast repertory of figures and compositions that he memorized at that time. Just such a figure as this could have contributed to Chenavard's reputation for eclecticism, if not outright plagiarism. Of this quality in Chenavard's work, Sloane has aptly remarked, "Lacking the pictorial ability to convey his ideas in suitable artistic form, he fell back on the styles of those greater than himself, thereby incurring charges of imitation and plagiarism."[14]

14 Sloane (1962): 9&16.

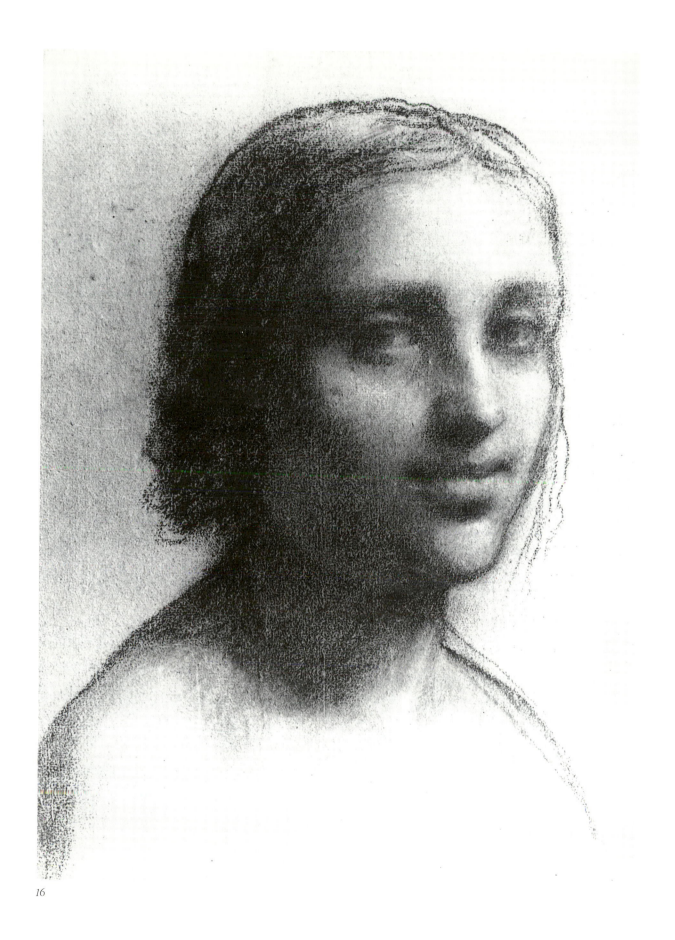

16

PAUL CHENAVARD

17 Head of a Young Man Wearing a Turban

Charcoal and pastel. Height: 0.348;
width: 0.292. Signed (?) in black chalk
at lower left.
Inventory number: H 1894

Provenance: Gift of the artist
(unspecified date).
Catalogue: See Lyon (1989): 30, no.17.

Grunewald related this brilliant study to portraits done 1815-1840 by the Nazarene painters, who profoundly influenced the young Chenavard during his second Roman sojourn, which began in 1832.[15] This work was compared in the San Francisco exhibition catalogue to a drawing called **Bacchus and Ampelos** (circa 1840), which, after having been attributed to Prud'hon, was restored to Chenavard.[16] However, the long ringlets framing the young man's face suggest the possibility of a connection between this sensitive figure study and one of the Panthéon compositions dealing with Biblical subject matter, in which the young man would be a Hebrew.

15 Grunewald (1985): 41.
16 **San Francisco** (1977): 244.

18 Woman's Head, Right Profile

Charcoal and pastel. Height: 0.264;
width: 0.199.

Provenance: Entered the Museum
at an unknown date.

Chenavard conceived of a series of sixty-three scenes beginning with "Adam" to illustrate "the march of human destiny through trial and tribulation, through alternating ruin and rebirth" on the walls of the interior of the Panthéon, as well as six mosaics — Purgatory, Hell, Paradise, Elysian Fields, the Crucifixion, and, under the central dome, "Social Palingenesis" or The Philosophy of History — for the floor, and four designs illustrating the ages of human intelligence — religion, poetry (art), philosophy, and science — for the piers.[17]

The commission, which Chenavard saw as the culmination of his life's work to that point, was awarded in 1848 but revoked after the monument, secularized since 1831, was re-established as a church by order of the Emperor Napoléon III in December, 1851. Even though, to Chenavard's everlasting disappointment, the project came to an abrupt halt, some of the 11′ × 18′ cartoons were exhibited in the Salon of 1853 and at the Exposition Universelle of 1855. They were shown again, along with a body of preparatory drawings, in Lyon in 1876.[18] Both the cartoons and the drawings are preserved in the Lyon museum today.

Although this head has not been linked to a specific Panthéon composition, it is of a type that can be seen in many of them. The few lines on the crown of the woman's head suggest a loose headdress characteristic of Biblical times. Typical of Chenavard are the suppression of color (the scenes were painted in grisaille) and the hard generalization of forms, attributes intended to emphasize ideas over sensation.

17 The Panthéon commission is discussed in summary in Joseph C. Sloane, *French Painting Between the Past and the Present: Artists, Critics, and Traditions, from 1848 to 1870* (1973) and in depth in Sloane (1962).

18 For further discussion of the 1876 exhibition, see entry for no.36, Français, **The Banks of the Rhine**.

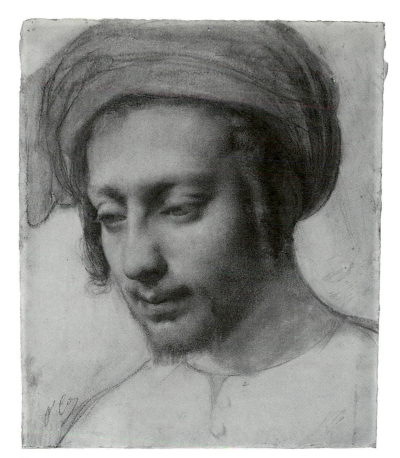

17

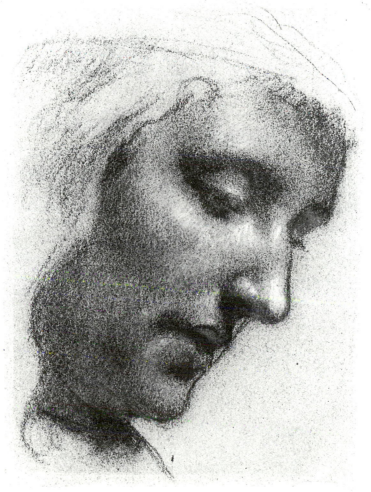

18

19 Woman's Head, Left Profile

Black chalk and red chalk, heightened with white chalk, on tracing paper.
Height: 0.270; width: 0.218.
No Inventory number

Provenance: Gift of the artist (unspecified date).
Catalogue: See Lyon (1989): 30, no.14.

The pose and features of this profile study are almost identical to those of the *Portrait of Madame d'Alton-Shée* by Chenavard, preserved in the Musée des Beaux-Arts de Lyon.

When given further definition in the painting, the hair appears more crimped than the representation of hair in the drawing would suggest, and a wisp of hair is pulled loosely across the top of the ear. In the painting, the face is rendered slightly more in profile and the sitter's chin is slightly stronger than in the drawing. Otherwise, Chenavard would appear to have worked out in this carefully-modelled and subtly-toned drawing everything concerning the head and expression of his sitter. In the painting, moreover, the ear, which in the drawing seems a little too large and somewhat disembodied, is counterbalanced and integrated successfully into the overall composition by the sitter's large chignon.

Chenavard was an intimate member of an intellectual circle populated by the Comte and Comtesse d'Alton-Shée, the Comte's sister, Madame Jaubert (the friend and sponsor of the poet Alfred de Musset), and his daughter Berthe de Rayssac. Although the exact date of the portrait has not been established, Madame d'Alton-Shée mentions the painting in a letter she wrote in 1867, and it might be the picture that her husband, who was an important liberal figure in the Second Republic, mentions in a letter from 1856.[19]

Whatever the date of the work, it is interesting to see this departure from the cold, generalized figure-types that populate Chenavard's Panthéon compositions. The artist has represented a specific individual with warmth and sensitivity, at no compromise to the admirable economy of style that he had developed earlier in his career. If Chenavard was justly criticized as "a painter who does not paint," this exceptional work shows what he could accomplish when the urge to portray triumphed over the will to instruct.

19 The painting is discussed in Sloane (1962): 187-188.

19

JEAN-BAPTISTE CAMILLE COROT
Paris, 1796–Paris, 1875

20 Castel Sant'Elia

Pen and brown ink over graphite.
Height: 0.275; width: 0.410.
Annotated and dated, with pen and
brown ink, at lower right: "Castel St
Elia 8bre 1827." Stamp on lower left:
"VENTE COROT (Lugt 461)." On
the verso, a sketch in pen and brown
ink: "cliffs of Castel Sant'Elia."
Inventory number: B 1029 a (recto)
and B 1029 b (verso).

Provenance: Corot's studio (sale of
1875). Henri Rouard Collection.
Acquired from the Henri Rouard sale
in 1913 (no.17).
Catalogue: See Lyon (1989): 35, no.19.

Of Corot's three trips to Italy, the first
(late 1825–summer 1828) was the long-
est and most important for his artistic
development. He produced this land-
scape at Castel Sant'Elia, a village north
of Rome next to Civita Castellana, in
October 1827, during the first trip.[20]

Corot stayed twice in the regions of Ci-
vita Castellana and Castel Sant'Elia, first
in May-June 1826, a few months after
his arrival in Italy but before he went to
the Sabine Mountains, then a year later
in September-October 1827. The inten-
sity of his work in this area, whose nat-
ural beauty provoked enthusiastic re-
sponse, reveals itself in an impressive
number of drawings and in thirty or so
paintings. About one fourth of the works
Corot produced during his first voyage
in Italy resulted from these two stays
north of Rome.[21]

Castel Sant'Elia, seven kilometers west
of Civita Castellana, perches with nearby
Nepi, on a plateau of volcanic tuff atop
steep cliffs dominating the Suppentonia
Valley, itself a deep gully formed by the
Fosso di Fontanacupa River. The Lyon
drawing shows Nepi in the distance, as
seen from Castel Sant'Elia, with a per-
spective view of the Suppentonia valley.

One can discover this panoramic land-
scape from the top of the cliffs next to
the chapel of San Michele.[22] Aligny
adopted the same perspective in two
views of Nepi now in the Louvre.[23]

The hastily drawn sketch on the verso
shows the cliff that dominates the valley,
with the San Michele chapel at the cen-
ter, the exact spot where Corot sat to
produce the view of Nepi on the recto.
This same view appears in another
drawing dating from the same month,
October 1827, (Castel Sant'Elia, Ro-
baut, no.2631) representing the basilica
of Sant'Elia dominated by the cliff and
San Michele. The absence of the basilica
in the present drawing is probably due
to a slightly different perspective and a
very schematic treatment, perhaps the
artist's first approach to this subject.

The astonishing rapidity of Corot's artis-
tic progress in Italy is apparent from a
comparison of the relative tentativeness
of the two drawings produced at Castel
Sant'Elia in June 1826 with the asser-
tiveness of line as seen in drawings like
the Lyon example made a year later.[24]
In the fall of 1825, when Corot arrived
in Italy, he was still a novice. Within a
few years, however, confronted with the
landscapes of Rome and its environs and
in contact with cosmopolitan circles in-
cluding the French artists Edouard Ber-
tin, Léopold Robert and Aligny, his art
would assert itself with a speed and au-
thority quickly recognized by Aligny. The
influence of Aligny, who had arrived in
Italy a year earlier and already enjoyed
great prestige, played an important yet
subtle role in the artistic development of
the young Corot, who admired his
friend's precise and powerfully construct-
ed drawings and at his side learned to
construct and simplify compositions.

The tight, detailed nature of this draw-
ing is very close to that of some of the
drawings executed at Civita Castellana
as early as 1826 (Robaut no.2492) or
even a little later (Robaut nos.2527 and
2540). The precision of line stops short
of dryness, yet ignores none of the solid-
ity and perpendicular construction of the
landscape, vividly presented underneath
a profusion of vegetation covering the
rocky escarpment. The conciseness of the
simple sketch on the verso, executed in
one continuous burst of energy, reveals
the deftness with which Corot could put
the essentials of a landscape into place
with a light touch that is both ethereal
and incisive.

20 Held (1943): I, 183-186.

21 André and Renée Jullien carefully reconstructed
the details of Corot's travels in this area as well as
in the Sabine Mountains. Their study reveals the
precise locations of the sites where Corot worked
and the ones he depicted.
Jullien (1982-1): 179-202; (1984-1): 179-197.

22 Corot produced several renderings of this
particular view, taken from the cliffs of Castel
Sant'Elia and showing Nepi in the far back-
ground. In June 1826, he executed a view of
the Nepi's valley, called *Castel Sant'Elia—
Rocky and Wooded Ridge Dominating the
Valley and the Factory in the Background*
(Louvre, RF 8969, Robaut no.2522), taken
from the sanctuary of Santa Maria ad Rupes,
which was built in one of the grottos in the cliff.
He also produced a painting while standing on
the road that goes from the Basilica of Sant'Elia
to the same sanctuary as mentioned above.

23 *View of Nepi from Castel Sant'Elia—
Surroundings of Rome—1826* (RF 8258) and
*View of Nepi from the Gully of Castel
Sant'Elia—Surroundings of Rome—1826*
(RF 8259).

24 The two 1826 drawings are *Castel Sant'Elia*
and *Factories on the Top of the Rocks* (Louvre
RF 8971, Robaut no.2522 mentioned above).

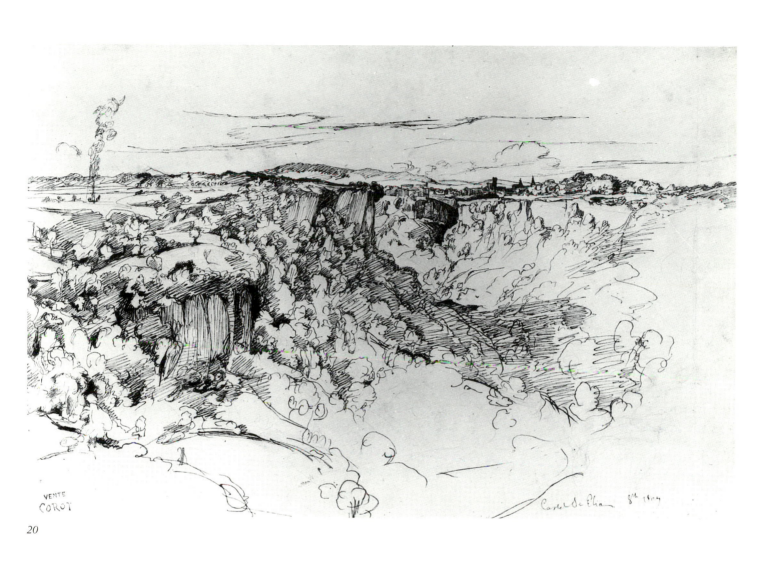

20

GUSTAVE COURBET

Ornans, 1819–La Tour de Peilz (Switzerland), 1877

21 Young Women in a Wheat Field (Les Femmes dans les blés)

Charcoal with traces of white heightening. Height: 0.463; width: 0.560. Signed and dated in charcoal at right: "G. Courbet 1855." Inventory number: B 1153 bis h

Provenance: Antonin Proust Collection. Georges Lutz Collection (sold at the Georges Petit Gallery in 1902, no.131). Gérard Collection. Raymond Tripier Collection.
Bequest of Raymond Tripier in 1917. Catalogue: See Lyon (1989): 37, no.20.

For a long time, this drawing was thought to be a preparatory study for the *Young Ladies on the Banks of the Seine (Demoiselles au bord de la Seine)*, even though Courbet exhibited it in 1867 with the title, *Les Femmes dans les blés*, and in spite of major differences between the drawing and the painting.

As early as 1906, Georges Riat cited this work as a preparatory drawing for the famous painting of the Salon of 1856.[25] This was reaffirmed by Louis Aragon, who believed the drawing to be the initial approach to the subject of the painting, which he considered to have been painted from life, then reworked to give the figures the quality of caricature present in the final work.[26] In 1969-1970, Pérot sided with this hypothesis, as had Kahn and Ecalle in their 1957 study.[27] Not until the Grand Palais exhibition of 1977-1978 were all ties between the Petit Palais painting and this drawing dismissed, an opinion reiterated recently by Sarah Faunce.[28] Despite a date just preceding that of the painting and an obvious relationship between the themes of the two works, this drawing should be considered as independent from

Young Ladies on the Banks of the Seine, an unrelated work whose preparatory studies are all very close to the final version.[29]

Young Women in a Wheat Field belongs to a group of highly-finished drawings that Courbet produced from the 1840s until the end of his life, usually with no relation to his painted oeuvre. He evidently considered these drawings, generally executed in charcoal and in large scale, as full-fledged oeuvres. He exhibited them in the same way he exhibited his paintings, some even several times. Four were shown in 1855, three in 1867, and, for Courbet's first retrospective — organized in 1882 at the Ecole des Beaux-Arts — Castagnary presented no less than sixteen drawings.[30] Their very pictorial style results from Courbet's masterly use of charcoal and stump, adding the illusion of weight through the play of light. The monumentality of the two figures is striking; their placement in the composition resembles a photographic close-up.

It is possible to relate the profile of the woman on the right to that of the woman depicted in the Petit Palais painting, *La Mère Grégoire*, also known as *Madame Andler*, but the identity of this woman is as yet undetermined because the figure bears no kinship to the two other known portraits of Mother Gregory.[31]

René Huyghe stressed the recurrence of the theme of sleep in the painted as well as the graphic oeuvre of Courbet.[32] Under various titles — *The Dream, Sleep, The Nap* — it is always the same "essential theme, the same obsessive theme, that Courbet incessantly reused." We can

cite, for example, *The Nap in the Countryside* and *Sleeping Female Reader*, drawings in the Musée de Besançon and the Louvre, respectively.[33]

Until recently, Courbet's graphic oeuvre seemed limited to thirty or so drawings, except for the three notebooks of sketches in the Louvre. The exhibition, "The Secret Trips of Monsieur Courbet," (Baden-Baden and Zurich) in 1984, considerably expanded our knowledge by revealing the no less than two hundred sketches in the hitherto unknown Reverdy Collection.

25 Riat (1906): 150.

26 Aragon (1952): 208.

27 Pérot (1969-1970): 31.
Kahn and Ecalle (1957): 9.

28 Toussaint (1977-1978): 143.
Faunce (1988): 216.

29 Apart from the six painted studies related to the *Young Ladies on the Banks of the Seine*, we can mention a preparatory drawing for the painted sketch of the Stang and Pierre Mathiesen collections (Norway), depicting the reclining woman in the foreground (drawing on tracing paper belonging to Jean Matisse). According to Aragon, Courbet would also have executed a drawing of the general composition after the canvas for an illustration in a magazine (1952): 109, no.13.

30 The four works shown in 1855 are no.39: *Portrait of a Woman,* 1847; no.40: *Young Girl with a Guitar, Reverie,* 1847; no.41: *The Young Painter at his Easel,* 1848; no.42: *A Young Man,* 1847.
The three works displayed in 1867 are no.111: *The Painter at his Easel,* 1848 (previously exhibited in 1855); no.112: *Young Women in a Wheat Field,* 1855; no.113: *Young Girl with a Guitar, Reverie,* 1847 (previously exhibited in 1855).

31 Courthion (1987): nos.162, 163 and 164.

32 Fernier (1969).

33 See *Paris, Grand Palais* (1977-1978): nos.136 and 138.

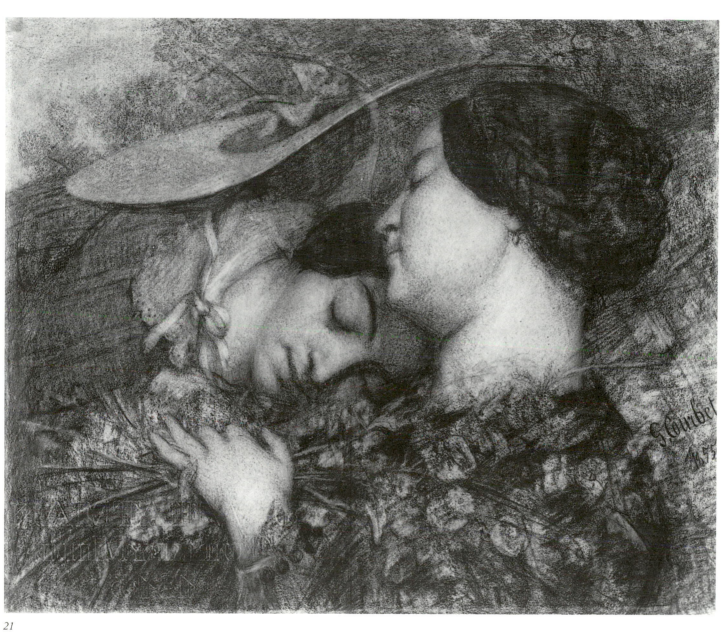

21

HONORÉ DAUMIER
Marseille, 1808–Valmondois, 1879

22 The Wrestlers

Black chalk. Height: 0.298; width: 0.200. On the verso, traces of a chalk sketch.
Inventory number: B 1054-a

Provenance: Claude Roger-Marx Collection.
Acquired at the sale of the Claude Roger-Marx Collection in 1914 (part of no.116).
Catalogue: See Lyon (1989): 39, no.21.

This and the following drawing are studies for the *Wrestlers* of Copenhagen (Ordrupgardsamlingen, Hansen Collection) in which the wrestlers, to the left in the background, fight in a circus arena. In addition to a study in the Albertina, there are four other studies of this subject; all are drawn on the same sheet and, like the Lyon drawing, all belonged to the Claude Roger-Marx Collection.[34] The highly detailed musculature in at least two of these sketches is quite different from the passionate quality of the Lyon studies, in which the two bodies form a compact mass of intertwined lines.

None of the different poses Daumier studied in this set of sketches survived in the final composition. He abandoned the effect of the compact mass, created by the partial superimposition of the two bodies, in favor of a more expansive composition where the wrestlers appear more detached from each other, their legs aligned on the same plane.

Except for Adhémar, who dated the painting to the years 1865-1868, art historians (Larkin, Maison, Rey, Mandel) have agreed on an earlier date of around 1852. The style of the drawings, especially the style of the Albertina drawing, confirms the earlier date for the painting which was one of the first compositions in which Daumier treated the theme of the circus.

34 Maison (1968): no.525 (for the Albertina study), no.536 (for the sheet). Paris, Musée de L'Orangerie (1934): no.114, formerly in the Marcel Guérin collection, (present location unknown).

23 The Wrestlers

Black chalk. Height: 0.262; width: 0.200. On the verso, traces of a chalk sketch.
Inventory number: B 1054-b

Provenance: Claude Roger-Marx Collection.
Acquired at the sale of the Claude Roger-Marx Collection, in 1914 (part of no.116).
Catalogue: See Lyon (1989): 39, no.22.

Maison, in his 1968 catalogue, indicated the existence of this drawing but admitted he did not know its location. Acquired with the previous work by the Musée des Beaux-Arts de Lyon at the Claude Roger-Marx sale, the two formed part of a set of three drawings; the third, absent from the exhibition (Maison, no.528), was sold as lot number 116 under the title *Wrestling* with the following text: "while wrestling, one of the men tries to lift his adversary by seizing him round the waist." The position of the bodies, the inverse of that in the previous drawing, is very close to their positions in the more detailed sketches in the former Guérin Collection (see the previous catalogue entry).

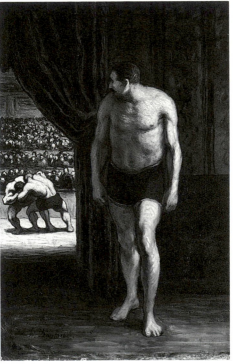

Honoré Daumier, *The Wrestlers*, Copenhagen, The Ordrupgaard Collection.

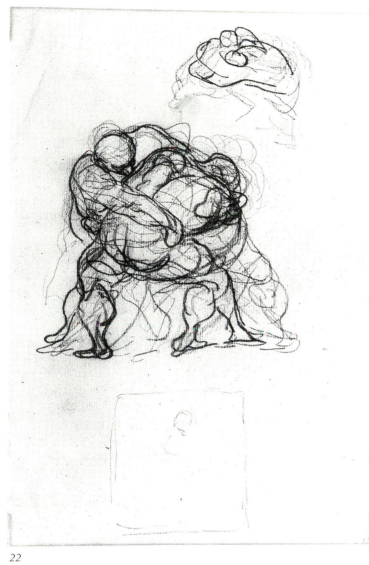

22

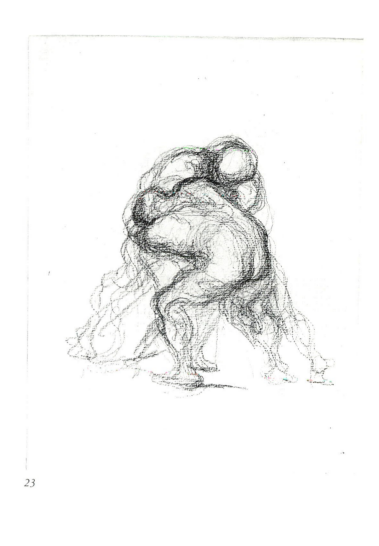

23

GABRIEL-ALEXANDRE DECAMPS
Paris, 1803–Fontainebleau, 1860

24 Samson Turning the Millstone

Black chalk, watercolor heightened
with gouache on paper prepared with
brown wash. Height: 0.420; width:
0.625. Signed in black chalk at lower
right: "DC."
Inventory number: B 944

Provenance: The Benjamin Delessert
Collection (acquired directly from
the artist in 1845).
Acquired at the sale of the Delessert
Collection in 1911 (no.14).
Catalogue: See Lyon (1989): 42-43,
no.24.

This important drawing belongs to a
cycle of nine works devoted to the *Story
of Samson*, which Decamps presented
to great critical acclaim at the Salon of
1845, when, eleven years after the
triumph of his *Defeat of the Cimbri
by Marius*, he reclaimed a position as
one of the most important artists of his
time.

Because of the transitional role that it
plays in his later art, the *Story of Sam-
son* occupies a particularly important
place in Decamps' oeuvre. As Mosby
has written, this later period encapsu-
lates both the apogee of the artist's career
and the source of his greatest disap-
pointment.[35] In reverting to the heroic
inspiration and classical style of his work
from the 1830s, he was attempting to
prove his skill as a history painter. Aware
that Delacroix and Chassériau were
working on large decorative commis-
sions, Decamps ardently wished for a
State commission on a monumental scale.
Yet, even with the success of the *Story
of Samson*, nothing of the sort came his
way.

In an autobiographical letter written in
1854 at the request of Doctor Véron for
publication in *Mémoires d'un bourgeois de
Paris*, Decamps refers bitterly to this
situation: "About ten years ago, I exhib-
ited a set of drawings executed vividly
and with various methods (the *Story of
Samson*). I had hoped to demonstrate
that I was able to improve.... The
drawings were praised, doubtless even
more than they deserved; a distinguished
connoisseur generously bought them; but
neither the State nor any of our wealthy
patrons thought of asking me to produce
a work of that kind.... At that time, I
would have been able to put to good
use even the most ludicrous idea pro-
posed to me if only I had been given a
room to decorate." The artist com-
plained of being known only as painter
of monkeys. He added that the "*Defeat
of the Cimbri by Marius* characterized
the kind of paintings I wanted to do ...
but I have been condemned to produc-
ing easel paintings."

Decamps' goal in the *Story of Samson*
was to show that he could produce
something new and original without ig-
noring the great classical models. He
may well have been inspired by Rem-
brandt, who had worked on this subject
more than once and who was Decamps'
most important and constant reference.
Théophile Silvestre pointed out as early
as 1855, however, that a set of thirty-
eight engravings with the same title by
François Verdier (Bibliothèque Nation-
ale) had the most direct influence upon
Decamps.[36] Nonetheless, for *Samson
Turning the Millstone* Decamps could
have benefited from no such model, in
that Verdier never engraved that episode.

As to sources, Mosby has noted that the
window recalls the one in Raphael's *De-
livery of St. Peter* in the Vatican. The
guard is very close to certain figures from
Decamps' Italian scenes, such as *An
Italian Family* (Ponce, Museo del
Arte). The attitude of the hero derives
from Samson's position in *Samson Made
Prisoner*.[37] The contrast of light and
shadow, characteristic of Decamps' style,
is spectacular and dramatic. Focillon re-
marked that Decamps "seemed to have
studied the effect of light on the cell
walls for days, for years. The light is
coming from the upper part of the draw-
ing, filtered by a basement window. This
light, through a diagonal, defines its own
area and the one of shadow. It explodes
with an incredible violence."[38]

The *Story of Samson* astonished the
critics. Baudelaire devoted several ad-
miring pages to the drawings, conclud-
ing that: "the most beautiful of all is
incontestably the last — Samson with
his big shoulders, the invincible Samson
condemned to turn a millstone — his
hair, or more exactly, his mane gone —
his eyes gouged out — the hero bent
over, as a draught animal, under the
weight of his work — cunning and
treachery have subdued this terrible
power that once could have defied the
laws of nature — indeed — here is
Decamps, at his truest and best...."[39]

Charles Clément agreed, describing the
composition as follows: "The scene hap-
pens between three protagonists: Sam-
son, a slave armed with a stick in charge
of making Samson do his work, and a
rat who warms himself in the sun."[40]
Delacroix wrote in his diary on March
11, 1847: "I saw with great pleasure
Samson Turning the Millstone by
Decamps, it has genius."[41]

Despite this tremendous critical success,
the *Story of Samson* became the failure
that caused Decamps to return to genre

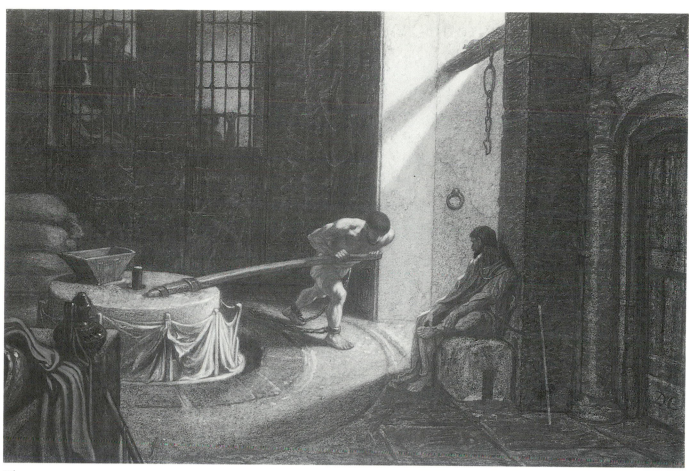

24

painting. To Véron he wrote: "I am convinced that the position I found myself in, wherein it was necessary to produce only easel paintings, totally diverted me from my natural aspirations."[42]

As early as 1845, the set of drawings was bought by Benjamin Delessert. At the sale of part of the Delessert collection in 1911, the Lyon drawing became the only one to enter a French public collection. Today, five of the set are in the Comte de Saint-Léon collection.[43] Of the three remaining works thought to be lost, one (**Samson Killing the Lion**) was recently discovered in a private collection in Paris. This discovery, which Mosby made in 1981, inspired a new publication of the ensemble.[44] The Lou-

vre owns a complete series of the drawings, smaller in size, which Mosby believed to be preparatory studies rather than copies.[45] The entire set of the **Story of Samson** was lithographed by Eugène Leroux.

35 Mosby (1981): 583.

36 Silvestre (1855): 174.

37 Mosby (1977): 192 and (1981): 578.

38 Focillon (1927): 260-261.

39 Edited by Lemaitre (1962): 21.

40 Clément (1886): 66.

41 Edited by Joubin (1981): 142.

42 Véron, ibid.

43 Mosby (1977): nos. 404-407.

44 Mosby (1977): no. 544.

45 Lemaitre in note no.1 (p.19) accompanying the *Curiosités Esthétiques* by Baudelaire (1962) incorrectly identifies the Lyon drawing as one of those small copies.
Mosby (1977): nos. 304-312.

ALFRED DEHODENCQ
Paris, 1822–Paris, 1882

25 **Study for the Central Group of *The Execution of the Jewish Woman.***

Pen and brown ink, brown wash, reworked with graphite, on tracing paper, laid down. Height: 0.250; width: 0.200. On the verso, a graphite sketch of the executioner.
Inventory number: B 1287-f

Provenance: Séailles Collection. Gift of Madame Séailles in 1922. Catalogue: See Lyon (1989): 48, no.27.

The Orientalist Dehodencq was attracted to North Africa. Following the example of Delacroix, he traversed Morocco between 1853 and 1863. In 1861, after an absence of five years from the Salon, he submitted two important canvases, of which *The Execution of the Jewish Woman* (no.819) was one. The State purchased it but soon returned it in favor of *The Night Wedding in Tangiers* (see following number), the artist's other entry, with the result that *The Execution of the Jewish Woman* went to England sometime before 1882.

Gabriel Séailles, friend and first biographer of Dehodencq, related the difficult conditions under which this work was created.[46] In 1860, the painter, fascinated by the spectacle of Tangiers street life, witnessed a random, bloody event. A Jewish woman who had renounced her religion in order to marry a Muslim wished to return to her own religion after the death of her husband. Outraged, the Muslims had her beheaded after trying unsuccessfully to make her change her mind. The painting that Dehodencq produced while still affected by this drama was destroyed by Jews irritated that the artist had transcribed onto canvas the suffering of one of their own. Dehodencq sent the Salon a copy of the destroyed canvas. Gabriel Séailles also mentioned the existence of a third version.[47]

This violent episode reclaimed Dehodencq's attention before his return to France, for he painted two other canvases on this same theme; one is in the Bibliothèque polonaise (Paris, inv.625), while the other is in the Musée des Arts africains et océaniens (Paris, inv.12943).

An impressive number of preparatory drawings for this painting survive, including three drawings for the general composition (Rouen, Musée des Beaux-Arts, nos.1043 and 1044; and Louvre, RF 3777) and additional studies, like the Lyon drawing and the two reproduced by Séailles, which were created for the central group composed of the executioner and the victim.[48] Together, these show that Dehodencq seemed to have settled quickly on the general composition. He hesitated, however, with the pose of the executioner, who stands, alternatively, facing us, in a profile view, erect, or bending toward the woman. The artist's deliberation is further manifested by the graphite reworking of this figure and the rapid sketch on the verso of the sheet. The position of the sword also varies: extended horizontally in the Lyon drawing, it slopes downward in the final version. Numerous sketches dealing with the details of each figure complete this group of studies.

The ardor, so characteristic of Dehodencq's passionate style, is masterfully expressed by the pen stroke, alone or accompanied by wash. Claude Roger-Marx spoke about the "very peculiar frenzy that observation communicates to the pen" of the artist and of "the authority of the line, which even while not mastering all its sensibility, recalls the lines of Delacroix. . . ."[49]

46 Séailles (1910): 112-116.
47 Today possibly in the Jerusalem Museum. Séailles (1910): 112-116.
48 Séailles (1910): III, XVII.
49 Claude Roger-Marx (1930): LVII, 298, 300.

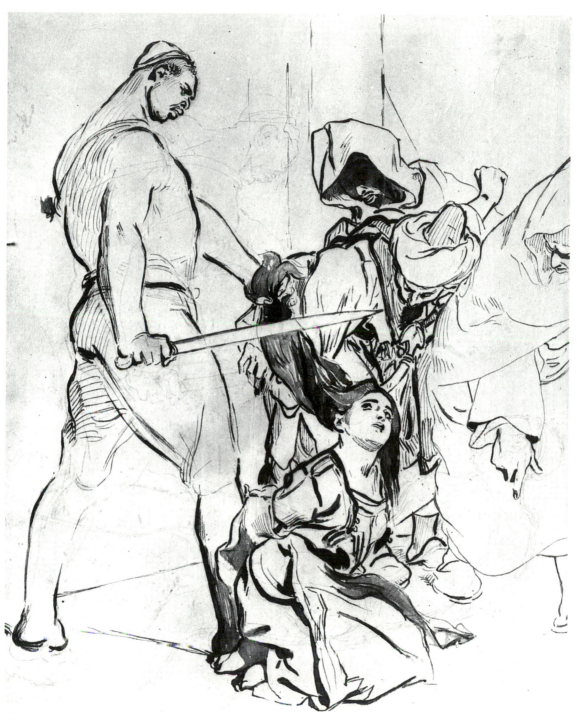

25

ALFRED DEHODENCQ

26 Compositional Study for *The Night Wedding in Tangiers*

Pen and brown ink, brown wash, and traces of red chalk over graphite. Height: 0.320; width: 0.225. Inventory number: B 1287-e

Provenance: Séailles Collection. Gift of Madame Séailles in 1922. Catalogue: See Lyon (1989): 48-49, no.28.

The Night Wedding in Tangiers, presented to the Salon of 1861 along with ***The Execution of the Jewish Woman***, was acquired by the State and sent to the Musée des Beaux-Arts de Dunkerque. Apart from this drawing, there is in the Louvre (RF 7258) a single detailed study devoted to the bride. Dehodencq chose to depict the moment when the bride, presented to the assembly, must close her eyes and not reopen them until after the "torch walk," when she arrives at the nuptial house. This sketch is very close to the final composition, although the nocturnal atmosphere is less evident here than in the final painted work, wherein strong backlighting from flaming torches emphasizes the groups of figures in the foreground. Once more, Dehodencq worked on a scene that allows him to depict a crowd, the motif he used most frequently. The scene of the Jewish wedding captivated him and gave rise to four more very different compositions. These are in Poitiers (a work presented at the Salon of 1870) and in museum collections at Reims, Algiers and Lille; the latter three were shown at the Salon of 1879.

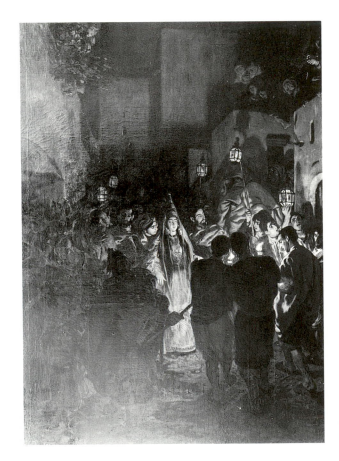

Alfred Dehodencq, *The Night Wedding in Tangiers,* Dunkirk, Musée des Beaux-Arts.

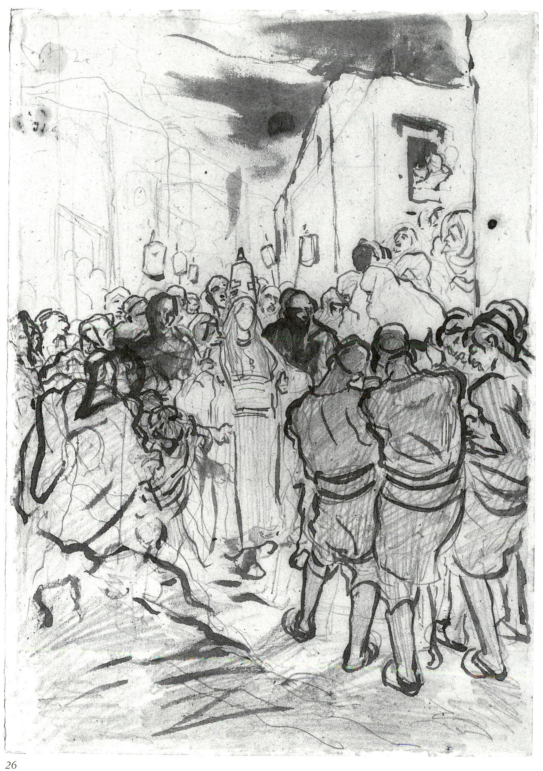

26

EUGÈNE DELACROIX
Charenton-Saint-Maurice, 1798–Paris, 1863

27 Study for *Woman Stroking a Parrot*

Graphite. Height: 0.147; width: 0.195.
Stamp on lower left: "E.D. (Lugt 838a)."
Inventory number: B 1291

Provenance: Delacroix's studio (sale of 1864, perhaps a part of no.653). Ch. Haviland Collection. Acquired at the Haviland's sale on December 7, 1922 (no.11, ill.)
Catalogue: See Lyon (1989): no.30.

This is a preparatory study for the 1827 painting, now preserved at Lyon. The model, Laure, was one of Delacroix's favorites. Although the pose is identical to that in the painting, the headdress and the drapery around the wrist that would appear in the painting are missing from the drawing.

The inspiration, technique and style of this drawing are very close to **Nude Lying on a Bed** (Louvre, RF 4156; Serullaz, 1984, no.92, verso), which was probably an initial approach to the subject of the painting, **Young Nude Woman Lying Down Seen from the Back**, dated by Johnson circa 1824-1826, now lost.

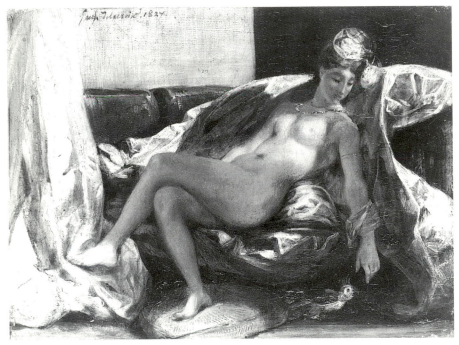

Eugène Delacroix, *Woman Stroking a Parrot*, Lyon, Musée des Beaux-Arts.

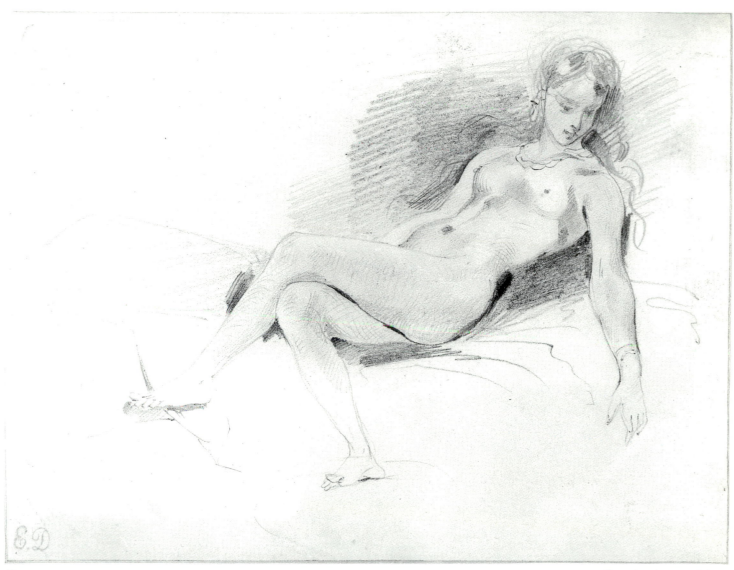

27

Reproduced to actual size

EUGÈNE DELACROIX

28 An Arab Youth

Watercolor and graphite. Height:
0.235; width: 0.134. Stamp on lower
right: "H.L. (Lugt 1333)."
Inventory number: X 1029-26

Provenance: His de La Salle Collection.
Gift of His de La Salle in 1877.
Catalogue: See Lyon (1989): 50, no.31.

The importance to Delacroix of his trip
across Morocco and Algeria, from the
end of January to the end of June, 1832,
when he travelled in the diplomatic mis-
sion of Count Charles de Mornay, is
well-known. This study may have been
executed during the trip, yet it cannot
be precisely dated. The use of delicate
watercolor and graphite was Delacroix's
preferred technique while on the trip.
Evident in this drawing is a nobility of
attitude and costume that led critics to
comment that Delacroix had discovered
in Moroccans draped in their burnous
and jellabas a living Antiquity compa-
rable to the Ancient Greeks.

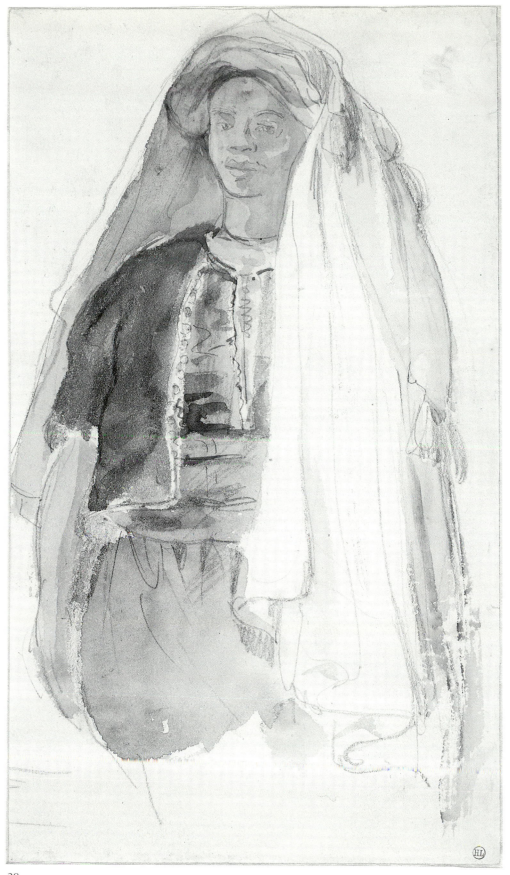

28

29a Saint Paul on the Road to Damascus

Graphite on paper prepared with light brown wash. Height: 0.228; width: 0.355. At lower left: "E.D. (Lugt 838a)."
Inventory number: B 357-14a (recto)

Provenance: Delacroix's studio (sale of 1864, part of no.376). Paul Chenavard Collection.
Gift of Paul Chenavard in 1884.
Catalogue: See Lyon (1989): 53, no.32.

29b The Death of Saint John the Baptist

Graphite on paper prepared with light brown wash. Height: 0.228; width: 0.355. Annotated, with graphite, at lower right: "Héroidiade–Jean-Baptiste."
Inventory number: B 357-14b (verso)

These drawings on each side of a single sheet are studies for the pendentives of the cupola above the fourth bay in the Deputies' Library of the Palais Bourbon. The cupola illustrated the theme of Theology. Although Delacroix received this commission on April 30, 1838, it was not completed before December, 1847, and would only incorporate the *Death of Saint John the Baptist*. In the complete description of his oeuvre that Delacroix sent to Thoré, who included it in his article in the *Constitutionnel* of January 31, 1848, the composition was described as follows: "The death of Saint John the Baptist. The executioner is presenting to King Herod's daughter the head of Saint John, whose pallid body lies on the steps of the jail."

Serullaz, who on the whole accepts the dates proposed by Robaut, grouped all the studies done for the Deputies' Library of the Palais Bourbon around the years 1838-1840. Anita Hopmans questioned these dates, demonstrating that Delacroix, instead of following a well defined plan for this work, hesitated until the last moment over the choice of topics.[50] Initially, he adopted the classification established by Brunet in his *Table méthodique* du *Manuel du libraire et de l'amateur de livres* (1820); yet, when he started work on the first two cupolas, he still had not settled on a precise plan for the whole decoration.

On September 3, 1840, the commission for the decoration of the Library of the Palais du Luxembourg interrupted this work. By April, 1841, the preparatory studies for the Luxembourg were finished and Delacroix returned to work at the Palais Bourbon. By then, he seems to have dropped the idea of a precise iconographic scheme, for there are no further traces of Brunet's classification in his drawings. In 1843, Delacroix was working on the Theology cupola but remained undecided as to the final choice of topic, as can be seen in the sheet exhibited here, wherein are represented, on one side, *The Death of Saint John the Baptist*, and on the other, *Saint Paul on the Road to Damascus*, the subject that Delacroix later would abandon. The same juxtaposition of these two subjects can be found in another drawing,[51] and several other drawings on the life of Saint Paul survive.[52]

Apart from the Lyon drawing for the *Death of Saint John the Baptist*, Robaut, in 1885, listed two other drawings as having the same theme (nos.859 and 860).

In 1858, Delacroix returned to the theme of the beheading of St. John, but with variations, which can be seen in *The Beheading of Saint John the Baptist*, executed for Robert de Sèvres and now in the Berne Museum of Fine Arts.[53]

50 Hopmans (1987): 264.

51 Dessins de Delacroix sale, Paris, Drouot, November 6, 1979, the Bourbon Palace, no.12, illustrated in De Launay (no date): I, fol.36.

52 Joubin (1928): 430; Serullaz (1984): nos.275-276; Robaut (1885): no.823; De Launay (no date): I, fol.38.

53 Robaut (1885): no.858.

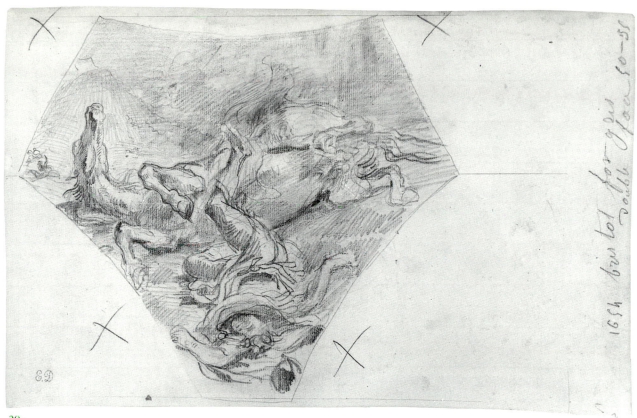

29a

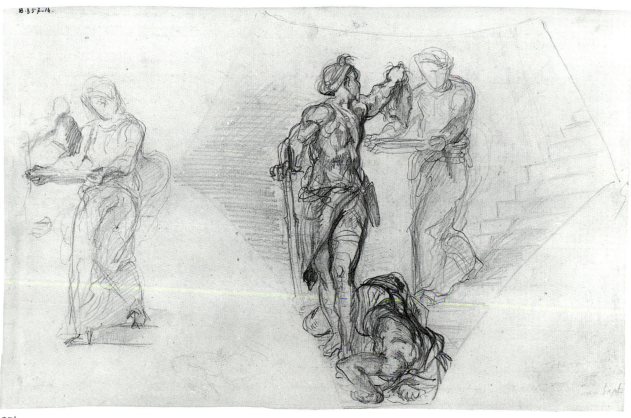

29b

EUGÈNE DELACROIX

30 A Scene of Moroccan Life

Pen and brown ink, brown wash.
Height: 0.250; width: 0.392. Stamp
at lower right: "E.D. (Lugt 838a)."
On the verso, a graphite sketch of
two corner pieces and annotations, at
the top of the drawing: "Hippocrate–
Sénèque–Bergers–Socrate"; in the
center: "Pline–bergers–Aristote."
Inventory number: B 1153 bis-g

Provenance: Delacroix's studio
(sale of 1864). R. Tripier Collection.
Bequest of R. Tripier in 1917.
Catalogue: See Lyon (1989): 54, no.34.

The style of this drawing and the presence of two annotated sketches on the verso of the sheet suggest a date after Delacroix's North African trip of 1832. The sketches on the verso with the annotations, "Hippocrate, Aristote, Socrate, Sénèque," are for the decoration of the first two bays in the Deputies' Library of the Palais Bourbon, which are devoted to the Sciences and Philosophy. They can be dated around April 1841, when Delacroix resumed work on the Palais Bourbon after mapping out the decoration of the Library of the Palais du Luxembourg. Anita Hopmans compared these sketches to a study bearing numerous notations pertaining to seven of the first eight pendentives, notations that constitute a sort of inventory of the subjects Delacroix was considering at that time.[54]

The Arab horseman, to whom a familial group offers up presents, raises his arms in a gesture that could signify either salutation or farewell. This horseman offers distant parallels with **Moroccan Chief Giving a Signal**, a canvas of 1851 in The Chrysler Museum, Norfolk. On the other hand, the subject is very close to that of the painting of circa 1837 in the Musée des Beaux-Arts de Nantes called, variously, **An Arab Chief with his Tribe**, **Moroccan Chief Visiting a Tribe**, or **The Halt Where the Moroccan Chief Accepts the Hospitality of the Shepherds**. Delacroix later reused this theme in an 1862 painting.

54 The study belonged to Serullaz. Paris (1963):
 no.370. Hopmans (1987): 162, no.81.

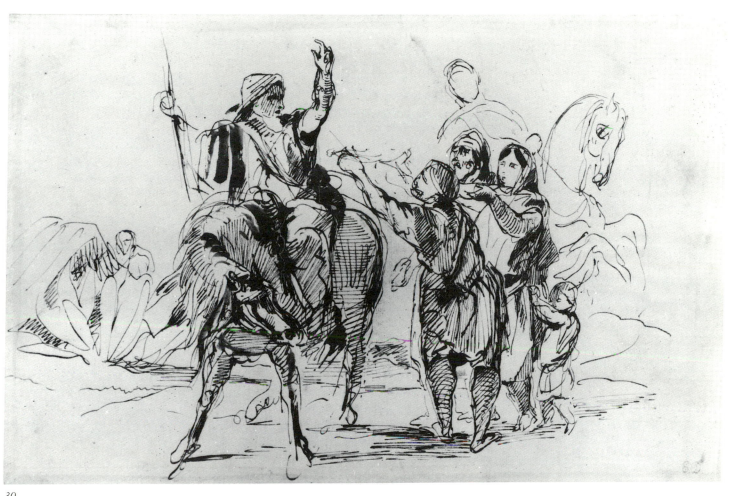

30

MICHEL DUMAS
Lyon, 1812–Lyon, 1885

31 Study for *The Glorification of St. Denis*

Graphite and brown wash, squared for transfer with red chalk. Height: 0.335; width: 0.214. Stamp on the lower right on the reverse of the sheet: "Michel Dumas 1812-1885."
Inventory number: 1989-48

Provenance: Gift of the Association of the Friends of the Museum in 1989. Bibliography: *Bulletin des Musées et Monuments Lyonnais* 1-2 (1990): 84.

Michel Dumas, a well-known student of Ingres, took part with many of Ingres' Lyonnais followers in the great rebirth of religious painting in Paris during the second half of the nineteenth century.

This composition, squared for transfer, is a study for a painting in a church at Clignancourt. The artist exhibited this painting along with *The Apostolate of Saint Denis* and *The Martyrdom of Saint Denis* at the Paris Salon of 1866. However, his *Entombment of Saint Denis*, a painting commissioned for the same church at Clignancourt, was not shown publicly until the Exposition Universelle of 1878.

The Musée des Beaux-Arts de Lyon acquired this drawing simultaneously with a second drawing and a small painted sketch for the same composition.

32 Eurydice

Watercolor over black chalk and red chalk. Stamp at lower right on the reverse of the sheet: "Michel Dumas 1812-1885."

Provenance: Gift of the Association of the Friends of the Museum in 1989. Bibliography: *Bulletin des Musées et Monuments Lyonnais* 1-2 (1990): 82.

The subject of this drawing is unclear. Is it a study of Eurydice, as the title under which the drawing entered the museum would suggest, or is it an inspired Muse, crowned by laurels with her lyre at her feet? This watercolor manifests a great freshness in the choice of colors and in the seductive harmony of the composition.

31

32

Auguste Flandrin

Lyon, 1804–Lyon, 1842

33 Portrait of a Woman

Graphite. Height: 0.320; width:
0.250. Signed and dated at lower left:
"Auguste Flandrin Lyon 1839."
Inventory number: B 1606

Provenance: Gift of M. Visseaux in
1929.
Bibliography: Foucart (1987): 12-13.

The eldest of the Flandrin brothers, Auguste is the least known of the family.[55] A portraitist above all, he comes closest to Ingres in his drawn portraits.

Only a dozen of Auguste Flandrin's drawings have been found. This portrait was created when, back from his travels in Italy, Auguste opened a studio with the help of Louis Lamothe, future assistant of Hippolyte Flandrin. Despite the tradition inherited from Révoil and upheld at the Ecole Municipale de Lyon by Bonnefond, Auguste Flandrin taught in the style of his master, Ingres. This drawing exemplifies Auguste's mature talent and mastery of draftsmanship.

55 In spite of a MA thesis presented at the
University of Lyon II in 1984 by Doublet.

auguste Flandrin
Lyon 1839.

pers.p. 26 x 32³ Cadre - 41 x 48,5.

33

HIPPOLYTE FLANDRIN
Lyon, 1809–Rome, 1864

34 Study for an Apostle

Graphite faintly heightened with watercolor. Height: 0.315; width: 0.145. Annotated, in graphite, at lower center of the sheet: "Louis Lamothe posant pour SV de P." Stamp on lower left: "Hte Flandrin."
Inventory number: 1987-20

Provenance: Flandrin Family Collection. Acquired in 1987.
Catalogue: See Lyon (1989): 56-57, no.36.

Louis Lamothe, a student first of Auguste then of Hippolyte Flandrin, posed for this figure of an apostle, a study for St. Matthew leading the procession behind SS. Peter and Paul on the left side of the nave of the Church of Saint-Vincent-de-Paul in Paris. The painting cycle for Saint-Vincent-de-Paul and the subsequent cycle at Saint-Germain-des-Prés constituted Hippolyte Flandrin's principal decorative works. After some delay, he accepted the commission in July 1848 with the painter, Picot, who was in charge of the decoration of the choir. The entire decoration was completed in July 1853.

Flandrin depicted the long procession of saints in two parallel lines: on the right (proceeding from the choir toward the entrance of the church) are the Apostles, the Martyrs, the Doctors, the Bishops, and the Confessors; on the left are the Virgin Martyrs, the Virgins, the Holy Women, the Penitents, and the Couples. This presentation of the cycle as a frieze was compared by Théophile Gautier to "Panathénées chrétiennes," or a Christian version of feasts given in honor of Athena. The frieze-like presentation lends to the whole a great sense of unity; each figure is subordinated to the general rhythm and all narrative details have been eliminated in favor of stylization of form and generalized symbolism.

The numerous preparatory sketches for this decorative ensemble show how very closely the two Flandrin brothers collaborated, posing for one another or using students of Hippolyte or friends of both as models. Louis Flandrin described this frequent practice as follows: "Whether it was for an important figure, for a gesture very difficult to grasp, or for a physiognomy that no other model could have rendered, the artist (Hippolyte) embodied the attitude and facial expression he wanted to give his protagonists, draping himself as he thought appropriate. Paul Flandrin captured and put on paper the lines of the projected figure."[56]

The likeness of Louis Lamothe had already appeared in the Martyrs' Choir of the church of St. Paul at Nîmes, which was a veritable gallery of portraits. Lamothe also posed for one of the Apostles on Christ's right in the Chapel of Saint-Jean-l'Evangéliste at Saint-Séverin. In the present drawing, the lines of the face are simply rendered through zones of light and shadow and the whole face lacks the precise detail that usually characterized Flandrin's technique. Nevertheless, it is possible to compare this drawing to both the portrait of Lamothe drawn by Paul Flandrin in 1849 at Nîmes and the self-portrait of 1859 preserved at Lyon.[57] In the final painted work, the features of the Apostle Matthew are completely different and his face is shown in pure profile, while in the drawing the face is presented slightly tilted. On the other hand, the drapery is rendered with precisely the same emphasis upon simple, vertical folds.

56 Louis Flandrin (1902): 271.
57 Aubrun (December 1983): ill. A.

35 Saint Joseph

Red chalk. Height: 0.320; width: 0.150. Stamp at lower right: "Hte Flandrin."
Inventory number: 1954-38

Provenance: Gift of Madame Appenzeller in 1954.
Bibliography: Foucart (1987): 76 & 78.

This figure of Saint Joseph belongs to the group of studies for the nave of the church of Saint-Vincent-de-Paul in Paris. It is very close to the Saint Joseph who, holding a lily, walks ahead of the procession of confessors on the right side of the nave. The simplicity of line and great delicacy of modelling give this drawing a quality of almost evanescent purity.

34

Louis Lamothe posant
pour S. V. de P.

35

PAUL FLANDRIN
Lyon, 1811–Paris, 1902

36 Portrait of Madame Balaÿ

Graphite over tracing paper, laid down.
Height: 0.328; width: 0.248.
Inventory number: 1987-12

Provenance: Flandrin Family Collection.
Acquired in 1987.
Catalogue: See Lyon (1989): 57, no.37.

The fascinating story of this superb drawing and its connection with Ingres' oeuvre became known with the publication of Hans Naef's article and the 1984-1985 retrospective exhibition of the Flandrin brothers.[58]

Paul Flandrin drew a portrait of Madame Balaÿ when his brother, Hippolyte, was painting her portrait (private collection) around 1852.[59] This habit of "drawing, for himself, the models of which Hippolyte was executing the portraits" is mentioned by Louis Flandrin.[60] Ingres liked the drawing so much that he asked for a duplicate, whereupon Paul gave him a replica on tracing paper. Ingres then drew upon this autograph copy for his ***Venus at Paphos*** (circa 1852, Musée d'Orsay).[61] Paul, horrified at the prospect of a scandal arising if the Balaÿ family discovered this transformation of his model, asked Ingres not to exhibit the painting. Ingres agreed, and the ***Venus*** remained in the master's studio until his death, when Madame Ingres gave it to Paul Flandrin. Fosca and Naef think that the original drawing may still belong to the heirs of Madame Balaÿ, to whom Paul Flandrin gave it, but it cannot be located.[62] The version exhibited here may be the intermediary drawing on tracing paper that Paul employed in transferring the original to the sheet presented to Ingres.

The influence of Ingres is striking in this portrait of the beautiful Antonie Balaÿ (1833-1901), daughter of a Lyon industrialist and wife of a deputy from the Loire Department. The delicacy of line and elegant stylization of form reveal Paul Flandrin as the worthy student of his master.

58 Naef (July-September 1979).
59 *Paris-Lyon* (1984-1985): no.98.
60 Flandrin (1902).
61 See commentary of the laboratory analysis in the *Revue du Louvre* 3 (1985): 205-206.
62 Fosca (July 1921) and Naef (1979).

Jean-Auguste Dominique Ingres, *Venus at Paphos*, Paris, Musée d'Orsay. ©Photo R.M.N.

36

PAUL FLANDRIN

**37 Portrait of
Two Young Girls**

Graphite. Height: 0.114; width: 0.182.
Inscriptions at lower right: "3 avril
1844" and at lower left: "27 mars 44."
Inventory number: 1987-4

Provenance: Acquired in 1987.
Bibliography: *Bulletin des Musées et
Monuments Lyonnais* 1 (1989): 38-39.

This double portrait possesses an im-
posing seductivity born of great simplic-
ity and Flandrin's rejection of the slight-
est artifice. The continuous line seems to
hesitate to pierce the whiteness of the
paper.

This drawing is somewhat reminiscent
in style and composition of another sheet
by the artist entitled **Studies of a Young
Woman (Etudes de jeune femme)**,
signed and dated 25 July 1843.[63]

63 *Paris-Lyon* (1984-1985): no.207.

37

Reproduced to actual size

FRANÇOIS-LOUIS FRANÇAIS
Plombières-les-Bains, 1814–Paris, 1897

38 The Banks of the Rhine

Watercolor, gouache, pen and China ink. Height: 0.220, width: 0.305. Signed, dated and annotated in pen and ink, at lower right: "Limite de l'Empire Français 1855"; dedicated at lower left: "à mon ami P. Chenavard." Inventory number: H 862

Provenance: Paul Chenavard Collection. Gift of Paul Chenavard in 1881. Catalogue: Lyon (1989): 59, no.39.

This drawing, characteristic of a painter who specialized in riverbanks and undergrowth, dates from the period (1850-1860) considered to be the most prolific of his career. As Georges Lafenestre remarked in his catalogue of the exhibition, *Français*, at the Ecole Nationale des Beaux-Arts in 1898, this period coincided with the artist's return from Italy and assumption of his rightful place in the front ranks of French landscape painters. This peaceful view of the French countryside is very close in composition to such works as *The Seine at the Bas-Meudon* at the Musée des Beaux-Arts de Mulhouse.

The long friendship between Français and Chenavard, evidenced by the dedication on this drawing, began in the 1840s, when both painters formed part of the lively circle that frequented the Divan, a famous Parisian café in the rue le Pelletier. The two friends engaged in heated discussion of Fourier utopianism.[64] On a Chenavard drawing in the Musée Tavet, Pontoise, done for one of the figures of the *Martyrdom of Saint Polycarp*, one can read, "to my friend Français."

From 1851 to 1876, the two artists participated in the "Friday Circle," a dining club of which Chenavard was president and which counted Corot, Barye, Daumier, Paul de Musset, and Viollet-le-Duc among its members. They also frequented the salon of Chenavard's great friend, Berthe de Rayssac, the daughter of the Comte d'Alton-Shée who had played such a prominent part in the Revolution of 1848. Français animated these evenings with good fellowship and old songs. During the war of 1870, the two friends enlisted in the same Garde Nationale unit recruited from among scientists, scholars and artists.

Ultimate proof of the sympathy, confidence and attachment between the two men may be found in a letter that Chenavard wrote his old friend, Guichard, on November 12, 1876, wherein he mentions the possibility of an exhibition of his drawings for the Panthéon, an exhibition that ultimately took place in Lyon. He wished to turn to Français for advice concerning this crucial matter. The very bad condition of the drawings made the older artist hesitate until the last minute over such a presentation. He wrote: "I am really perplexed as to whether to show these horrible things to the Lyon public . . . I therefore postponed my decision after having consulted Français and several friends. . . ."[65] A set of letters Chenavard sent to the painter Matout between 1867 and 1886 also makes numerous affectionate allusions to their friend in common, Français.[66]

The dedication on this drawing, addressed to Chenavard, includes a play on words concerning the family name of the artist. "La limite de l'Empire Fran-çais" (The limit of the French Empire), if it refers to the Rhine, which is represented in the drawing, may allude to Chenavard's slight contempt for landscape painting, a genre he considered secondary. Dubuisson in *Les Echos du Bois Sacré* (1924) recalled the rather sarcastic attitude of Chenavard in the face of the enthusiasm of his French friends, including Matout, during their working sessions in the countryside. If we can believe Gros, Chenavard typically would have had the following caustic reaction upon seeing *The Sacred Woods*, Français' chief work presented to the Salon of 1864: "Another example of your profession. It's good: a corner of nature well transposed onto a canvas It could be more furnished on the right and a little less on the left, or vice-versa. It could be doubled or quadrupled in size; that is one of the advantages of the genre."[67]

64 Around 1830, Charles Fourier (1772-1837), an economist and philosopher, elaborated a system under which society was to be organized into phalanxes large enough to be self-sufficient.

65 A letter published by Grunewald (1985): 431-432.

66 Paris, Doucet's library, "Carton 8 peintre."

67 Gros (1902).

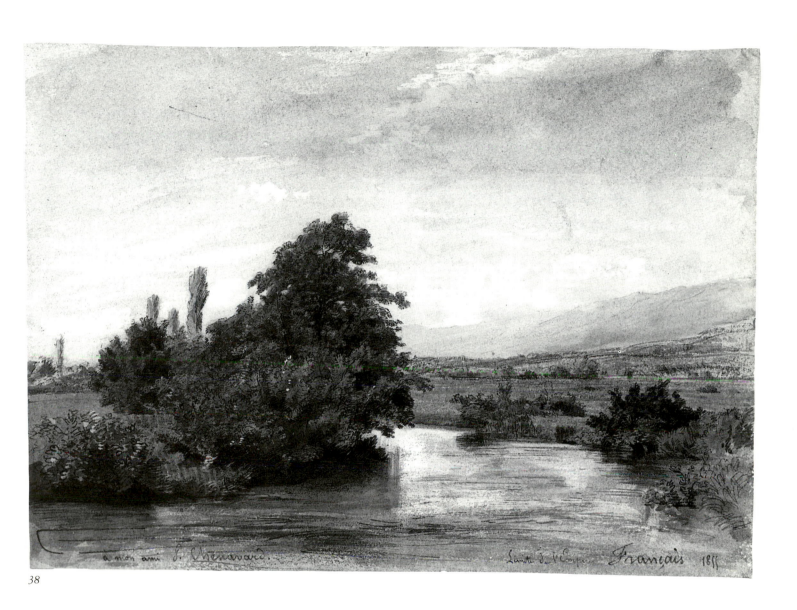

à mon ami P. Chenavard. Souv.te de Vénasque Français 1855

38

THÉODORE GÉRICAULT

Rouen, 1791–Paris, 1824

39 Louis XVIII Reviewing Troops on the Champ-de-Mars

Pen, brown ink, China ink, brown and gray wash and watercolor over graphite. Height: 0.180; width: 0.214. On the verso: three sketches. At the top: a graphite drawing of *Louis XVIII Reviewing the Troops at the Champ-de-Mars;* at lower left, a graphite drawing depicting a cavalry engagement, and at left, in the corner, a pen and brown ink drawing of a group of cavalry. Inventory number: X 1029-21 (recto) and X 1029-22 (verso)

Provenance: His de La Salle Collection. Gift of His de La Salle in 1877. Catalogue: Lyon (1989): 60, no.40.

Charles Clément, Géricault's biographer, mentions an "important composition" prepared by the artist on this theme, but never realized.[68] He also refers to an oil sketch, now lost, which belonged to Jamar, a friend and student of the painter.[69] This drawing is one of a large number that were preliminary to the oil sketch. It is close to the one in the Louvre (RF 1396), although less developed.[70] Two other versions exist, one in the Prat Collection in Paris and one less detailed sketch in the album preserved at The Art Institute, Chicago, representing a first approach to the hastily devised composition.[71]

Charles Clément describes the specific review of the troops that Géricault has depicted: "On the left, cavalrymen are making an about-face and saluting with their sabres when passing before the King, who is seated with the Duchesse d'Angoulême between the columns at the entrance to the Ecole Militaire. In perspective, on the right, we can see the general staff. The presence of two British officers, standing on the stairs on either side of the King, suggests the date of this project. A group of reined-in horses, who became frantic during the cavalry parade, comprise the foreground of the composition. . . . The architecture was not from Géricault's hand."[72]

Régis Michel has remarked that the date cannot be pinpointed to 1814, as Charles Clément has done, solely on the basis of the presence of the British officers, because the occupation of Paris extended all the way to the fall of 1818.[73] The very strong contrast between the rigidity of the architectural perspective, drawn with a ruler, and the animation of the troops of cavalrymen, may confirm Charles Clément's hypothesis concerning

the intervention of another hand. Resembling a theater set, the architecture seems to have been conceived as a backdrop for the lively cavalcade.

The composition here is less advanced than in the Louvre drawing. The contour lines for the assembly of the King and for the general staff are simply sketched, while the flutes on the columns are still missing. The group of cavalrymen is summarily defined and the entire composition appears clearer due to a slight change in perspective which permitted the different groups to be isolated more precisely.

The sketch in the Chicago album is accompanied by a detailed handwritten list of the troops being reviewed. These notes, designed to facilitate the later elaboration of the composition, are symptomatic of the documentary precision of Géricault's preparatory work. It is noteworthy that in 1815, Géricault belonged for a short time to the Company of the King's Musketeers, which escorted Louis XVIII to Ghent.

68 Clément (1879, reprinted in 1973).

69 Grunchec points out that it is possible to connect this painted sketch to *A Review of the Cavalry at the Champ-de-Mars, by King Louis XVIII*, which is listed in the catalogue of the Couvreur's Sale (May 26-28, 1875, no.223). He also reproduced (fig. 78[2]) a painting which used to belong to Richard Qoetz (sale of February 23-24, 1922, no.134), probably representing a different version of this project; however, the present location of this painting is unknown. Grunchec (1978): 98, no.78.

70 Clement (1879, reprinted 1973): no.48.

71 For the Prat drawing, see *New York, Fort Worth, Pittsburgh, Ottawa* (1990-1991): 184-185, no.75. For the Chicago drawing, see *Los Angeles, Detroit, Philadelphia* (1971-1972): 47, no.13, folio 54 recto.

72 Clement (1879, reprinted in 1973): no.49.

73 Michel (1983): 49.

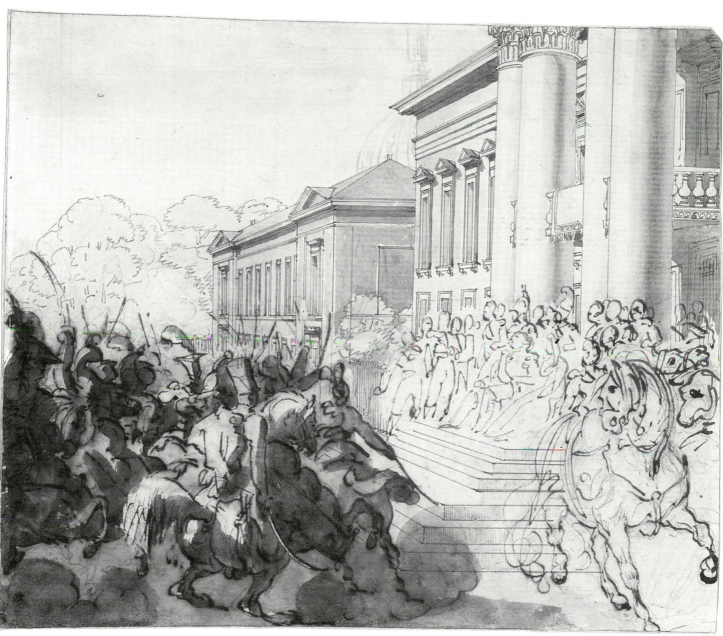

39

THÉODORE GÉRICAULT

40 Five Studies of a Negro

Pen and brown ink. Upper left: graphite sketch of a rider. Height: 0.230; width: 0.283. Signed and dated in pen and brown ink at lower right: "Gericault." Stamp on lower center of the page: "H.L. (Lugt 1333)." Inventory number: X 1029-25

Provenance: His de La Salle Collection. Gift of His de La Salle in 1877. Catalogue: See Lyon (1989): 63, no.41.

In spite of uncertainty surrounding the precise purpose of this drawing, it appears almost certainly to be a study for **The Raft of the Medusa**. Even though nothing in the drawing corresponds exactly to the three male Negroes that Géricault placed on the raft, Philippe Grunchec sees in this sheet a study for one of the shipwrecked persons and dates it stylistically to the first research for the painting.[74] On the other hand, Lem completely dismissed any connection between this drawing and the painting of 1819 and proposed a later date.[75]

Numerous testimonies to Géricault's abiding interest in black people can be found in his notebooks and studies, drawn and painted. The figure depicted here is probably the Haitian, Joseph, a well-known professional model, who posed for the figures of **The Raft of the Medusa**, as well as for a portrait by Géricault. It is interesting to note that while three blacks are represented in Géricault's canvas, only one, the one whose story was recorded by Corréard, was among the shipwreck survivors.

The central figure of this sheet of studies embodies one of Géricault's favorite motifs: the masculine back whose powerful musculature recalls the painter's admiration for Michelangelo. Of the numerous examples of this motif in his oeuvre, one of the most famous is the **Study of a Back** in the Montauban Museum (RF 580), a preparatory study for the black man who stands erect on a barrel, at the pinnacle of the pyramid of survivors, waving a torn rag.[76]

Géricault's enduring interest in the theme of blacks also manifests itself in one of his last projects, the realization of an important painting on the subject of **The Black Slave Trade**. This project never proceeded beyond the graphic stage, owing to the painter's death, but it attests to this political engagement and to a sensitivity to one of the great problems of the age.

74 Grunchec (1985-1986): 123, no.60, fig. 60b.
75 Lem (January-June 1962): 9.
76 Clément (1879, reprinted in 1973): no.104.

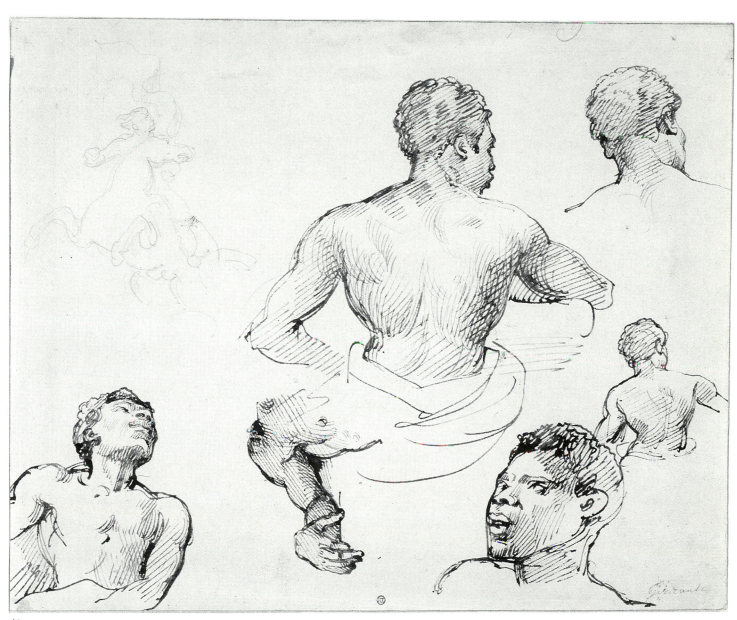

40

FRANÇOIS-MARIUS GRANET
Aix-en-Provence, 1775–Aix-en-Provence, 1849

41 Roman View

Brown wash over black chalk. Height:
0.145; width: 0.110. Signed and dated
at lower left: "Granet. Rome 1815."
Stamp at lower center: "HL" (lugt
1333).
Inventory number: X 1029-16

Provenance: His de La Salle Collection.
Gift of His de La Salle in 1877.

Granet arrived in Rome in 1802 with
his friend and benefactor, Louis-Nicolas-
Philippe Auguste, Comte de Forbin
(1777-1841), who in 1816 became Di-
rector of the Royal Museums. Granet
lived in Italy until 1824, when he re-
turned to Paris and two years later was
named Director of the Musée du Louvre
and of Versailles. In 1829-1830, he went
back to Rome for a final sojourn, during
which he executed numerous views of
cloisters, interiors of monasteries and of
churches, among other things. The pre-
cise character of this drawing shows the
great attention paid to the effects of light
and shadow. Granet emphasized the
composition by framing it with an arch
in shadow in the foreground, and used
the motif of shadow again in the center
middle ground to lend emphasis to the
surrounding sunlit facades.

Granet — Roma 1815

41

FRANÇOIS-MARIUS GRANET

42 Monks in the Courtyard of a Monastery

Watercolor, pen and brown wash, heightened with white gouache over black chalk. Height: 0.344; width: 0.260. Annotated and dated at lower left: "Granet to his friend Jauffret 1846." Stamp at lower left: "H.L." (Lugt 1333).
Inventory number: X 1029-17

Provenance: His de La Salle Collection. Gift of His de La Salle in 1877.

The date of 1846, inscribed on this view of an Italian monastery, is much later than Granet's sojourns in Italy. If it dates the execution of the drawing, Granet has worked either from memory or from notes made in Italy. Until the end of his life, he drew upon his Italian memories for inspiration, as can testify, for instance, a drawing in the Musée Granet at Aix-en-Provence, dated 1849 and entitled: *A Poor Family around a Table, under an Illuminated Oratory*.[77] However, one can as easily hypothesize that the 1846 date marks a dedication on the drawing which he made many years before.

Granet used the medium of watercolor to enhance the ink wash with fine and precise touches. The virtuoso technique of this finished sheet may be compared to a drawing in the Musée des Beaux-Arts de Besançon entitled *The Construction of the Church of Santa Croce in Jerusalem in Rome* (inv. D.2187).

Eugène Jauffret, to whom this drawing was dedicated, is listed in Granet's Will of November 16, 1849, as a man of letters and also deputy chief of the Paris Police Department. Granet bequeathed him "the sum of 4000 francs, half of the silverware that I have in Paris, two drawings, a gold snuffbox ornamented with guilloche that is located at Aix."[78]

77 *Dialogue d'Yves Brayer avec Granet sur l'Italie* (1976): no.66.
78 Archives Municipales d'Aix, liasse R. 4–Art. 26; reproduced in Rivau's *François-Marius Granet* (1947) [Thesis from l'Ecole du Louvre].

43 A Monk Reading

Pen and brown ink wash. Height: 0.153; width: 0.118. Stamp at lower center: "HL" (Lugt 1333).
Inventory number: X 1029-18

Provenance: His de La Salle Collection. Gift of His de La Salle in 1877.

Throughout his entire life, Granet was heavily influenced by Flemish and Dutch painters, an influence that is obvious in several drawings reminiscent of Rembrandt, such as this one. In these drawings, Granet deployed all the possibilities offered by the medium of wash, especially as to the intensity of contrast.

42

43

JOSEPH GRANIÉ
Toulouse, 1866–Paris, 1915

44 **Portrait of Romain Rolland**

Black chalk and crayons. Height: 0.375; width: 0.238. Signed and dated at lower right: "Granié." Inventory number: B 971

Provenance: Acquired from the artist in 1911.

Rémy Salvatov writes: "The art of Mr. Granié, even if different in essence, is not that far from Mr. Knoff's. He has the same concern for precise drawing, the same love for the mysterious. The portraits he offers us are extraordinarily suave."[79] The drawings of Granié — highly esteemed by his contemporaries and sought after by collectors — are executed with an extreme precision due both to his work as an illuminator and to his admiration for the German masters of the Renaissance.[80] Here he achieved a technical tour de force, summoning this head from nowhere, like a ghostly apparition. The intense, hallucinatory gaze, nearly hypnotic, seems fixed upon something beyond the outer limits of reality. Romain Rolland (1866-1944) was a French novelist, essayist and art historian.

79 Salvatov, "La Société moderne des Beaux-Arts. Première exposition," in *L'Art Décoratif* (1900): no.27.

80 It was Félix Ziem who encouraged Granié to pursue a career as an illuminator.

GRANIÉ

44

JEAN-MICHEL GROBON

Lyon, 1770–Lyon, 1853

45 Rochecardon

Brown wash heightened with pen and China ink, over graphite. Height: 0.470; width: 0.655. Signed and dated, in pen and ink at lower right: "Grobon. 1823."
Inventory number: B 465

Provenance: Bequest of Benoîte Rivoire in 1890.
Catalogue: See Lyon (1989): 65, no.42.

Grobon pursued most of his career as a landscape painter in the region around Lyon. He frequently set up his easel on the uneven terrain at Rochecardon at the gates of Lyon, a site offering an inexhaustible repertoire of motifs — some- times grandiose, with craggy, wooded boulders among which flow waterfalls and streams — sometimes picturesque, with little valleys and a windmill or a dovecote. At the Salon of 1796, Grobon successfully exhibited the **Forest of Rochecardon**, from which he made an engraving. Two of Grobon's landscapes in the collection of the Musée des Beaux-Arts de Lyon also depict Rochecardon: **The Dovecote at Rochecardon**, 1795, and **The Windmill in the Valley of Rochecardon**, 1808. The present study of rocks, with its meticulously analyzed geometric structure, foreshadowed a theme that became a favorite of Aligny. The landscape evokes the Italian coun- tryside, which Grobon always regretted that he had not seen.

This drawing and the view of Mont- mélian (see next entry) date from a pe- riod in which Grobon practically never painted. From 1820 onward, he mainly produced drawings, sketching the motif in pencil, then finishing the landscape in pen and ink and sometimes gouache.

It is worth noting that a drawing in Fleury Richard's sketchbook (acquired by the Musée des Beaux-Arts de Lyon in 1988) depicts the same site.[81]

81 Chaudonneret (1980): no.117, notebook XI, fol.20, fig.156.

46 View of Montmélian

Pen and brown ink, brown wash, over graphite. Height: 0.430; width: 0.590. Signed and dated in ink at lower left: "Grobon. 1823."
Inventory number: B 462

Provenance: Bequest of Benoîte Rivoire in 1890.
Catalogue: See Lyon (1989): 65, no.43.

The classical composition of this vast landscape reminds us that, apart from seventeenth-century Dutch Masters, Claude and Poussin were Grobon's greatest reference points. A carefully de- tailed wooded foreground opens at the center to a distant view of a luminous valley dominated by the hills of Francin and Montmélian.[82] The structure of the work is comparable to that in **The View of the Hill at Sainte-Foy**, a painting of 1848 preserved at Lyon, in which may also be found the motif of two spindly trees, slightly bent and dominating the left side of the composition.

Grobon sojourned several times in Savoy (in 1807, 1808, 1819 and 1821 for cer- tain) where Mesdames de Bellegarde, whom he had met in Paris, welcomed him in their house as they also did at Aix-les-Bains. Benoîte Rivoire, in her handwritten biography of Grobon, mentions no voyage in 1823, the year this drawing was produced.

82 According to Aubert; cited by Haudiquet-Biard (1983): 131.

45

46

Jean-Auguste Dominique Ingres
Montauban, 1780–Paris, 1867

47 Study for *La Source*

Black chalk. Height: 0.360; width: 0.165.
Inventory number: B 1055

Provenance: Marquis de Biron Collection (Sale of 1914, no.32). Maurice Fenaille Collection. Gift of M. Fenaille in 1914. Catalogue: See Lyon (1989): 66, no.45.

Probably begun in Florence in 1820, *La Source* was not completed until 1856. The inspiration for this figure, descended so directly from Venus, was probably a bas-relief in the courtyard of the Hôtel Sully in Paris;[83] but the theme derives equally from one of Jean Goujon's nymphs on the *Fontaine des Innocents*, which Ingres also had copied in two drawings now in the Fitzwilliam Museum (Cambridge, PD 42 U 43 1959).

La Source is actually a different version of an earlier painting called the *Venus Anadyomène* (Chantilly, Musée de Condé), which also required a long period of gestation (1808-1848). The two figures differ only in the gesture of the arms, and it is rather difficult to distinguish studies made for the first from those for the second. This drawing is very free and far from the pose Ingres finally adopted. The painting inverts the posture of the hips. The juxtaposition of several positions of the arms creates the impression of a gesture moving continuously from bottom to top. None of the positions relates to the final solution. The absence of the jug and the position of the two highest arms, which seem to be gathering the hair, are closer to the *Venus Anadyomène*.

At Montauban, the number of drawings connected with *Venus* exceeds that related to *La Source*. However, two studies can be linked to the *Venus* (MI-867–2316 and MI-867–2319).

The Boymans-Van Beuningen Museum of Rotterdam owns a beautiful study of the figure without the head (inv. FII177). Another drawing, relating closely to the painting — one of three studies for *La Source* formerly in the Haro Collection — is today in a private collection.[84] A general composition study, squared for transfer, was sold at Drouot, June 13, 1988.[85]

83 According to the *Journal des Goncourt* (June 11, 1892).

84 *Petit Palais* [Paris] (1967-1968): no.253.

85 June 13, 1988; no.47 in the Ingres sale of May 6-7, 1867.

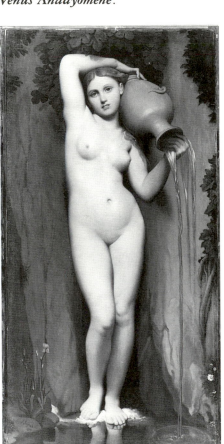

Jean-Auguste Dominique Ingres, *La Source*, Paris, Musée du Louvre. ©Photo R.M.N.

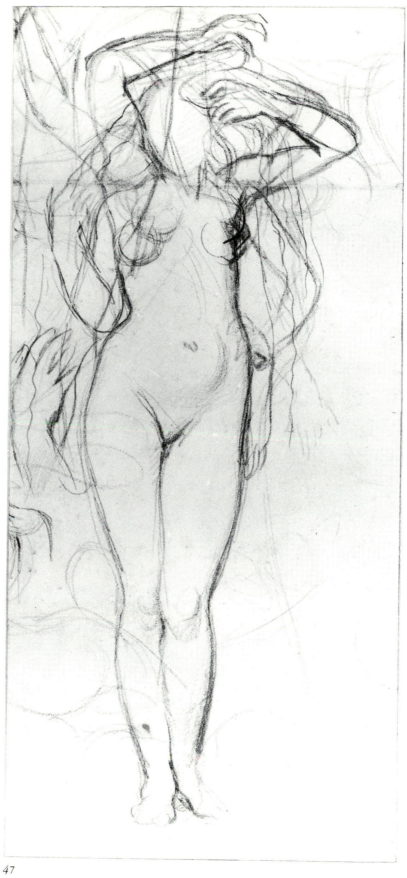

47

48 Madame Flandrin

Graphite heightened with white gouache. Height: 0.325; width: 0.243. Signed, dated and dedicated, in graphite, at lower left: "Ingres del: à son ami et son illustre élève Hte Flandrin 1850." Annotated, in graphite, at upper right: "Madame Aimée Hippte Flandrin née Ancelot." Inventory number: B 1554

Provenance: Given to Hippolyte Flandrin by the artist. Madame Hippolyte Flandrin Collection. Paul-Hippolyte Flandrin Collection. Madame Paul-Hippolyte Flandrin Collection.
Gift of Madame Paul-Hippolyte Flandrin in 1928.
Catalogue: See Lyon (1989): 68, no.46.

Soon after the death of his first wife in 1849, Ingres produced this portrait of Aimée Flandrin, who at the time played music at the master's house to relieve his sorrow. Second cousin of Edouard Gatteaux, a friend and patron of the Flandrins with close links to Ingres, Aimée Ancelot married Hippolyte Flandrin in 1843, when she was twenty-one years old. From this happy union four children were born and three survived, among them the future painter Paul-Hippolyte. The sitter has a simultaneously reserved attitude and energetic expression in this portrait. It is interesting to compare Ingres' rendering to Hippolyte Flandrin's own portrait of his wife, produced four years earlier (acquired by the Louvre in 1984, RF 1984-29). The romantic character and melancholic, dream-like expression of Flandrin's painting are replaced here by a direct and lively gaze.

49 Hippolyte Flandrin

Graphite. Height: 0.330; width: 0.254. Signed, dated and dedicated, in graphite, at lower right: "Ingres à son ami et grand artiste Hippolite (sic) Flandrin 1855."
Inventory number: B 1553

Provenance: Given to Hippolyte Flandrin by the artist. Madame Hippolyte Flandrin Collection. Paul-Hippolyte Flandrin Collection. Madame Paul-Hippolyte Flandrin Collection.
Gift of Madame Paul-Hippolyte Flandrin in 1928.
Catalogue: See Lyon (1989): 69, no.47.

The feelings of profound friendship and high esteem that Ingres had toward his favorite student are well-known. Hippolyte Flandrin, who arrived with his brother Paul in Paris in 1829 and entered the studio of Ingres, truly venerated his master, whose active support he would enjoy the rest of his life. In 1832, Hippolyte Flandrin won the Prix de Rome. Three years later Ingres joined him at the Villa Medici when appointed Director of the French Academy. Throughout the rest of his life, Flandrin cherished the memory of those years of apprenticeship spent in Italy with Ingres. In 1863, near the end of his life, when he was again in Rome, Flandrin wrote to Ingres: "I am in Rome! My heart is overflowing with happiness and admiration, and since this joy has its roots in the memories of your kindness, of your teaching, I want to let you know about it and to thank you forever. [. . .] Rome: already twenty-five years ago I left that city! It was there that I was so happy! It was there that with you and because of you, I admired the masterpieces possessed by this 'unique' city!"[86] After returning to France from the Villa Medici in 1838, Flandrin launched his successful career as a "peintre-décorateur" of Parisian churches, due, among other things, to the active support of Ingres and of Ingres' friends Gatteaux and Baltard, who helped him secure commissions.

Hippolyte's death at age fifty-five affected Ingres deeply. At the announcement of the news, the master cried, "Death made a mistake," and a few days later drew an allegory that he entitled: "Death, herself, regrets the blow she gave."

The strong feelings of esteem and affection that linked the two men find expression in the dedication of this portrait in which Ingres successfully conveys the anxious and austere nature of the artist from Lyon.

86 Naef (1977-1980): 455.

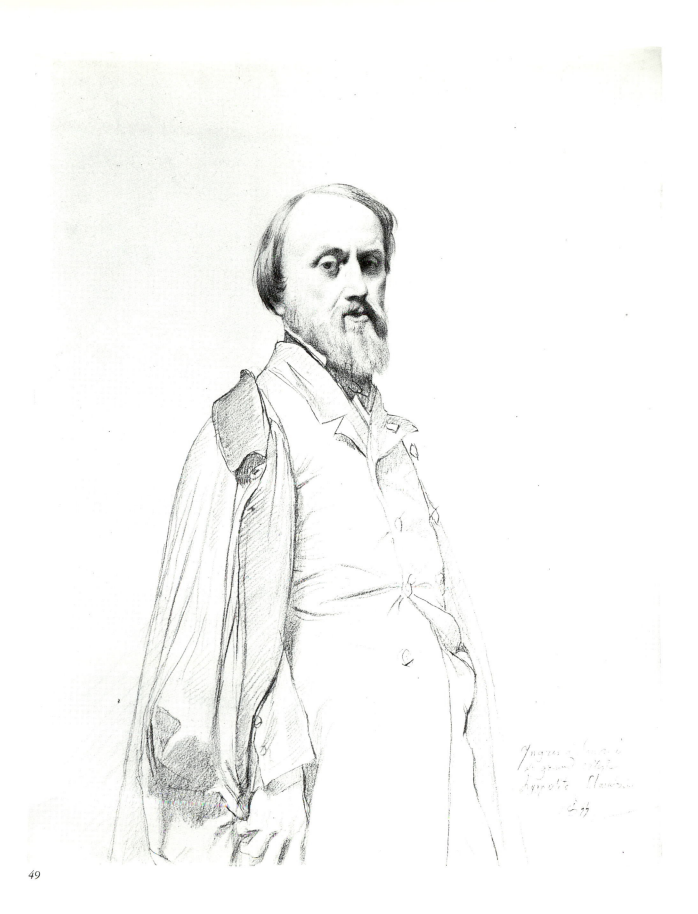

49

50 Study for "La Fornarina"

Graphite on Japanese paper (laid down). Height: 0.376; width: 0.293. Annotated, with graphite, at upper left: "clair." Stamp on lower right: "JI" (Lugt 1477).
Inventory number: B 1051

Provenance: Ingres' studio (sale of 1867). Marquis de Biron Collection. Acquired at the Biron Sale in 1914, no.29.
Catalogue: See Lyon (1989): 71, no.48.

The five versions of **Raphael and La Fornarina** offer important differences in setting, accessories, gesture and costume. This study represents Raphael's mistress in the pose Ingres finally adopted for her in the last three versions.

The loss during the war of the version formerly in the Riga Museum renders the reconstruction of a chronology for the series extremely complicated for art historians. Hélène Toussaint, when she published the hitherto unknown photograph of the lost painting, proposed a chronological order for the five works and determined more precisely the evolution of the theme.[87] Although the lost Riga painting was traditionally thought to be the first in the series, she placed it second and put the version in the Fogg Art Museum first. Bought by Portalès at the Salon of 1814 and probably executed in 1811 or 1812, this painting in which La Fornarina sits erect on Raphael's lap is the most important of the group. In the Riga version (circa 1813), which is more simplified, the straight back is slightly relaxed.

It was doubtless to the third version, now in a New York private collection, that Ingres referred in a letter to Pastoret dated 1827; yet the date of this third painting remains difficult to pinpoint. Only from this version onward does the young woman bend toward her lover, putting her head on his "in a gesture of quasi-maternal tenderness."[88] The celebrated **Virgin with a Chair** by Raphael is, in fact, visible in the background of both the Fogg painting and this version.

The final position of La Fornarina, characterized by supple, continuous lines, derives directly from the Lyon drawing. From then on Ingres started to emphasize the continuous arc of the back and the nape of the neck. This feature is particularly apparent in the fourth version, dedicated to Duban and dated 1846, now at the Gallery of Fine Arts, Columbus, and in the last version, an unfinished work, at the Chrysler Museum in Norfolk. The absence of Raphael's hand around his mistress' waist could persuade us to relate this drawing to the New York painting, the only composition in which the painter does not put his arms around her. However, this may be seen as Ingres' desire to disengage the figure totally from all details that could inhibit the study of the nude.

The style of this drawing reveals a much later date than the two other studies for **La Fornarina** preserved in the Bern Kunstmuseum and the Metropolitan Museum of Art, which are connected to the Fogg and Riga paintings, respectively.[89] The great sensuality created by the powerfully modeled volumes in the present drawing differentiates it markedly from the other two versions, which are purely linear in character.

There exists a sheet of studies with the head of La Fornarina and the hands of Madame de Senonnes (Chicago, The Art Institute, Chicago, 1972-322RX8597), which cannot have been produced later than 1816 (the date of the portrait of Madame de Senonnes) which is close to the Lyon drawing with respect to the position of the head and the modelling of the bust.

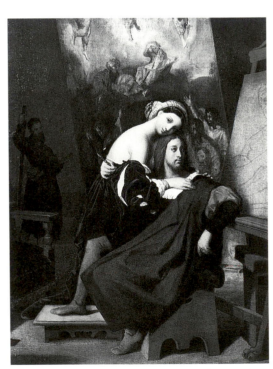

Jean-Auguste Dominique Ingres, *Raphael et la Fornarina*, Columbus, Columbus Museum of Art, Bequest of Frederick W. Schumacher.

87 Toussaint (1986): 63-74.
88 Toussaint (1986): 63.
89 Toussaint (1986): 65, fig.5 (for the Bern study) and Toussaint (1986): 66, fig.7 (for the New York study).

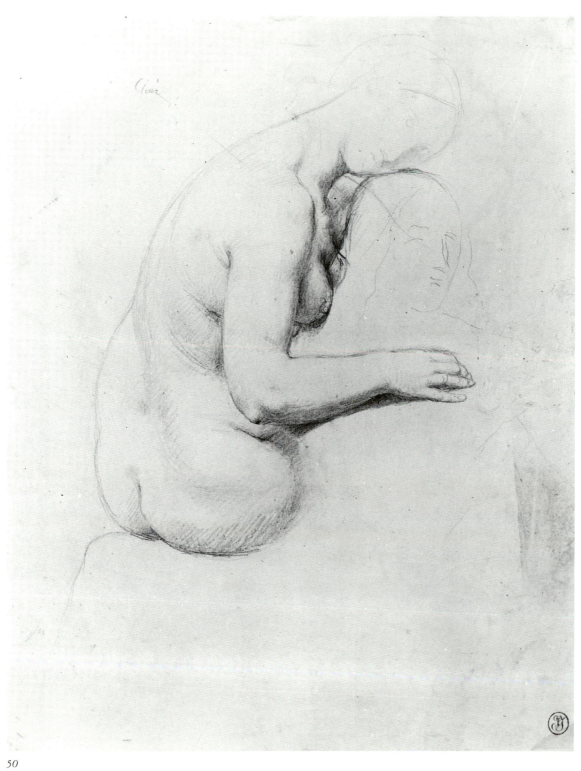

50

LOUIS JANMOT
Lyon, 1814–Lyon, 1892

51 Four Young Women Dancing

Graphite. Height: 0.153; width: 0.234.
Signed and dated, with graphite, at
lower left: "Poème de l'âme. Lyon
1844. L. Janmot."
Inventory number: B 1104

Provenance: Acquired from M. Maire-
Pourceaux in 1916.
Catalogue: See Lyon (1989): 74, no.50.

Characteristic of Janmot's style, these ethereal figures are a study for the young girls dancing in a circle who were to appear in the celestial portion of the first composition of Janmot's *Poem of the Soul, Divine Generation*. This theme of the dance in a circle was reused and even amplified in the thirteenth painting of the cycle, *Rays of the Sun*. Linked to the passage of time, it can be connected to the same motif in Ingres' own interpretation in the *Golden Age*.

In this drawing, Janmot captured the evolution of the four successive dance steps of a single figure. The circle remains open. The silhouette seems to come before us then to fade away in a weightless step. Graceful as Botticelli figures, these young dancing girls, whose feet barely touch the ground, are a leitmotif for the *Poem of the Soul*. Hardouin-Fugier noted the close resemblance between the physical type of these dancers and those in *Wild Flowers*, a painting shown at the Salon of 1845.[90] Only three preparatory studies for the first composition of the *Poem* survived: the present one and the two mentioned by Hardouin-Fugier that were formerly in the Maurice de Pessonneaux du Puget Collection.[91] The three preparatory studies date from circa 1844-1845, yet only in 1854 did Janmot complete the inaugural composition whose conception sums up the entire first part of the cycle.

Production of the entire decorative ensemble for the *Poem of the Soul*, composed of eighteen paintings, sixteen drawings (all preserved in the Musée des Beaux-Art de Lyon), and thousands of verses, occupied about fifty years of Janmot's life. Conceived in Rome in 1835, the *Poem* was not published until 1881, when it was illustrated with photographs by Félix Thiollier, who for the first time presented the texts and the images together.

Despite considerable reservations, Delacroix recognized the singularity of Janmot's poetic world and personally intervened on his behalf to have the entire cycle of eighteen paintings accepted by the Exposition Universelle of 1855. Delacroix recorded in his diary, "this Janmot has seen Raphael, Perugino, etc. . . . There is about Janmot a remarkable Dantesque flavour. When I see him, I think of the famous Florentine's angels of Purgatory."[92]

90 Hardouin-Fugier (1978): XXV, 337.
91 Hardouin-Fugier (1978): 115 and 239 (note no.357).
92 Diary entry of June 17, 1855. Delacroix edited by Joubin (1981): 514.

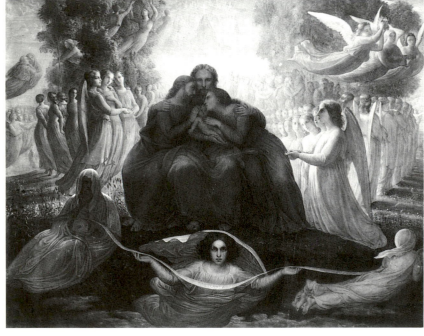

Louis Janmot, *Poem of the Soul, Divine Generation*, Lyon, Musée des Beaux-Arts.

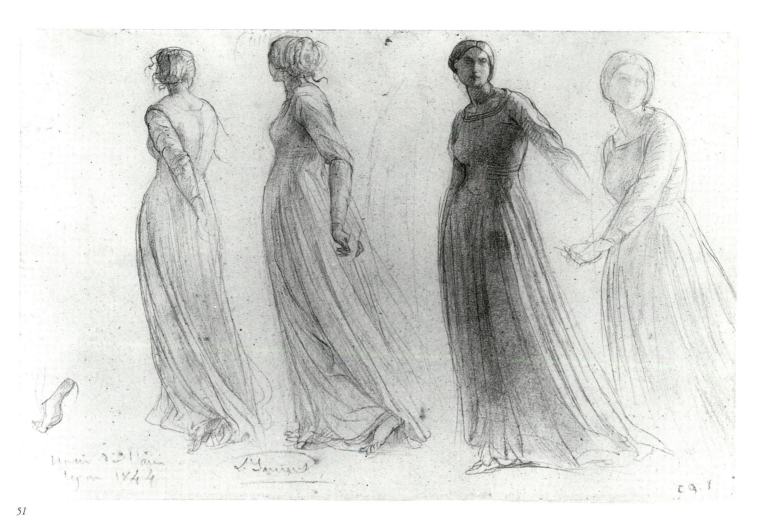

51

52 A Child Walking

Graphite. Height: 0.520; width: 0.345.
Inventory number: H 852

Provenance: Entered the Museum's
Collection at an undetermined date.
Catalogue: See Lyon (1989): 75, no.51.

Janmot used this study of a child without further change in **Spring**, the fourth painting of the **Poem of the Soul**. The painting actually was inserted retroactively into the cycle at an unknown date. It shows, for the first time in the cycle, the two children, a boy and a girl, who are to grow up together and live next to each other until the young girl's death in the seventeenth painting, **The Ideal**. It is with **Reality**, the eighteenth painting, depicting the young man alone and desperate, that the first part of the **Poem** is concluded.

In this drawing, the little girl is asking her companion to follow her, but he lags behind, picking flowers. So idyllic is the character of the painting that it does not communicate the anxiety linked to both the passage of time and the ephemeral nature of happiness, which can be felt in the poetic text accompanying the image. A never-satisfied desire for novelty continually pushes man towards the unknown, and a warning concludes the poem:

"Child, the faster you walk,
The sooner you will see the limit,
Where the flowery pathway ends."93

93 Enfant, plus vous marcherez vite,
Plus tôt vous verrez la limite,
Où finit le sentier fleuri. (IV, 194-196).

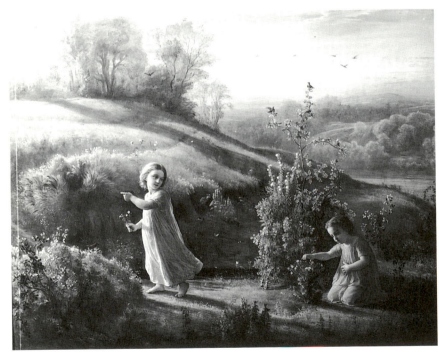

Louis Janmot, *Poem of the Soul, Spring,* Lyon, Musée des Beaux-Arts.

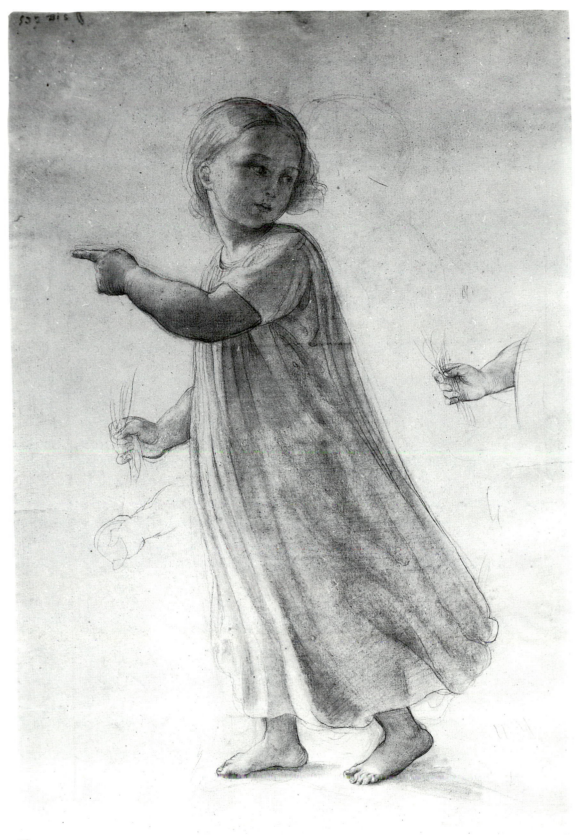

52

53 Bust of a Woman

Graphite. Height: 0.167; width: 0.235.
Signed and dated, in graphite, at lower
center: "L. Janmot, poème de l'âme,
Lyon 1849." Inscribed in graphite,
along the left side of the sheet: "poème
de l'âme. L. Janmot."
Inventory number: B 1106

Provenance: Acquired from M. Maire-
Pourceaux in 1916.
Catalogue: See Lyon (1989): 77, no.52.

This is a study for the *Paternal Roof*,
the sixth painting of the *Poem of the
Soul* cycle, which illustrates the benefits
of education received in the bosom of
the family. Despite the protective pres-
ence of the father, who is in fact a self-
portrait of the artist, the feminine ele-
ment, comprised of three women seated
around a table, once more dominates the
scene. In addition to this study of the
mother, wherein a detail of the dress was
reworked on the left, there is another
preparatory sketch for this composition
dating from 1848 (formerly in the Mau-
rice de Pessonneaux du Puget Collec-
tion) as well as the preparatory cartoon
preserved in a Parisian private collec-
tion.[94]

Delacroix reflected in his *Journal*, apro-
pos the *Poem of the Soul*, "I like . . .
these inspired or dream-like faces, which
are like reminiscences of another world."
His words could serve as a commentary
on this beautiful face, possessed of a
spirituality which by its softness evokes
the art of Perugino.

94 Hardouin-Fugier (1978): notes nos. 413 and 414.

Louis Janmot, *Poem of the Soul, The Paternal Roof,* Lyon, Musée des Beaux-Arts.

53

LOUIS JANMOT

54 A Mystical Vision

Graphite and gray wash. Height:
0.310; width: 0.246. Inscription at
lower center: "Vision mystique, le pain
et le vin."
Inventory number: 1981-25

Provenance: Gift of the Association of
the Friends of the Museum in 1981.

Inscribed in a double oval, this Madonna and Child evoke the central figure of Perugino's *Assumption* particularly with respect to the arrangement of the drapery, the sentiment and the stance as Gilles Chomer (1987) has correctly pointed out.[95]

95 This observation was first published in the catalogue of the exhibition at Lyon (November 13, 1987–April 3, 1988), *Quattrocento: Italie 1350-1523, Peintures et Sculptures du Musée des Beaux-Arts de Lyon*. The exhibition was organized by Dominique Brachlianoff, Philippe Durey and Jean Habert. Catalogue entries under the heading "Maîtres italiens, élèves de Lyon" were written by Gilles Chomer. [Editor's note].

54

EUGÈNE LAMI
Paris, 1800–Paris, 1890

55 The Indian Section of the Crystal Palace Exposition, London, 1851

Gouache and watercolor. Height: 0.370; width: 0.525. Signed in ink at lower center: "EUGENE LAMI." Inventory number: B 943

Provenance: Alexis Rouart Collection. Acquired from the Alexis Rouart sale in 1911.
Catalogue: See Lyon (1989): 81, no.57.

As official painter to King Louis-Philippe from 1832 onward, Lami followed the exiled royal family to England in 1848, and remained there for more than four years. Protected by Queen Victoria, he enjoyed the same success in British aristocratic society that he had experienced in France. During this second sojourn (the first had taken place 1826-1827), he produced numerous watercolors of British life. His old friend, Prince Demidoff, not only recommended him to Drum, but also steered commissions to him.

On September 11, 1851, Demidoff wrote the artist asking him to produce a series of watercolors illustrating the Crystal Palace Exposition of 1851.[96] In effect, Demidoff, who had been seduced by Lami's view of the Russian section of the exhibition, was asking him to produce two series on the same subject, one for the Empress of Russia, and the second, identical to the first, for himself. The nine watercolors, which depicted the inauguration of the exhibition by Queen Victoria, two exterior views, and the Russian, French, English, Indian, Prussian and Austrian sections, were probably finished by February 1852. In a letter dated February 7, Demidoff thanked Lami warmly for the drawings, praising their charm, verisimilitude and modernity.[97] Commenting on the Indian section, he wrote: "The Indian room is a mysterious Brahmin sanctuary where European faces confront a rare pleasure," and he concludes, "You gave to all your gentlemen and ladies a characteristic style of the civilization of 1852, which will remain the spiritual date for your compositions. . . ."

Among the series Lemoisne mentioned two views of the Indian section.[98] The first one, from the Alexis Rouart Collection, corresponds to the Lyon watercolor and is described as follows: "On the left, on a red base, a kind of palanquin in ivory; more to the right, on a platform, an elephant with a cover lavishly topped by a small tent; in front, a woman and two children; to the right, a seated woman in black."

The other watercolor (no.865) is smaller in size (0.234 × 0.163) and might be identified as the piece published by Paul Prouté.[99] This watercolor differs slightly from the Lyon sheet in that the group formed by the woman and children is missing; it comes from the fourth sale of the Demidoff collections in San Donato (no.325), which, in March 1870, dispersed *Three Years in London*, a very important series of watercolors by Lami, as well as the nine watercolors of the Universal London Exposition that belonged to the Prince.

Lami, whom Baudelaire dubbed the "poet of official dandyism" (Salon of 1846), here displays his great gifts as a chronicler of the mundane and aristocratic life of his times. His gifts were primarily for accuracy and intricacy of description (rooted in his interest in documentation) and for an ease and brilliance of execution. Taught the art of watercolor by Bonington, whom he had met in the studio of Horace Vernet, Lami participated in the founding of the "Société des aquarellistes français" in 1874, and through the watercolor medium asserted his gift as a remarkable colorist. Henri Béraldi perfectly defines Lami's art when he writes: "the artist in love with modernity and elegance, painter of life today, who knew how to perceive (it is remarkable!) a nineteenth century that is aristocratic, even sparkling, a nineteenth century with fashion, with sports, with hunts, with feats, with reviews and receptions."[100]

96 Lemoisne (1912): 123-124; (1914): 202, no.871.
97 Lemoisne (1912): 124; (1914): 202-203, no.871.
98 Lemoisne (1914): nos.867 and 865.
99 Domenico catalogue (1980): no.102.
100 Béraldi (1885-1892): IX, 30.

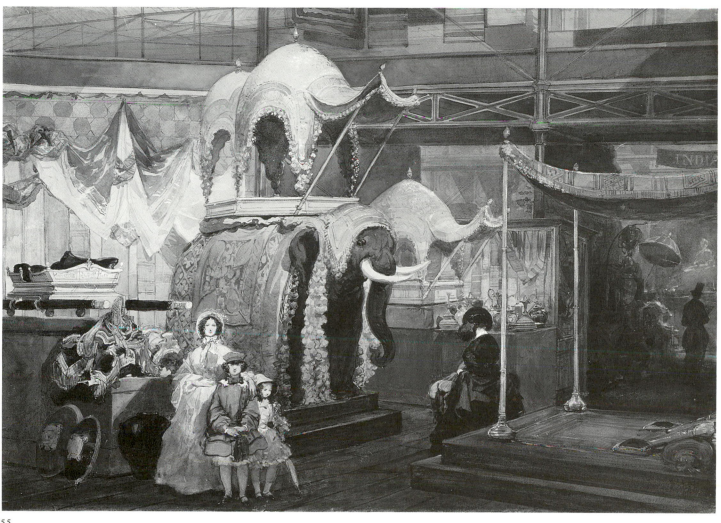

55

LOUIS LAMOTHE
Lyon, 1822–Paris, 1869

56 Portrait of Madame Lamothe

Graphite. Height: 0.510; width: 0.350.
Inscription on the back: "Louis
Lamothe portrait de Madame
Lamothe."
Inventory number: 1937-59

Provenance: Gift of Jacques Lerolle
in 1937.

The immateriality of the body, barely sketched, of this Ingresque portrait gives full weight and lends a presence to the beautiful, dream-like face.

Lamothe, unique and highly prized student of Auguste Flandrin, moved to Paris in 1839, to the great regret of his master, who had to resign himself to surrendering his best student to his younger brother, Hippolyte. Lamothe functioned as Hippolyte Flandrin's chief assistant in nearly all his great decorative commissions between 1840 and 1859. This artist, who thereby spent most of his career in the shadow of the most famous of the Flandrin brothers, had several gifted students, among them James Tissot, Henri Regnault and Edgar Degas.

56

HIPPOLYTE LEYMARIE
Lyon, 1809–Saint-Rambert-en-Bugey, 1844

57 Edinburgh Castle

Watercolor. Height: 0.290; width: 0.400. Signed at lower left with the monogram: "HL" and annotated: "Edinburgh Castle 17 août." Inventory number: B 382

Provenance: Acquired in 1886.
Bibliography: Vial (1905): 68.

The landscape painting of Leymarie — who was a student, successively, of Trimolet, Berjon and Guindrand — took place essentially in the Dauphiné and around Lyon and in the Bugey countryside. Yet, he also painted in Belgium, Scotland and England, as travel journals and certain paintings he sent to the Salons of Lyon testify. Unlike his orientalist watercolors, which undoubtedly were painted in Lyon, his views of **Liverpool** and the **Coasts of Dublin**, shown at the Salon of 1840 (nos.329 and 330) and two views of London, shown at the Salon of 1841 (nos.252 and 253), are connected directly to his travel. From his visit to Scotland sometime prior to 1841, two drawings aside from the present watercolor survive: **A View of Glasgow** and **A View of Edinburgh from the Castle** (Private Collection).[101]

Leymarie's affinity for archaeology led him to publish articles and illustrations in magazines such as *Lyon ancien et moderne*, *Lyon vu de Fourvière* and *La Revue du Lyonnais*. The critics of his time enjoyed the precision of his style and the accuracy of his urban views.

Leymarie here manifests a freer aspect of his art. Even if this watercolor faithfully recreates the site, it is, above all, a subtle study of atmospheric effects. No superfluous details disturb our gaze, which Leymarie leads by a succession of wooded planes to the rocky mass on which the castle stands. Leymarie appears the equal here of the best British watercolorists of his time.

101 These two drawings are illustrated in Vial, *Exposition rétrospective des artistes lyonnais* (1904): nos.293 and 71.

57

JEAN-LOUIS-ERNEST MEISSONIER
Lyon, 1815–Paris, 1891

58 Self-Portrait

White gouache and brown wash.
Height: 0.290; width: 0.220. Signed,
dated and dedicated, in ink wash, at
top: "Mon cher Chenavard, que ce
croquis témoigne toujours de notre
vieille et bien bonne amitié.
E. Meissonier 1881."
Inventory number: B 299

Provenance: Paul Chenavard Collection.
Gift of Paul Chenavard in 1881.
Catalogue: See Lyon (1989): 83, no.59.

"The energetic and determined head, with its large black eyes half drowned under the creases of the eyelids, the open nostrils, the rebellious brown hair, the beard, short at first, that later he would let grow into large curls as majestic as those of Moses and Michelangelo. . . ." That is the portrait of the artist as described by Léonce Bénédict.[102]

According to Meissonier's own account, his long friendship with Chenavard dated from 1835, the year they were introduced in Lyon, after the latter's return from Italy.[103] For about two years, Meissonier had wanted to meet the artist of **A Session at the Convention**, a work that tremendously impressed him when he saw it in the rue Vivienne. In those days, the two friends frequented the "Club des Haschichins" at the Hôtel Pimodan, the residence of Boissard de Boisdenier.

According to Meissonier himself, it was Chenavard who determined the final orientation of his art. In 1839, while Meissonier dreamt of establishing himself as an history painter, he showed his older friend a work in progress: **Christ with the Apostles**. Chenavard, often called the "grand démolisseur," severely criticized the work: "Come on, don't tell me you pretend to do these things better than Raphael did? . . . So, why try to restate less successfully that which has already been said?" And leading Meissonier in front of the **Bass Player**, Chenavard enthusiastically complimented his friend's originality.[104]

Appreciating this criticism from his friend, whose tremendous intellect he admired, Meissonier decided then and there to devote himself to genre painting.

The careers of the two painters were different and their work was poles apart, but they could meet on the common ground of their love of history and its connections with art. The 1883 portrait of Chenavard that Meissonier dedicated to Chenavard also testifies to the friendship of the two artists from Lyon. Chenavard gave the painting to the museum of his native city.

The use of white gouache lends to the artist's aging face a striking intensity as it emerges from the brown wash shadow. The same majestic and thoughtful expression can be found in the other self-portraits Meissonier produced in the 1880s. A full-length portrait in the Musée de Valenciennes (inv. D 46-2-63) portrayed him wrapped in Venetian fashion in a large red velvet robe, seated in his armchair, his greyhound at his feet. The Orsay portrait, which was shown at the Exposition Universelle of 1889, depicts him with his head in his right hand, a pose also used in a photograph taken in 1890 in Meissonier's atelier and the same pose that Mercié would use again for the sculpture unveiled on October 25, 1895, in honor of the illustrious painter, who had died four years earlier.

102 Bénédict (no date): 32.
103 Cited by Gréard (1897): 29 and 153.
104 Gréard (1897): 154 and cited by Bénédict (no date): 68.

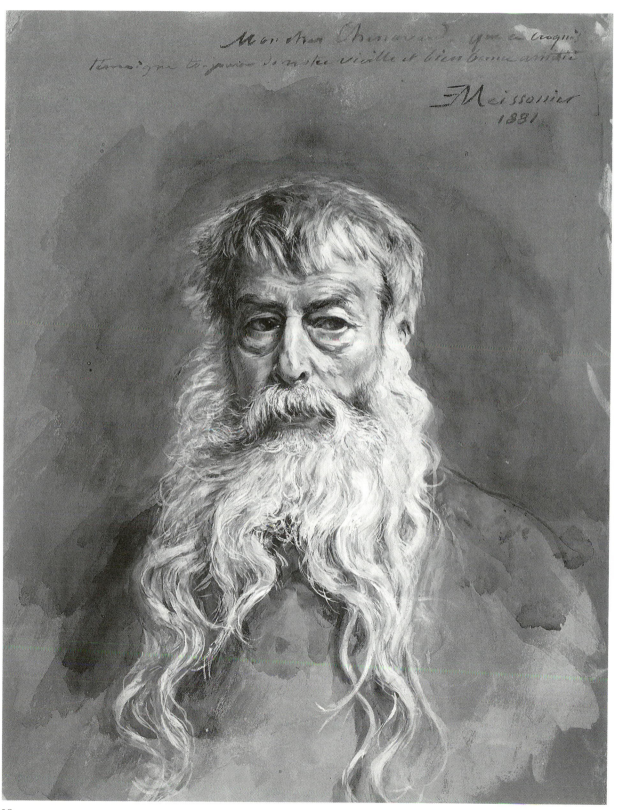

58

LUC-OLIVIER MERSON

Paris, 1846–Paris, 1920

59 Two Children with Animals

Black chalk, red chalk, heightened with white chalk. Height: 0.570; width: 0.685. Signed and dated, in black chalk, at lower right: "L.o.M." Inventory number: B 639

Provenance: Acquired from the artist in 1902.
Catalogue: See Lyon (1989): 84, no.61.

Even if they are not preparatory studies, these two figures are very close in spirit to motifs in the decoration of the main staircase of the Hôtel de la Ville de Paris, a commission Merson received in 1888 and for which he presented the studies in 1898. Each of the great allegorical figures created for the inside panels of the staircase is accompanied by a little winged genie, girl or boy, seated on a platform that supports the allegory; their more or less acrobatic postures recall those of the two young boys in this drawing. The grace of these dream-like figures, who are holding animals ready to escape, is due to virtuosity of both line and modelling characteristic of Merson, who admired Ingres and the artists of the Florentine Renaissance.

59

JEAN-FRANÇOIS MILLET
Gruchy, 1814–Barbizon, 1875

60 August, The Gleaners (Août, les glaneuses)

Black chalk. Height: 0.156; width: 0.223. Stamp at lower left: "J.F.M." (Lugt 1460).
Inventory number: B 1242

Provenance: Millet's studio (sale of 1875). Jules Ferry Collection. Acquired from the sale of Madame Jules Ferry, on February 11 and 12, 1921 (no.71).
Catalogue: See Lyon (1989): 87, no.62.

From 1850 to 1857, Millet developed the theme of gleaners in a series of drawings, an engraving, and at least two paintings. The famous painting now at the Musée d'Orsay was finally exhibited in the 1857 Salon. The motif of gleaners first appeared in the artist's oeuvre after he settled in Barbizon in October 1849. The complexity of the theme was analyzed by Robert L. Herbert in the Grand Palais exhibition catalogue of 1975-1976 and again in the study, *Millet's Gleaners*, which accompanied The Minneapolis Institute of Arts exhibition of 1978. Herbert proposed a chronology of no less than sixteen known drawings of the gleaners, thereby establishing the principal stages in the evolution of the theme.

The drawing corpus can be divided into three slightly different yet interdependent themes: (1) *The Month of August*, circa 1852, used by Charles Jacque when he published one of the engravings of the set *Twelve Months* in the newspaper *L'Illustration*; (2) *Summer*, including the first painting of the gleaners, *Summer, The Gleaners*, which was produced as a part of the *Four Seasons* commissioned in 1853 by Feydeau;[105] and (3) the last version of the theme, comprising the etching of 1855-56 and the great Orsay painting of 1857. In the latter two works, the artist changed the composition from vertical to horizontal.[106]

In the course of this evolution, the Lyon drawing, incorrectly assumed to be a preparatory drawing for the great painting of 1857, should be seen as one of the studies executed circa 1852 on the theme of *The Month of August*. Herbert established that this drawing is in fact the most important preparatory study for a drawing of nearly identical dimensions, *The Month of August, The Gleaners* (1978-32) acquired by the Fogg Museum in 1978.[107] Charles Jacque based the engraving in *L'Illustration* of August 7, 1862, on the Fogg drawing, reusing the main group and modifying the background.[108]

The present drawing represents the last point in the evolution of the theme at which the gleaners would be turned towards the right. In the drawing from the Musée Grobet-Labadié in Marseille (K03) dating from the same period, the figures appear to be turned definitively towards the left.[109]

Herbert points out that the Lyon and Fogg drawings introduced an important change in atmosphere vis-à-vis the two earlier drawings, which isolated two gleaners in the landscape.[110] In the Lyon drawing, the women are integrated with the group of harvesters, and the presence of children considerably softens the harshness of the scene, giving it an almost bucolic flavor. The figure of the young boy standing erect and holding a sheaf, who will become very important in the Fogg drawing, is already present in the Lyon drawing, if only in the form of a sketch-like figure superimposed retroactively on the bending women. In the case of the two gleaners, they are still very close to their counterparts in the Dublin drawing, because of the fierce

Jean-François Millet, *The Month of August: The Gleaners*, Cambridge, The Fogg Art Museum. Gift of Therese Kuhn Straus in memory of her husband Herbert N. Straus, Harvard Class of 1903. Courtesy of The Fogg Art Museum, Harvard University, Cambridge, Massachusetts.

60

energy of their poses. In the Fogg drawing, this tension will relax and one silhouette will be easier to differentiate from another.

Later, Millet would transform this peaceful harvest scene by progressively isolating the gleaners and concentrating the composition solely on these figures' activity; this considerably modified the meaning of the picture. In fact, as Herbert concluded, the opposite of what was expected actually occurred. Effectively,

the social overtones in this oeuvre, minor at the beginning just after the Revolution of 1848, grew progressively louder as the Revolution faded into the distance and culminated in the painting now in the Musée d'Orsay. This work was badly received at the Salon of 1857 by conservative critics like Paul de Saint-Victor, who declared for *La Presse*: "these three female gleaners (. . .) pose as the three Parcae of Pauperism. They are bogeys in rag."

105 *Summer* and *The Gleaners* are now in an American private collection.

106 The etching is mentioned by Delteil (1906): no.12.

107 Herbert (1978): no.6, fig.8.

108 The engravings of *The Twelve Months* were executed after the drawings that Charles Jacque produced under the influence of Millet. However, the name of the painter did not appear in the publication, which provoked a definitive break between the two men. The series of the *Months* was in fact published again in 1853 and once more Millet's name was not mentioned.

109 Herbert (1978): no.7, fig.10.

110 One of these "earlier" drawings is in the Hugh Lane Municipal Gallery of Modern Art in Dublin while the other is in the Louvre. Herbert (1978): no.2, fig.4 and no.3, fig.5.

VICTOR ORSEL
Oullins, 1795–Paris, 1850

61 Study for *Charity and her Beneficiaries*

Pen and brown ink, gray wash, over graphite. Height: 0.195; width: 0.145. Inventory number: 1987-5

62 Study for *Charity and her Beneficiaries*

Oil on paper, mounted on cardboard. Height: 0.200; width: 0.145. Inventory Number: 1987-6

On the back of the mount which unites the two studies, there is a handwritten letter by V. Orsel which was addressed to Legendre-Héral: "Monsieur/ Monsieur Le gendre-hérald professeur de sculpture A l'école royale des Beaux-Art de Lyon—Mon cher Hérald/je te remets les reçus de tes ouvrages, ainsi qu'un mot de moi pour mr ducquesne qui n'est point mr duchesne, qui désire avoir ta figure d'euridice, je te verrai incessament pour te dire adieu/ton ami V. Orsel/vendredi."

Provenance: Acquired from the Arenberg Gallery in 1987.
Catalogue: See Lyon (1989): 90, nos.64 and 65.

Recently published by Gilles Chomer in the *Bulletin des Musées et Monuments Lyonnais* this mount unites a drawing and an oil sketch that are direct preparatory studies for the painting, *Charity and her Beneficiaries*, in the Musée des Hospices Civils de Lyon.[111] Commissioned in 1821 for the board room of the nursing home, this 1822 entry was the first painting shown by Orsel at a Salon. Temporarily exhibited at the Musée des Beaux-Arts de Lyon before it was installed at its final destination, it displayed Orsel's ambitions as a history painter at the conclusion of his apprenticeship in Guérin's studio.

Alphonse Périn, friend and biographer of Orsel, devoted a long commentary to this work and regrouped all of the preparatory drawings related to it.[112] These two studies are the only ones known to survive. The pen-and-ink drawing, executed in 1821, is probably the artist's first scheme after receiving the commission, for he made a certain number of compositional modifications in the final version, the most important of which concerns the reclining figure of the old man in the foreground. By contrast, the perfect correspondence between the painted sketch and the painting reveals the ultimate state of Orsel's compositional arrangement just prior to final execution. The lithograph, realized by James Bertrand and published by Périn, does not correspond to the first idea for the painting, as Périn affirmed, but, rather, to the final composition, as already in place in the present oil sketch.[113]

111 Chomer (1988-4): 40-43.
112 Périn (1852-1878): 7-10, fasc.2.
113 Périn (1852-1878): pl.9.

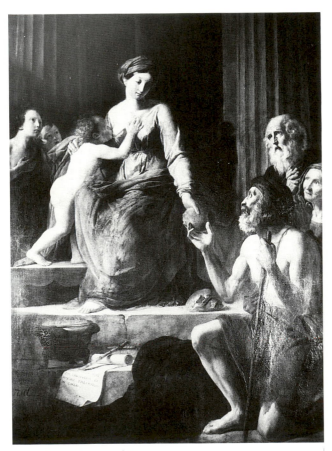

Victor Orsel, *Charity and Her Beneficiaries*, Lyon, Musée des Hospices Civils de Lyon.

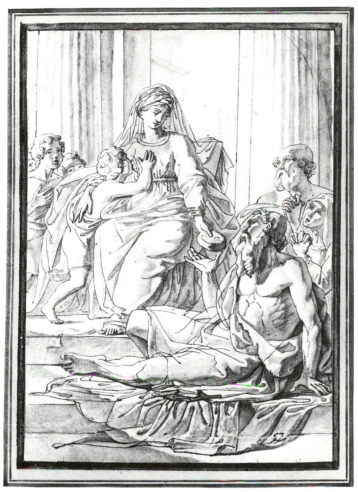

61

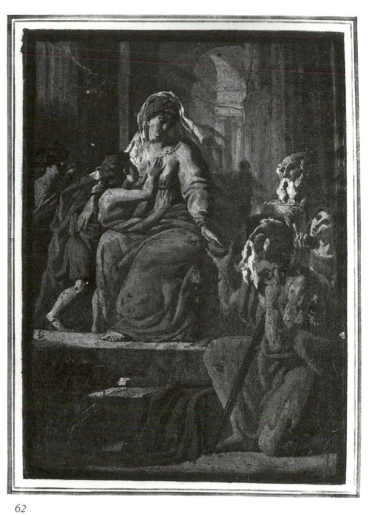

62

DOMINIQUE PAPETY

Marseille, 1815–Marseille, 1849

63 The Mandolin Player

Graphite. Height: 0.330; width: 0.235. Stamp at lower left: "H.L." (Lugt 1333).
Inventory number: X 1029-29

Provenance: His de La Salle Collection. Gift of His de La Salle in 1877.
Catalogue: Lyon (1989): 91, no.66.

Amprimoz dated this drawing 1841, which corresponds to the end of Papety's Italian sojourn.[114] Papety had arrived at the Villa Medici in 1837, after winning the Grand Prix de Peinture. With this drawing he revealed a superb talent for improvisation. The pose of this figure portrayed with such liveliness and confidence recalls *The Mandolin Player* (inv.876.3.155) in the Musée Favre, Montpellier, on which is based *The Improvisor of Capua*, a lithograph by Blanchard the Elder after Papety (Bibliothèque Nationale, Cabinet des Estampes, inv.EF 152) published in 1849.[115]

114 Amprimoz (1980): II, 144.

115 For *The Improvisor of Capua* see Amprimoz (1908): fig.630.

64 Dancing Woman

Graphite. Height: 0.343; width: 0.217. Stamp at lower left: "H.L." (Lugt 1333).
Inventory number: X 1029-28

Provenance: His de La Salle Collection. Gift of His de La Salle in 1877.
Catalogue: Lyon (1989): 91, no.67.

This very elegant drawing has the same liveliness and grace, devoid of all academicism, as no.63, with which it is exactly contemporary.

63

64

ANTOINE-CLAUDE PONTHUS-CINIER

Lyon, 1812–Lyon, 1885

65 Les Baux, from the St. Rémy Road

China ink wash heightened with white gouache, over graphite; gray paper. Height: 0.320; width: 0.480. Stamp at lower left: "Ponthus Cinier." Annotated, in graphite, at lower right: "Les Baux, de la route de St. Rémy." Inventory number: B 346-6

Provenance: Bequest of the artist in 1885.
Catalogue: Lyon (1989): 92, no.68.

This and the following drawing belong to a group of fifty wash drawings that Ponthus-Cinier bequeathed to the Musée des Beaux-Arts de Lyon. He also left the city three volumes containing 419 wash reproductions of his major paintings (with the dimensions of the originals and name of the purchaser) and an album of pen-and-ink drawings entitled *Travels in Italy 1844* (Library of the Palais des Arts).

Ponthus-Cinier used ink wash, his favorite medium, to constitute his ***Liber Veritatis*** as well as to render the landscapes he produced during his frequent travels across France. The catalogue of the posthumous sale in March, 1885, lists more than 600 wash drawings. Germain called the severe grandeur of the rocky landscapes that were the artist's favorite sites, "veritable poems dedicated to the glory of the rocks."[116] A view of the southern flank of Les Baux is also preserved at Lyon.

116 Germain (1907): 350.

66 The Great Oak

China ink wash heightened with white gouache on gray paper. Height: 0.385; width: 0.540. Stamp at lower left: "Ponthus Cinier." Inventory number: B 346-46

Provenance: Bequest of the artist in 1885.
Catalogue: Lyon (1989): 91, no.70.

In his images of forests and isolated trees, Ponthus-Cinier reveals a close kinship to the landscape painters of the Barbizon School. Old oaks, cork-oaks and chestnut trees are favorite motifs. In this romantic study he effectively realized a "portrait" of this oak.

65

66

PIERRE-PAUL PRUD'HON
Cluny, 1758–Paris, 1823

67 Study for the Victim in *Justice and Divine Vengeance Pursuing Crime*

Black chalk heightened with white gouache, on blue paper. Height: 0.146; width: 0.218. On the verso, a sketch with black chalk heightened with white gouache: left part of a study for *Andromache*.
Inventory number: B 1052

Provenance: Jules Boilly Collection (sale of March 19-20, 1869, no.206). Paul Casimir Perier Collection (sale of April 26, 1899, no.68). Marquis de Biron Collection.
Acquired from the first Biron sale on June 9-11, 1914, (no.14).
Catalogue: Lyon (1989): 94, no.70.

The famous Louvre painting, *Justice and Divine Vengeance Pursuing Crime*, one of the most admired works at the Salon of 1808, was commissioned by Prud'hon's friend, Frochot, Prefect of the Department of the Seine, to embellish the criminal courtroom of the Palais de Justice. The stages in the long process by which this work evolved were very precisely analyzed by Sylvain Laveissière.[117] As early as 1804, Prud'hon began to develop two projects simultaneously. The first, *Themis and Nemesis*, is known through three drawings. Prud'hon abandoned this composition in favor of a completely different one that he described to Frochot in a letter dated June 24, 1805. The elaboration of this definitive project took four years, 1804-1808.

To document the evolution of *Justice and Divine Vengeance*, there are two general compositional drawings, one preserved at the Musée Condé (Chantilly, no.485), the other at the Louvre (RF 14). Certain elements of the Louvre drawing appear more developed in the painted sketch at the J. Paul Getty Museum in Malibu (84 PA. 717).[118]

Four detail studies complete the evolutionary stage of the work: a sheet of studies for the figure of Justice (Bayonne, Musée Bonnat, no.1129), a drawing of the head of Vengeance (Chicago, The Art Institute, no.19) and two studies for the figure of the victim, the one preserved at Lyon and another that is much more finished (Paris, private collection).[119]

The position of the victim's body, whose location is of great importance for the composition, was modified several times before being fixed definitively as it appears in both the Lyon drawing and the painting. Prud'hon's first idea (Chantilly drawing) was to show the victim lying facing down.[120] Next, he drew the victim lying flat on his back, as can be seen in the compositional drawing at the Louvre. A letter from Prud'hon to Constance Mayer on November 4, 1804, explains this fundamental change. Apparently Prud'hon had shown his composition to Frochot, who after examining it carefully said that "rather than having the shoulders and head of the cadaver, we would like to see his face and bust." "That," Prud'hon responded "can only increase the sentimental aspect of the painting." The draped and faceless cadaver in the Chantilly drawing is replaced by "the image of a juvenile victim offered up for our compassion."[121]

In the Malibu painted sketch, the position of the cadaver is the same as in the Louvre drawing, but the final position of the legs has yet to emerge. The right leg crossed over the left introduces a break in the curve of the body. Prud'hon modified this detail in the Lyon version, placing the left leg over the right and

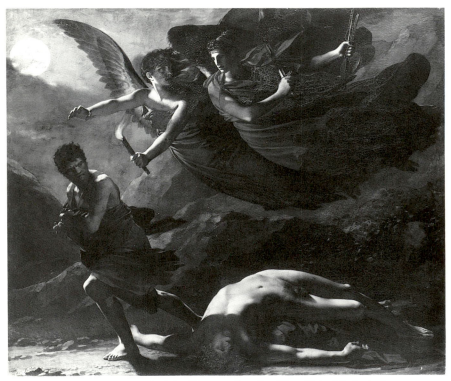

Pierre-Paul Prud'hon, *Justice and Divine Vengeance Pursuing Crime*, Paris, Musée du Louvre, ©Photo R.M.N.

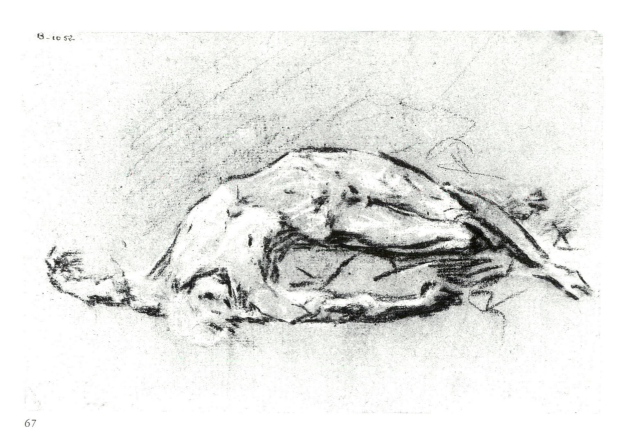

67

thus elongating the great arc produced by the figure. This, then, is the first drawing among those that survive to show the final position of the victim.

The only change the artist would make in the final composition concerns the position of the outstretched arms. Previously, they were parallel to the lower edge of the work, while ultimately they are elevated diagonally to counterbalance the great oblique curve formed by the rest of the body. The space occupied by the victim and the deliberately expressive elongation of the arched figure (already pronounced in the Lyon drawing, this accentuation becomes stronger in the painting due to the way moonlight strikes the figure) balances the composition by opposing the curve created by the two figures in flight. Moreover, the emphasis on the cadaver is intended to shock the viewer (the crim-

inal in the courtroom) with its profoundly emotional and pathetic character, a factor which Prud'hon carefully noted in his letter to Constance Mayer. This motif evokes the story of Cain and Abel and therefore caused many writers to read this painting incorrectly (E. and J. Goncourt, Joseph Aynard, Louis Réau . . .).

The obvious connections between this figure and that in the **Death of Abel** by François-Xavier Fabre (1790) lead us also to place this figure of a dead youth in the simple content of the academic nudes that Prud'hon drew all his life.

The fragmentary drawing on the verso of the sheet is a sketch for **Andromache**, a work that Prud'hon started around 1810 for the Empress Marie-Louise. The painting was announced at the Salon of 1817 but not exhibited there until 1824.

Laveissière explains the juxtaposition of these two sketches on the same sheet as follows: either Prud'hon was working on the Andromache project at the same time as **Justice**, or the verso was used later. In the latter case, the sheet, too big for the study of the victim, would have been trimmed to center this drawing, considered more interesting than the image on the verso, and the verso sketch would have been amputated accordingly.

117 Laveissière. *Dossier du Département des peintures du musée du Louvre*, 32. (1986).

118 These three drawings were illustrated in the Louvre exhibition catalogue (1986), respectively nos.15, 16 and 17.

119 These four studies are illustrated in the Louvre exhibition catalogue (1986); they are respectively nos.18, 19, 21 and 22.

120 It is worth noticing that the victim is no longer a woman, as in the abandoned project, but a man.

121 Laveissière (1986): 35.

**68a Study of a Man,
Arms Raised** (recto)

**68b Study of a Man,
Right Arm Raised**
(verso)

Black and white chalks, on blue paper.
Height: 0.530; width: 0.295.
Inventory number: 1971-126

Provenance: De Glatigny Collection (?).
Gift of Renaud Icard in 1971.
Catalogue: Lyon (1989): 95, no.71.

For a long time, Prud'hon's reputation rested on the popularity of his drawings, which were collected throughout the nineteenth century by numerous connoisseurs, foremost among whom must be mentioned the Marcilles. From Prud'hon's earliest days at the Ecole de Dessin at Dijon, when he was a student of François Devosge, to the period at the end of his life when he spent many evenings drawing in the studio of his student Trezel, he executed male and female academic drawings. At his death he willed several portfolios of these life studies to his friend Boisfremont.

"On his light blue paper, whose negative spaces create halftones, he first places not the contours but, rather, a large sketch of light areas in white chalk and dark areas in black chalk," wrote Charles Clément.[122] After this first step, which consisted of creating large black and white hatchings, still visible on the legs of the figures in both drawings, Prud'hon softened and modelled the volumes by stumping; then, with further white highlighting, he finished the drawing.

The two drawings on this sheet seem not to have been catalogued by Guiffrey. The gesture of the figure on the recto is also present in several studies sometimes called *The Bell Ringer* (Bayonne, Musée Bonnat, inv.1147; and private collection).[123] Another drawing at Bayonne (inv.1142) shows the same model in a pose akin to that in the drawing on the verso.[124] This model can also be found in a slightly different pose in a sheet in Budapest.[125]

122 Clément (1872): 379.

123 Guiffrey (1924): 1184 and 1191.

124 Guiffrey (1924): 1183.

125 Information given by Laveissière (written note of November 18, 1988). Perhaps Guiffrey (1924): 1216.

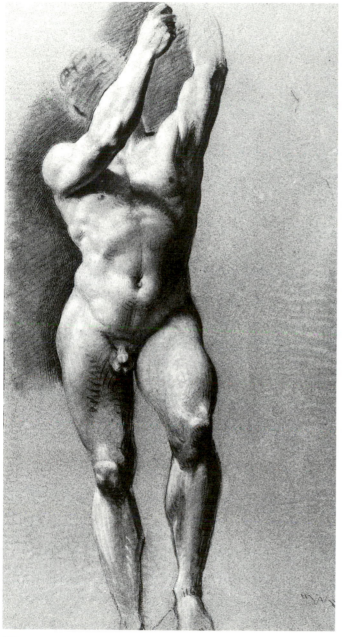

68a

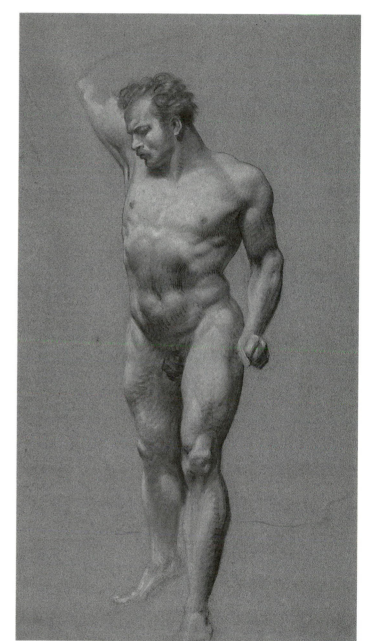

68b

PIERRE PUVIS DE CHAVANNES

Lyon, 1824–Paris, 1898

69 Draped Woman on a Pedestal

Gouache and watercolor over brown ink lines. Height: 0.247; width: 0.100. Annotated, in chalk, at lower left: "33."
Inventory number: B 607-44

Provenance: Gift of the artist's heirs in 1899.
Catalogue: Lyon (1989): 96, no.72.

These three studies for **The Game** (see also nos.70 and 71) constitute, with a drawing in the Petit Palais [P.P.D. 284(1)], the only surviving evidence of a painting now lost.[126] Shown at the Salon of 1868 (no.2074), the painting was commissioned in June 1868 by the Cercle de l'Union artistique while it occupied the Hôtel Aguado (18, Place Vendôme). Displeased with both the painting and the public's reaction to it, the artist destroyed it.[127]

We know of **The Game** through numerous descriptions, especially one by Théophile Gautier, a great admirer of

Puvis: "Monsieur Puvis de Chavannes symbolizes gambling with a young black haired nude endowed with a perfidious and pernicious physiognomy and a frighteningly fake smile, a woman whose slightly frail beauty and pallor betray the devouring zeal and exhaustion of sleepless nights. Her arms hang beside her hips. Gold coins spill from her left hand. Her right hand, tightly clenched, holds ill-luck, loss, the unknown, and fate. Behind her, a roulette wheel transforms itself into an apotheosis circle. A crown of clubs, spades, diamonds and hearts grips her dark hair and pensive forehead, full of calculations, probabilities and winning formulas; her ears are adorned with dice. A crimson cape fluttering like drapery in the background warms the livid whiteness of her body. At her feet bloom sad and dangerous flowers — veritable "fleurs du mal" — yellow marigolds with a bitter smell and the *datura stramonium* whose breathtaking calyx spills drunkenness, folly and death. A marble pedestal elevates the figure on the canvas and provides it with

the appearance of a statue, an effect confirmed by the rhythm of her pose and the unity of her color. It is difficult to characterize with a simpler vocabulary this abstraction we call *The Game*."[128]

The present study, still distant from the final composition, presents a winged figure that Puvis would ultimately abandon. To fill the background, he would substitute fluttering drapery for wings. The cape is already crimson although the coins spill from both hands rather than just from the left. The motif of the pedestal, which provides the allegory with an "appearance of a statue," is present in the three Lyon drawings but absent from the Petit Palais sheet. It should be observed that Puvis used the wash technique very rarely — only circa 1865.

126 For the Petit Palais drawing see exhibition: *Paris, Ottawa* (1976-1977): no.70 and Boucher (1979): no.34.

127 According to Brown Price (January 1977): 27-40.

128 Gautier, "Salon de 1868," 1st article, *Le Moniteur Universel*, May 2, 1868.

70 Draped Woman on a Pedestal

Pen and brown ink, gouache and watercolor. Height: 0.230; width: 0.100.
Inventory number: B 607-45

Provenance: Gift of the artist's heirs in 1899.
Catalogue: Lyon (1989): 96-97, no.73.

Here the fluttering drapery of the final composition has already replaced the wings of the previous figure. Nevertheless, certain details that later would be eliminated are still present. The putto will disappear, to be replaced by a roulette wheel, not yet visible. In traditional iconography, the right side brings luck, but here it is the left hand that spills the coins. In the final composition, the flowers held here in the right hand lie at the feet of the figure.

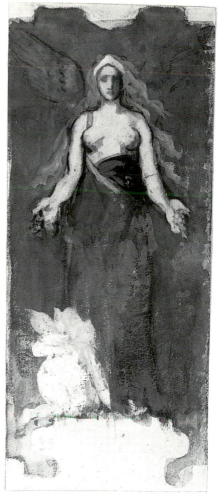

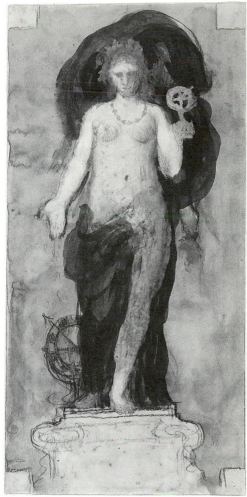

69 70 71

71 Draped Woman on a Pedestal

Gouache and watercolor over chalk.
Height: 0.270; width: 0.130.
Annotated, in chalk, at lower left:
"34,"
Inventory number: B 607-29

Provenance: Gift of the artist's heirs
in 1899.
Catalogue: Lyon (1989): 97, no.74.

Of the three drawings published here, this is closest to the final composition. A gambling wheel has replaced the putto and the coins spill from the right hand. The body, wearing jewelry, paler and more naked than before, comes closer to Gautier's description. Yet, the blue of the drapery will be replaced by crimson, and the position of the left arm, bent and holding a small gambling wheel, will shift in the final work.

Confronted by these three superb drawings, which display a relatively rare technique for Puvis, it is difficult to understand the critics' harsh reaction: "No head, no breasts, no arms nor legs. She cannot stand on her legs. She has no human form and cannot live. I guess that this ugly atrophy is a symbol: gambling destroys people . . . is that it?" Thoré-Bürger said ironically.[129] A connection with Gustave Moreau, to whom some contemporary critics attributed the painting, does not seem altogether absurd upon close inspection of the gouaches.

129 Thoré-Bürger. *Salons de W. Burger, 1861-1868.*
Paris (1870): II, 478.

72 Drapery Study

Black chalk. Height: 0.460;
width: 0.240.
Inventory number: B 607-41

Provenance: Gift of the artist's heirs
in 1899.
Catalogue: Lyon (1989): 100, no.77.

This drawing is a study of the young woman who is hurled toward death by her companions in the painting, *The Young Women and Death*, exhibited in the 1872 Salon with the title *The Grim Reaper Asleep*. The jury rejected it and to protest against the sternness of Charles Blanc and to demonstrate solidarity with the other *refusés,* Puvis resigned his position as a member of the jury. In 1890, along with Rodin and Meissonier, he founded the "Société Nationale des Beaux-Arts" (Salon du Champ-de-Mars).

The painting, today at the Sterling and Francine Clark Art Institute, Williamstown, is an allegory of "the fragility of youth and life." A painted sketch for it is in the National Gallery in London.[130] The painting shows two young women dancing with a carefree spirit luring their companion toward death, represented by an old man asleep on the ground with a scythe. In the Lyon drawing, both the pose of the young woman and the drapery closely correspond to these elements in the painting. The elongation of the silhouette can be found in a general way in other painted figures. The lower part of the drapery is partially hidden by the ground and by other figures, as it is in the painting. The loose tunic, revealing a breast, and the young girl's dancing strikingly evoke ancient bacchanalian figures.

130 The Williamstown painting was exhibited at the 1976-1977 exhibition (no.93) and the London sketch is mentioned by Davis (1957): 195. Riotor (1896).

Pierre Puvis de Chavannes, *Death and the Maidens (The Reaper)*, Williamstown, Massachusetts, Sterling and Francine Clark Art Institute.

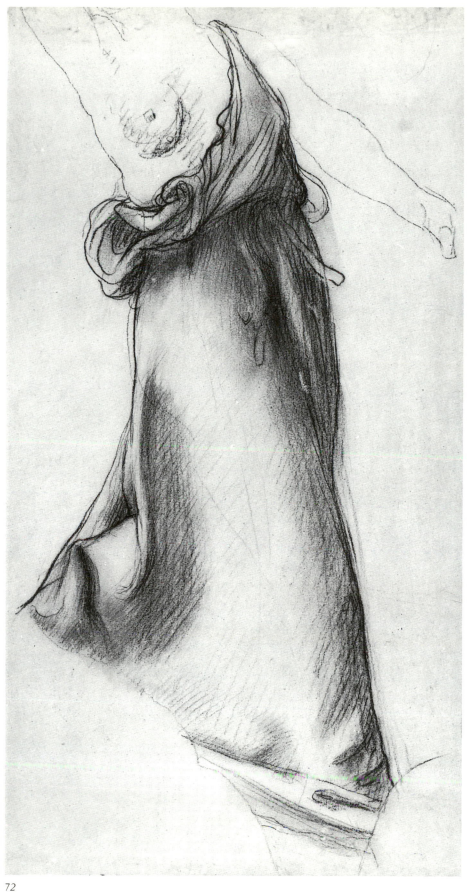

72

73 Portrait of Alexandre Séon

Black chalk. Height: 0.259;
width: 0.188.

Provenance: Gift of the heirs of the
artist in 1899.
Bibliography: Borel (1985): 137.

This drawing is probably a preparatory study for a pastel portrait of Alexandre Séon (1855-1917) executed in 1886 and dedicated to Miss E. Séon.[131]

A pupil and devoted admirer of Puvis de Chavannes, Séon prepared the master's canvases for the mural on the main stairway of the Musée des Beaux-Arts de Lyon. Borel has suggested that Puvis de Chavannes drew this portrait to thank Séon for his help.

131 See *Puvis de Chavannes et la peinture Lyonnaise au XIXe siècle*, Musée de Lyon (1937): 22-23.

42

74 Draped Woman in a State of Levitation

Black chalk. Height: 0.400; width: 0.280.
Inventory number: B 607-27

Provenance: Gift of the artist's heirs in 1899.
Catalogue: Lyon (1989): 102, no.79.

"The joyful muses rush up and align themselves on either side of the genie, following the order of sacred theory. The ninth is still gliding, enclosed by enveloping veils which she parts to admit the luminous rays," writes Vachon in 1896, describing this figure of a muse at the Boston Public Library. This drawing is a study for the first muse on the left in *The Inspirational Muses Acclaiming the Genie, Messenger of Light*.

After long hesitation, Puvis signed the contract for the staircase of the Library on July 7, 1893. Begun in 1894, the work was completed two years later. The artist was given complete freedom to conceive the decorative program. Puvis explains his work as follows: "I tried to represent in emblematic form the totality of the intellectual richness united in this beautiful monument." The themes of the other works, which complete the program, are the four manifestations of the human spirit: Poetry, Philosophy, History, Sciences. Puvis presented the first of these canvases at the Champ-de-Mars Salon of 1895. In October of the same year, it was sent to America where, accompanied by Victor Koos, it received an enthusiastic welcome. The artist several times repeated his sadness at seeing his paintings depart: "I am like a father whose daughters have entered a convent."[132]

The general compositional drawings in the Louvre (RF 15974, 2309 and 2310) show that before he thought to depict them in levitation, Puvis had placed the muses erect on a platform. The elongation of the forms and the fluid quality of the drawing, with its sinuous and entangled lines, are characteristic of the painter's late style. This muse can be found on the left side of the composition in another general study owned by the artist's heirs.[133] There also exist numerous studies for the composition as well as for details related to this work.[134]

132 Wehrlé, *La Revue de Paris* (February 1st, 1911): 470.
133 See 1976-1977 exhibition, no.209.
134 See Boucher (1979): no.151.

Pierre Puvis de Chavannes, *The Inspirational Muses Acclaiming the Genie, Messenger of Light,* Boston, Boston Public Library, second-floor level of grand staircase. Courtesy of the Trustees of the Public Library of the City of Boston. Richard Cheek photo.

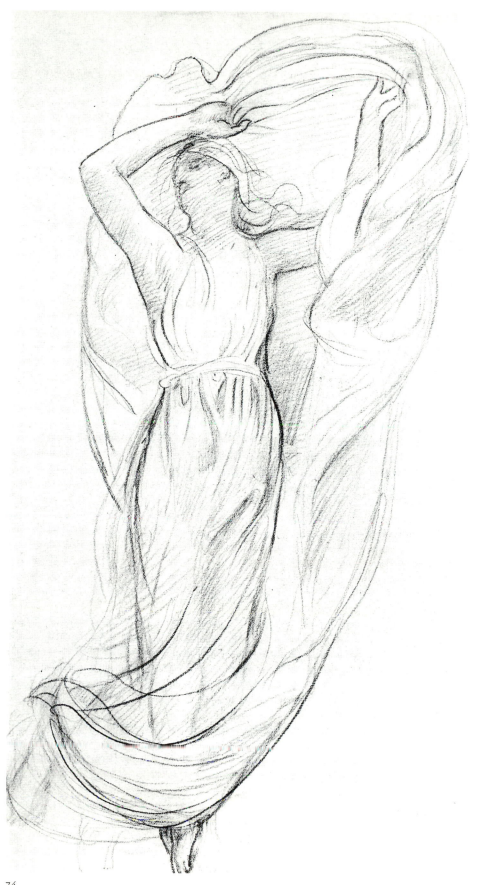

74

FRANÇOIS-AUGUSTE RAVIER

Lyon, 1814–Morestel, 1895

75 View of the Roman Campagna

Watercolor heightened with gouache over black chalk. Height: 0.300; width: 0.400. Signed at lower right: "F.A. Ravier."
Inventory number: 1964-13

Provenance: Gift of the Friends of the Museum in 1964.
Catalogue: Lyon (1989): 104, no.81.

Ravier arrived in Rome for the first time in September, 1840, and revisited Italy several times up through 1846. In Rome in 1843, he encountered Corot, whom he had already met in 1839 during a trip to Royat.[135] Ravier's decision to depart for Italy is, undoubtedly, connected with his first meeting with Corot, who exercised a profound influence over the younger artist. In a letter to his parents, Ravier stated that Corot was "one of the three greatest artists of his time."

Though much of the Italian work of Ravier has vanished, it is possible through what remains to follow the progressive emergence of his style, a style so close to Corot's that a number of his works were wrongly attributed to Corot. *View of a Roman Villa*, for example, was bequeathed by Claudius Côte to the Louvre in 1961 with a Corot attribution.

The present watercolor, which dates from 1840-41, at the beginning of Ravier's Italian sojourn, is still in the artist's early, timid style. Nevertheless, the deserted, melancholy quality of this austere and grandiose landscape is expressed with unaffected sincerity in dark shades that subtly model the glow of twilight. *Roman Countryside, Beginning of the Valley of Poussin*, a drawing from 1840 representing exactly the same site, was published by Félix Thiollier in 1888.[136]

135 Letter dated July 5, 1839 of Ravier to his parents. Jamot (1923): 322-323.

136 Thiollier (1888, reprinted in 1981): no.1.

76 The Great Umbrella Pine

Charcoal, black chalk heightened white gouache, on gray paper. Height: 0.460; width: 0.365. Signed at lower right: "F(r). A(te). Ravier."
Inventory number: 1971-134

Provenance: Gift of Renaud Icard in 1971.
Catalogue: Lyon (1989): 105, no.82.

This drawing, executed in Rome, is interesting not only for its superb quality but also because it provides a key to understanding the close artistic links between Ravier and Corot during the former's Italian period. The site represented here is exactly the same as Corot depicted in his drawing *Rome, Along the Villa Barberini* (Louvre, RF 4155), executed on October 8, 1827. Although long considered an exterior view of the Villa Medici, in fact this drawing depicts the Vicolo Sterrato, which runs along the gardens of the Barberini Palace, where the famous umbrella pine, a favorite subject of artists, stood until felled in 1872.[137] The church of San Caio is in the background. A small oil sketch in a private collection represents exactly the same motif.[138] Dated August 26, 1846, this sketch bears traces of a signature falsely imitating Corot's. Ravier, still in Italy at that date, could very well be its author; stylistically the sketch is very close to his Italian works.

137 Paris, Musée de l'Orangerie (1975): no.134.

138 This sketch (paper laid down on canvas; height: 0.245; width: 0.325) was mentioned to the author by Carlos Van Hasselt (written communication dated January 11, 1988).

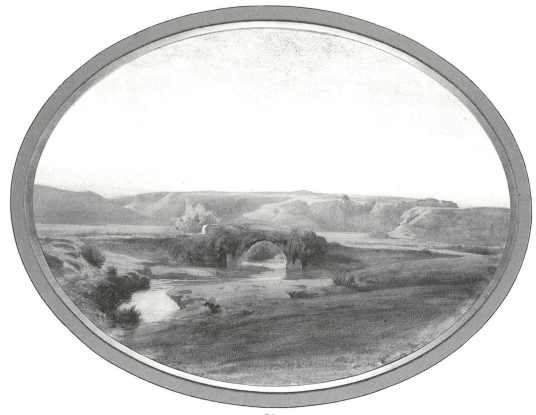

75

76

François-Auguste Ravier

77 Landscape near Crémieu

Watercolor and gouache over graphite.
Height: 0.210; width: 0.280. Signed
in pen and ink at lower right: "F. A(te).
Ravier."
Inventory number: B 543

Provenance: Gift of Madame Ravier
in 1896.
Catalogue: Lyon (1989): 105, no.83.

Ravier moved to Crémieu around 1854, before settling finally at Morestel in 1868. During his Crémieu period, a time when he attained the height of his powers, he drew or painted in oil from nature, then created his watercolors at night, transposing his impressions from memory. Thus, in contrast to traditional practices, he was using the medium of oil for his studies and watercolor to definitively express the lyricism of his artistic vision. To Paul Chenavard, Ravier said: "Everything is in the sky. The clouds and the atmosphere are making me dizzy. Always new. It is inexhaustible; it is the infinite."

Chenavard deeply admired his compatriot even though their aesthetic conceptions were fundamentally different. It is probably due to Chenavard that Delacroix not only obtained three watercolors by Ravier but also paid him the following compliment: "What no one could ever imitate is the impression of vastness that he could create while painting on small surfaces."

77

PIERRE-HENRI RÉVOIL

Lyon, 1776–Paris, 1842

78 Double Portrait of Révoil and Richard

Black chalk. Height: 0.315; width: 0.265. Signed and dated at lower left: "P. Révoil del. 1798." Inscription at lower center: "P. Révoil et F. Richard en 1798."
Inventory number: 1988-4. IV. 166

Provenance: Acquired in 1988.
Bibliography: Chaudonneret (1980): no. 58.

In spring of 1798, the two painters from Lyon, Pierre Révoil and Fleury Richard, were inseparable friends, having just returned together from Paris and David's studio. In this double portrait, they are posed against a Lyonnais backdrop showing the banks of the Saône and the Ile Barbe, which they frequented at that time. However, their friendship, very close since childhood, ended completely in 1823 during Révoil's successful struggle to reclaim his professorship at the Ecole des Beaux-Arts de Lyon, a battle in which Richard lost his job.

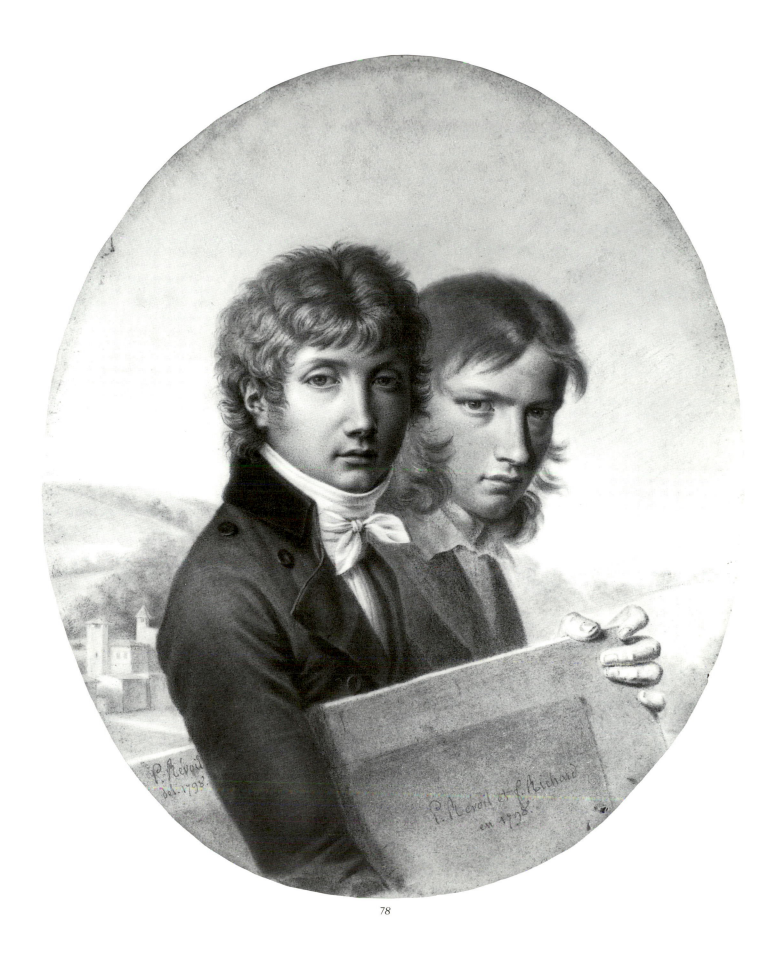

78

Pierre-Henri Révoil

79 Bonaparte Rebuilding the City of Lyon

Black chalk heightened with white chalk. Height: 0.445; width: 0.575.
Signed at lower left: "P. Révoil Lugdunensis." Inscription at lower center: "Lyon relevée par le premier consul."
Inventory number: A 3014

Provenance: Rosaz Collection (Lyon). Acquired by the city in 1846 and placed on deposit at the Municipal Archives. Transferred to the Museum in 1871.
Bibliography: Chaudonneret (1980): 150, no.65.

At the Salon of 1804, Révoil showed a painting entitled *Bonaparte Rebuilding the City of Lyon*, which had been commissioned by the Minister of the Interior to be hung permanently at the Hôtel de Ville in Lyon. The painting remained in the Hôtel de Ville until 1815, when it was removed. Then, on January 9, 1816, it was destroyed on the orders of the Prefect of the Rhône.

The painting, which commemorated Napoleon's visit to Lyon on June 29, 1800 (10 messidor an VIII) to lay the cornerstone for the reconstruction of the Place Bellecour, is known to us through two nearly identical drawings, one in the Louvre and this one preserved at Lyon.[139] In both, the City of Lyon is represented as a weeping lass, seated on the ground amid ruins, attended by geniuses of ill health. Bonaparte, attired in general's uniform and crown of laurels, takes her hand to help her to her feet. At his side, the geniuses of Commerce and the Arts, symbols of the coming prosperity, present the new ground plan of the Place Bellecour, which had become the symbol of the physical, economic and spiritual ruin of Lyon following its destruction during the Revolution.

Between the figures of Lyon and Bonaparte, a wounded lion symbolizes the city and recalls the story of Androcles and the lion. The hillside of Fourvière and the reconstruction work can be seen in the sunlight on the right. On the left, the storm menacing the city begins to dissipate. The same iconography had been used on January 15, 1802, for the celebration in honor of the First Consul.

139 For the Louvre drawing, see Chaudonneret (1980): no.64.

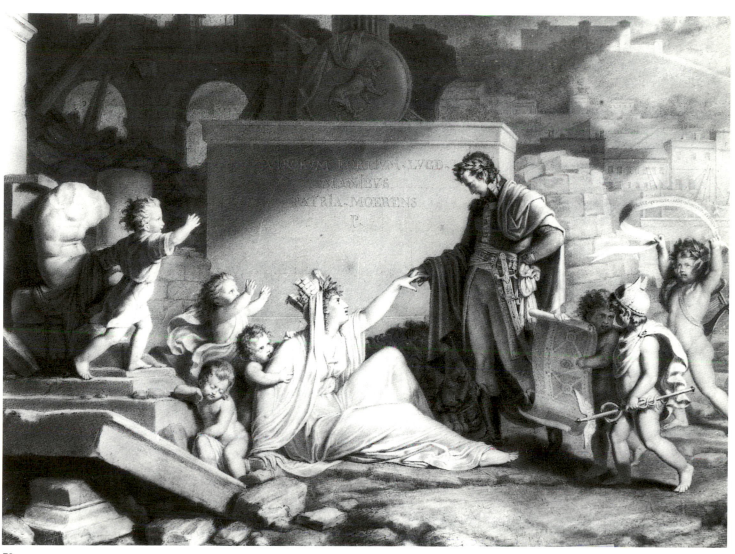

79

80 The Turnip of Louis XI

Pen and brown ink. Height: 0.458; width: 0.582.
Inventory number: 1983-4

Provenance: Gift of the Friends of the Museum in 1983.
Catalogue: Lyon (1989): 108, no.85.

This drawing by Révoil, whom Gault-de-Saint-Germain called "the historian of the private life of famous people," reveals his strong taste for entertaining and edifying anecdotes.

The rather obscure subject of the drawing was borrowed from the *Nouveaux Contes à rire, et aventures plaisantes de ce temps, ou Récréations françaises* (Cologne, Roger Bontemps editor, 1702), a collection of previously recorded, amusing anecdotes and "gallanteries" based upon the *Cent Nouvelles nouvelles*, a kind of French Decameron compiled for Philippe le Bon, Duke of Burgundy, and published by Antoine Vérard in 1486.

The story is this: when as Dauphin the future Louis XI sojourned at the Castle of Genappe in the domains of the Duke of Burgundy, he was in the habit of calling upon a peasant named Conon to taste Conon's delicious turnips. When the Dauphin became King, Conon went to him to offer the most beautiful turnips of his harvest. On the way, however, he was unable to resist temptation, and ate all but one. The King received the lone remaining turnip with gratitude and gave the peasant one thousand *écus*. Thereupon, a courtier, who was looking on, gave the King a magnificent horse in the hope that he would receive a reward commensurate with his present. But the King gave him Conon's turnip. When the courtier objected, the King told the man that he was well compensated in that he had received a present that cost one thousand *écus*.

Compared with episodes from the lives of Charles V, François 1er, or even Henri IV—to cite only the most illustrious kings—the life of Louis XI inspired the Troubadour painters relatively little. Chaudonneret mentions only one painting, ***The Donation of Provence to France***, based by Révoil upon an event from Louis XI's reign.[140]

140 Unknown location. Chaudonneret (1980): 144, no.46.

80

Pierre-Henri Révoil

81 Madame de Sermézy as Propertia

Brown wash. Height: 0.245; width: 0.200. Signed at lower left: "P. Révoil." Inventory number: X 907

Provenance: Acquired in 1874. Bibliography: Chaudonneret (1980): no.111.

Clémence Daudignac de Sermézy, student of Chinard and friend of Révoil, was the only woman sculptor in Lyon. She appears here in Neo-Renaissance costume, embracing an idealized bust of Raphael. In 1827, this drawing was exhibited at the Hôtel de Ville in Lyon with the following inscription: "Propertia (with the features of Madame de Sermézy) sculpting the bust of a young man she truly loves."

81

FLEURY RICHARD

Lyon, 1777–Ecully, 1852

82 Self-Portrait of the Artist Sketching in his Studio

Black chalk heightened with white chalk. Height: 0.290; width: 0.190. On the back, inscribed in ink: "Fleury Richard dessinant par lui-même." Inventory number: 1988-4. IV. 191

Provenance: Acquired in 1988. Bibliography: Chaudonneret (1980): no.76.

At the Salon of 1804, Richard exhibited **The Studio of the Painter**, a painting for which this self-portrait posed in front of a Gothic window is a finished preparatory study. The painting, now lost, is described as follows in *Lettres impartiales sur les expositions de l'an XIII*: "Look at this *painter in his studio,* he draws by the light shining through this narrow gothic window. . . ." Inscribed on the shield hanging on the column on the left is the motto, "Laissez dire et faites bien." The gloom of this "gothic" interior is suited perfectly to Richard, who with Pierre Révoil was the principal representative of the Troubadour style.

83 Scene in an Imaginary Architectural Setting

Black chalk and white chalk. Height: 0.222; width: 0.286. Inventory number: 1988-4. IV. 277

Provenance: Acquired in 1988. Bibliography: Chaudonneret (1980): no.63; Bruyère (1989-3): 25; Chaudonneret (1990-3): 27-28.

This drawing is directly connected to a painting in a private collection that depicts two young women in Renaissance attire dancing in front of the same kind of architecture as that represented here.[141] The drawing differs from the painting only in the way it is populated.

This work perfectly illustrates Richard's creative process, in which he first established the architectural framework, then introduced the protagonists in broad outline. However, it was unusual for him to invent an architectural setting rather than drawing from a real one. As Philippe Durey has pointed out, the gallery above the rosette in the main facade of Notre-Dame de Paris may have inspired the setting. Bruyère has suggested that the atmosphere of this drawing is close to that of certain works by Caspar David Friedrich.

141 See Chaudonneret (1990).

82

83

AUGUSTE RODIN

Paris, 1840–Meudon, 1917

84 Female Centaur and Child

Pen and brown ink, brown wash and white gouache over graphite; squared paper. Height: 0.150; width: 0.190. On the verso, a graphite sketch, representing two nude men, one of whom wears a winged cap.
Inventory number: B 191-5

Provenance: Acquired from the artist in 1910.
Catalogue: Lyon (1989): 113, no.92.

When the Museum bought this drawing from Rodin — as well as *The Shadows of a Woman and Child*, *Mask for a Man*, *Demon carrying a Shadow*, *Lust* and *Study for Ugolino* — all were attached to the same drawing board.[142] They had been reproduced, at Fenaille's instigation, in the famous Goupil Album, published in 1897, which brought together 142 facsimiles of drawings connected to *The Gates of Hell*. These drawings belong to the so-called "black" period of Rodin's drawing, when he was inspired by his reading of Dante.

In 1900, the artist stated in an interview: "I spent a full year with Dante, living only because of him and exclusively with him, drawing the eight circles of his Hell."[143] These drawings illustrate the poem more literally than does *The Gates of Hell*, and Rodin, with few exceptions, used them only indirectly for his sculpture. However, they do freely record the images that the poem inspired while Rodin was totally immersed in a Dantesque universe. A somber character and extensive use of brown wash with gouache highlights are their distinctive traits.

Consistent with nearly all of Rodin's graphic work, a precise date for these drawings remains hypothetical. Circa 1880 was traditionally thought to be when Rodin received the commission for *The Gates of Hell*. Rostrup and Grappe think that most of them can be dated to 1860-1875, inasmuch as Rodin probably discovered Dante in the 1850s at the Petite Ecole.[144] On the other hand, Judrin proposes to date them beginning in 1875, in order to correspond both to Rodin's return from Italy, where he was so deeply impressed by Michelangelo's oeuvre, and the time one year later when he was working on the first sculpture of Ugolino, which is now destroyed.[145] In any case, one may conclude that by 1880 most of these drawings already existed and that Rodin was reworking some older drawings with ink, wash and gouache, sometimes cutting them apart or trimming them for remounting.

Kirk Varnedoe supported Rostrup and Grappe's assertion that Rodin used his works from circa 1860-1875 as a point of departure for his investigations of the 1880s.[146] It is, nevertheless, impossible to determine the length of time between the execution of the initial drawing and the moment Rodin reworked it.

All of this may apply to the present drawing, which in no case can have been done later than 1883, the year in which it was published by Dargenty in *Art*.[147] Even if we can trust the title *Female Centaur and Child*, which was assigned to this drawing in the Goupil Album, where after all, it was published with Rodin's agreement, it is still difficult to determine the sex of this fantastic

creature, as is often the case in Rodin's drawings of this period. It was Canto XII of *Hell* that fed the imagination of Rodin in his representation of centaurs, a theme he particularly favored in the 1870s and 80s. Apart from this drawing, the Goupil Album reproduced another female centaur, shown here standing and protecting a child (pl.23).

In the present drawing, brown wash powerfully heightened with white is enclosed by a continuous pen line which seems to have been traced in order to contain any spreading of the wash. The sculptural density of the group and the passionate, savage tenderness of the powerful animal embracing the child are characteristic of Rodin's violent, darkly romantic drawings of Dantesque inspiration.

142 For more information concerning: *The Shadows of a Woman and Child, Mask for a Man* and *Demon carrying a Shadow*, see the French version of this catalogue, they are respectively nos.93, 94, 95. For *Lust* see the following catalogue entry and for the *Study for Ugolino* (Paris, Musée Rodin) see *Musée Rodin, Cabinet des Dessins*, dossier 2 (1982-1983): fig.1.

143 Cited in Serge Basset's "La Porte de l'Enfer" in *Le Matin*, March 19, 1900.

144 Rostrup (1938): II, 221.

145 Judrin (1981-1982): 29.

146 Elsen and Varnedoe (1971): 37-61.

147 Dargenty (1883): t.IV, vol.35.

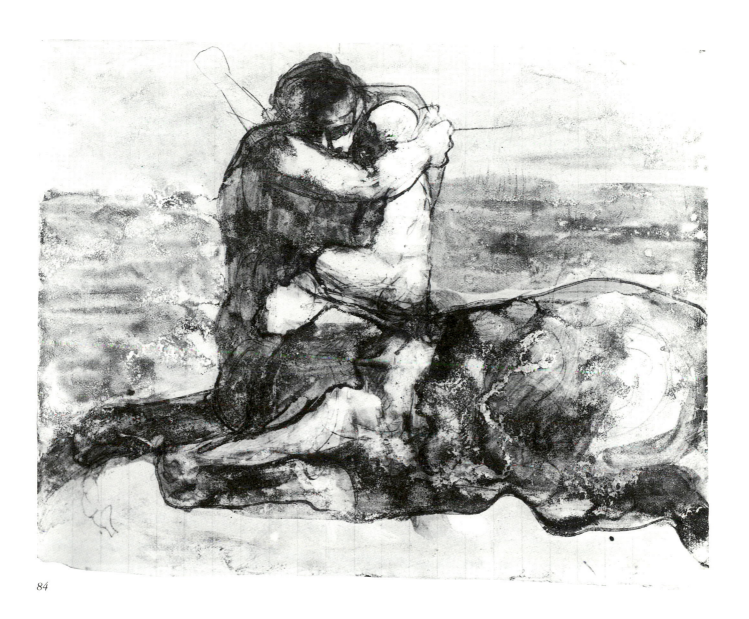

84

85 Lust

Pen and brown ink, brown and purple wash, white gouache over graphite; squared paper. Height: 0.148; width: 0.107. Annotated in brown ink at the top of the sheet: "la Luxure," and at right in brown ink: "deux jambes en queue de poison" and in graphite: "lit." On the verso, a graphite sketch of two nude men.
Inventory number: B 919-6

Provenance: Acquired from the artist in 1910.
Catalogue: Lyon (1989): 117, no.96.

In this drawing, which was published in the Goupil Album among the drawings inspired by Dante's *Hell*, the reference to *Lust* — a theme of fundamental Baudelairean inspiration — demonstrates along with many other works that Rodin worked simultaneously on the *Divine Comedy* and on the illustrations for *Les Fleurs du Mal*. Commissioned by Gallimard, the illustration of Baudelaire's work probably occupied Rodin for the entire year, 1887-1888. It is common to find references to Baudelaire in Dantesque drawings, one of the most beautiful examples being *Couple enlacé* (Paris, Musée Rodin, D.5630), entitled *Le Cercle des Amours* in the Goupil Album. Moreover, for several poems from *Les Fleurs du Mal*, Rodin reused drawings inspired by *Hell*. Dante and Baudelaire are intimately linked in Rodin's inspiration, such that the cross-references are so numerous that Judrin wrote: "*Les Fleurs du Mal* are like an echo of the *Divine Comedy*."[148] Rodin joined *Avarice* and *Lust* in one of the sculptures for *The Gates of Hell*.

There is a certain kinship between this intertwined couple and the one formed by *Dante and Virgil*, (Paris, Musée Rodin, D3768) in that the figure with arms raised in fear will be reused by Rodin to illustrate Baudelaire's poem, *La Béatrice*. The satyr is also close to the one present in the second illustration of the same poem. Strong white gouache accents, contrasting with darker zones created by the wash, give this drawing a very sculptural quality.

148 Judrin (1987): I, XXVII.

86 A Horseman

Pen and brown ink, brown wash over graphite; squared paper cut and mounted onto a supporting sheet. Height: 0.135, width: 0.102 and height: 0.175, width: 0.120. Annotated, in graphite, at lower right of the support: "César" (crossed out) and in pen and ink: "Don de M. Fenaille, mars 1913."
Inventory number: 1962-564

Provenance: Fenaille Collection. Bibliothèque Municipale, Lyon. Entered the Collection in 1962, through an exchange with the Bibliothèque Municipale.
Catalogue: Lyon (1989): 117, no.97.

Because of what could be read as pointed ears, this drawing entered the museum inventory under the title, *Faun on Horseback*, although the handwritten notation "César" on the support might suggest that the figure is wearing a crown of laurel. Still, this drawing should be compared with the study, *Dante and Virgil on a Chimerical Horse* (Paris, Musée Rodin, D 3767) inspired by Canto XVII of *Hell*, in view of close stylistic parallels.

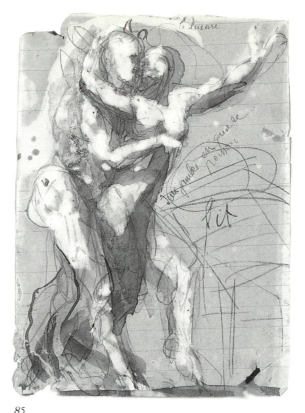

85

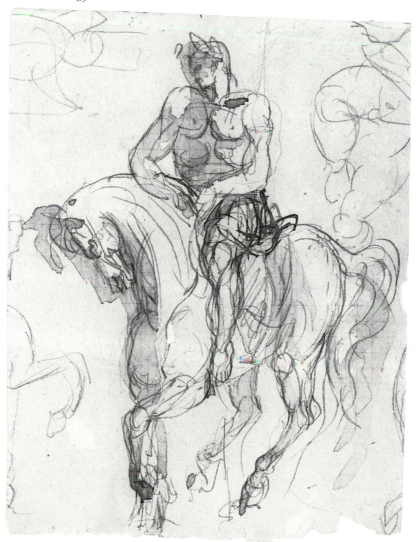

86

THÉODORE ROUSSEAU
Paris, 1812–Barbizon, 1867

87 Landscape

Watercolor, pen and brown ink.
Height: 0.235; width: 0.395. Signed
in pen and brown ink, at lower left:
"Th. Rousseau."
Inventory number: B 419

Provenance: Acquired from Henri
Hecht in 1887.
Catalogue: Lyon (1989): 119, no.98.

This landscape in its choice of a pano-
ramic vista, typifies Rousseau's artistic
experimentation during the 1830s much
as, for example, do two related large
landscapes, **The Valley of the Bas-
Meudon and the Séguin Isle** (Prague,
National Gallery) and **Paris Seen from
Bellevue Terrace** (Brussels, Royal Fine
Arts Museums of Belgium). In 1834,
while sojourning in the Jura, Rousseau
travelled briefly to Switzerland at the end
of October, as testified by **Landscape
around Fribourg** (Neuilly-sur-Seine,
Madame David-Weill Collection). This
drawing very probably was executed
during this trip.

88 The Plain

Pen and brown ink. Height: 0.124;
width: 0.150. Stamp on lower right:
"TH. R" (Lugt 2436).
Inventory number: B 1240

Provenance: Rousseau's studio (sale of
April 1868). Jules Ferry Collection.
Acquired at Madame Jules Ferry's sale,
on February 11, 1921 (no.84).
Catalogue: Lyon (1989): 119, no.99.

Far from the miniaturist's concern for
detail evident in the previous drawing,
this landscape view possesses the style of
Rousseau's mature, Barbizon-period art
from around 1860, as seen in the sim-
plification of motifs and economy and
authority of elliptical calligraphy. Rous-
seau's taste for vast linear horizons and
immense skies, which he could translate
onto formats as small, even, as that of
the present drawing, reveals his debt to
seventeenth-century Dutch landscape
painters, particularly, in this case, to
Rembrandt.

87

88

Reproduced to actual size

ALEXANDRE SÉON
Chazelles-sur-Lyon, 1855–Paris, 1917

89 Study for *Thought*

Black chalk heightened with white chalk. Height: 1.090; width: 0.480. Signed in black chalk, at lower right: "Etude pour *La Pensée*. Alex Séon." Inventory number: B 1223-b5

Provenance: Acquired from Mr. Gromollard in 1920.
Catalogue: Lyon (1989): 121, no.101.

This monumental drawing is a very finished preparatory study for *Thought*, a painting acquired in 1985 by the Musée de Brest and probably executed around 1900, just before the impressive Séon exhibition of 1901. The exhibition was organized by Milès at the Galerie Georges Petit, where this drawing was shown (no.5, inv.85-1-1) with a frame made by the painter Auburtin. The only changes from the drawing to the painting are the addition of a diadem of pansies on the head of the woman-angel and a brooch ornamenting the border of her tunic.

The figure is seated atop a ruined arch of antique inspiration set before a landscape evocative of the environs of Mont-Saint-Michel. She symbolizes the permanence of Thought: other-wordly, above earthly reality, enduring serenely throughout history, surviving destruction of civilizations. Séon remained ever faithful to this aesthetic ideal of young womanhood: pure, mysterious, thoughtful and hieratic with a dream-like and impenetrable gaze.

Firmly connected to the Symbolist movement, the artist exhibited on a regular basis at the Rosicrucian Salons from 1892 to 1897. His friend Sâr Joséphin Péladan commented on his work as follows: "There are always juvenile and chaste figures, nude or half-draped in tranquil poses. These are effigies of peace and freshness, very precise in form, very ambiguous in meaning."[149]

Beginning around 1890, Séon worked out theories on the symbolic meaning of color and line and introduced them systematically into his art. The verticality of the aerial figure symbolizes the exercise of the spirit, the elevation of Thought and feelings that lead mankind upwards toward the heavens. The opposing horizontality of the landscape represents materiality and the course of History. Strangely perched on a ruin, the figure gazes downward with a melancholic expression upon the terrestrial world to which she does not belong. Her static pose is one of the constants in Séon's art.

149 "Les grands méconnus: Alexandre Séon, "in *La Revue Forezienne illustrée* (1902): 15.

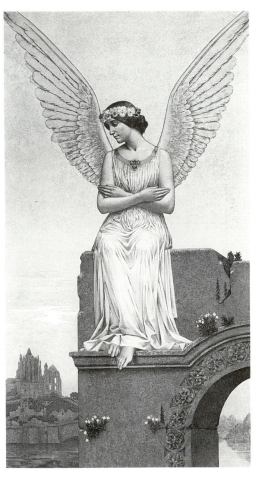

Alexandre Séon, *Angel Amidst Ruins (Thought)*, Brest, Musée des Beaux-Arts. ©Photo R.M.N.

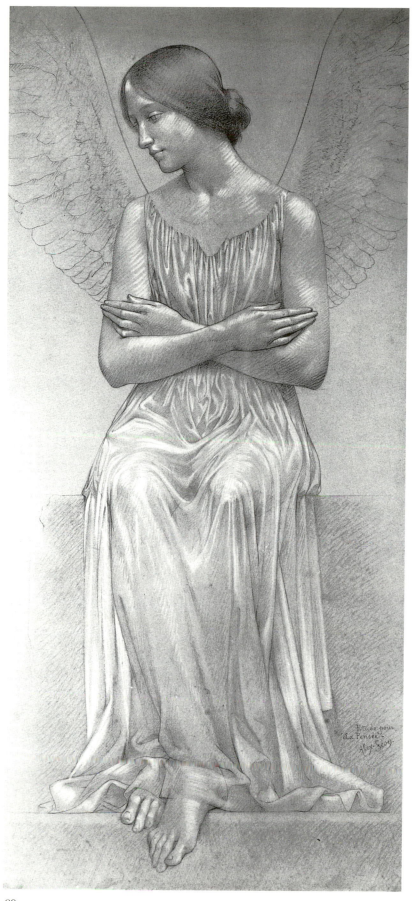

89

FRANÇOIS VERNAY

Lyon, 1821–Lyon, 1896

90 Landscape at Morestel

Charcoal and pastel. Height: 0.450; width: 0.800. Signed at lower right: "F. Vernay."
Inventory number: B 729

Provenance: Eugène Baudi Collection. Gift of Eugène Baudi in 1904.
Catalogue: Lyon (1989): 122, no.102.

Without doubt his drawings highlighted with chalk or pastel permit Vernay a claim to a talent as a most original landscape artist. Focillon perfectly defined the basis of his greatness in that domain: "Vernay . . . is neither a romantic of sunsets, nor a shimmering Impressionist, in that each aspect of nature is for him a whole, where a sovereign order reigns, one that he first outlines with large and powerful lines. His beautiful drawings, heightened with a line of chalk or with a touch of yellow pastel, are like a rustic Poussin made with powerful hands. When he traces the profile of a landscape where a herd of cattle is passing, he does not add the horns on the horizon afterwards, he produces them as he goes, pressing them into the same network, which gives to the whole image a kind of venerable continuity."[150]

It is often difficult to pinpoint the sites represented by Vernay, who usually omits any indication of specific locality and whose taste for synthesis results in elimination of superfluous pictorial elements.

The first Morestel landscape that can be identified with certitude, ***A Hay Wagon near Morestel***, dates to the Salon of 1860. The nearly epic grandeur of this drawing is far removed from Ravier's images of Morestel, where he lived from 1868 onward. The rider, a miniscule silhouette alone at the center of a wild, rocky landscape, is a motif also present in another Vernay drawing preserved at Lyon, ***Pathway between the Rocks: Horseman Seen from Behind*** (inv.B 700).[151] "Vernay imagines a nature that belongs only to him, like a fairy tale," wrote Marius Mermillon.[152]

150 Focillon (1928): II, 110-111.
151 Lyon (1984): no.109.
152 Mermillon (1946): Introduction.

90

Biographical Notes

On Twenty-four Lyonnais Artists
Represented in the Exhibition

by

Madeline E. McIntosh and DeCourcy E. McIntosh
Based on published texts, as indicated

Claude-Félix-Théodore Caruelle d'ALIGNY

Chaumes, 1798–Lyon, 1871

Claude-Félix-Théodore Caruelle, as he was christened, moved to Paris at the age of ten to attend the Ecole Polytechnique but after a few years left to join, successively, the studios of Baron Regnault (1754-1829) and Louis-Etienne Wâtelet (1780-1866).

By the early 1820s, Caruelle had committed himself to landscape painting in the classical style. His debut at the 1822 Paris Salon having completely escaped critical notice, he did not compete for the Prix de Rome; nevertheless, he left for Rome that same year and remained there until 1827. Once he had befriended Corot, which happened by 1825, the two often travelled and sketched together.

After returning to Paris in 1827, Caruelle became one of the first artists to frequent the Fontainebleau village of Barbizon. His first real success came at the Salon of 1831, where his *Massacre of the Druids under the Emperor Claudius* won a Second Class medal. As his reputation began to grow in the early 1830s, he set forth upon another Italian sojourn (1834-1835). In 1843, he was sent to make drawings of historic sites in Greece, which he then engraved for publication in *Vue des sites les plus célèbres de la Grèce antique* (1845).

At first very precise with subtle and delicate lighting, the artist's style relaxed and became more spontaneous in the 1850s, and by the 1860s it had developed a reliance upon decoration, cool colors, and simplification of forms. Around 1859, he assumed the name Caruelle d'Aligny, and in 1861 was named Director of the Ecole des Beaux-Arts de Lyon, a post in which he remained until his death in 1871.

Bibliography: New York, Colnaghi, 1990; Washington, New York, Minneapolis, Malibu, 1981-1982.

Jacques, Barthelémy dit Adolphe, APPIAN

Lyon, 1818–Lyon, 1898

Originally a cornet player and fabric designer, Appian turned to landscape painting full time around 1852, after meeting such Parisian painters as Corot, Daubigny and Français, who had come to work with Ravier in the region around Crémieu. He exhibited in Paris for the first time in 1853, and was admitted to the Universal Exposition in 1855. Appian received his initial training in art from Jean-Michel Grobon at the Ecole des Beaux-Arts de Lyon, 1833-1836.

Appian experienced tremendous commercial success starting with the work he did from 1862 in the Bugey region, which artists favored for its mountainous, Italianate landscape. He was further inspired by the numerous trips he made to the Mediterranean coast after 1870.

Great productivity and a high level of technical quality assured Appian success in the French provinces and beyond; but in Paris, his name tended to disappear on the long list of landscapists. Furthermore, in Lyon, his critical reputation suffered in comparison to that of his rival, Paul Bertnay. His fame barely outlasted his lifetime, but there has been a resurgence of appreciation for his gift for solid design and varied and poetic effects.

Bibliography: Lausanne, 1989; Lyon, 1984.

François ARTAUD

Avignon, 1767–Orange, 1838

Artaud came to Lyon about 1787 to train as a silk designer. At the Ecole de Dessin in Lyon he studied with Jean Gonichon (active 1775-1793) in Flower Painting and Ornamentation. He enjoyed sketching in the countryside with his fellow student, Jean-Michel Grobon, and on one sketching expedition his discovery of some Roman pottery shards ignited a lasting passion for archaeology.

Though indifferent toward a career as a silk designer, Artaud entered the workshop of the painter, designer, and silk weaver Pierre Toussaint Dechazelle (1752-1833). He participated with Dechazelle in the defense of Lyon against the revolutionary armies in the Siege of 1793, and later trained with the miniaturist Daniel Saint until about 1803, when he set out for Herculaneum and Pompeii. Upon returning to Lyon, he abandoned silk design forever, and began designing architectural ornamentation in the neoclassical taste.

In 1806, the Roman *Circus Games* mosaic was uncovered in Lyon. When Artaud's scholarly dissertation on this pavement came to the mayor's attention, he was named Inspector of the city's new Conservatory of Arts and Antiquities, which gave him authority over the museum recently installed in the Palais Saint-Pierre. In 1812, as a result of an administrative reorganization, Artaud became sole director of the museum. His lengthy tenure produced outstanding museological and archaeological accomplishments, including the publication of the first printed catalogue, the creation of the Salon des Fleurs, and the gathering of all ancient inscriptions and lapidary monuments from excavations in Lyon under the arcades of the Palais Saint-Pierre.

In 1810, while still in Lyon, Artaud was handed responsibility for cataloguing and installing the archaeological collections of the Musée Calvet, Avignon. In the bitter dispute between Pierre Révoil and Fleury Richard, 1821-1823, he sided with Révoil, but appears to have smoothed relations with Richard by 1828, the date of an ink wash drawing of Artaud by Richard. As a dedicated Royalist, Artaud resigned the directorship of the Musée des Beaux-Arts de Lyon in 1830, and departed for Orange, where he organized the Museum of Antiquities. He died in Orange eight years later, leaving a small number of portrait drawings, topographical views, miniatures, and paintings.

Bibliography: Lyon, 1989-1990.

Jean-François BELLAY

Chalamont, 1789–Rome, 1858

An engraver and lithographer as well as painter, Bellay received his first art instruction from the Lyon landscapist and genre painter Jean-Michel Grobon before entering the Ecole des Beaux-Arts de Lyon to study under Pierre-Henri Révoil. He won first prize at the Ecole in 1810 and made his début at the Paris Salon in 1817. Until 1833, he continued exhibiting landscapes and Dutch-influenced genre scenes, which placed him in a direct line of succession from Grobon and Grobon's mentor, the distinguished Lyonnais painter and etcher, Jean-Jacques de Boissieu (1736-1810).

Eventually, financial difficulties forced Bellay to turn out watercolor copies of Old Masters, and about the last part of his life little is known. It seems that he retired to Italy and died in Rome in 1858.

Bibliography: Benezit, 1966; Lyon, 1987.

Antoine BERJON

Lyon, 1754–Lyon, 1843

Antoine Berjon, the most eminent of all Lyon flower painters, received his initial training under the Lyonnais sculptor Antoine Perrache, a professor at the Ecole de Dessin de Lyon from 1756 to 1779. Berjon is believed to have remained at

the Ecole de Dessin until he was thirty, while also working as a silk designer.

When the Siege of Lyon in 1793 caused his factory to close, Berjon left his native city along with many other artists; he was settled by 1794 in Paris, where he allied himself with Jean-Baptiste Augustin (1759-1832), a miniaturist. He had already made his Salon début in 1791. In all, he exhibited in six Paris Salons before returning to Lyon in 1810 to succeed the flower painter Jean-François Bony (c.1760-1825) as professor of flower design at the Ecole des Beaux-Arts de Lyon. Berjon had already provided designs for Bony's raised-velvet factory.

Berjon occupied his professorial chair for thirteen years, during which time he taught about 200 students. Though much-loved, he was temperamental, a quality some biographers have attributed to childhood conflict with his father, who opposed his artistic career. In 1823 the municipality ordered Berjon to vacate his post. It appears that he had become involved in, or at least was a victim of, the vicious struggle between Pierre Révoil and Fleury Richard.

After his dismissal, Berjon retreated into near seclusion, painted rarely and took few students. His livelihood derived from a municipal pension garnished from the salary of his successor. Although he had exhibited at the Paris Salon of 1817 (where his entries were criticised, not unjustifiably, for compositional awkwardness) and again at the Salon of 1819, he sent no further entries until 1842, the year before he died. Shortly after his death, however, the City of Lyon paid him hommage with a retrospective exhibition.

Bibliography: Benezit, 1966; Chaudonneret, 1980; Hardouin-Fugier and Grafe, 1989; Lausanne, 1989.

Paul BOREL
Lyon, 1828–Lyon, 1913

The greatest formative influences on Paul Borel were the Dominican fathers at the Institution d'Oullins, where he was taken in after the premature death of his parents and where he absorbed the "esthetic theology" of Lammenais, as propagated by the Abbot Lacuria.

Under this creed, discovering and expressing the beauty of the universe through the medium of the arts was equated with the search for God. Borel, in fact, vacillated for a long time between an ecclesiastical vocation and an artistic career, choosing the latter only because he wished to marry.

After training under Louis Janmot, Borel made his début at the Lyon Salon of 1851-1852. During the next dozen years, he exhibited various

portraits and religious canvases including *Christ Dismissing Judas* at the Paris Salon of 1857. From 1863 on, however, he concentrated exclusively on church commissions. In the course of decorating the dome and ambulatory of the church at Ars, he formed a lasting friendship with the Lyonnais architect, Pierre Bossan (1814-1888). When Bossan began a new chapel for the Institution d'Oullins, Borel was chosen to decorate the interior surfaces. This work, which he undertook without recompense, occupied him during the 1880s and much of the 1890s. It was his most successful project, and in 1906, toward the end of his life, he made a dozen etchings that faithfully reproduced the Oullins compositions.

Around 1898, Borel painted scenes from the life of St. Augustine for the Augustine Chapel at Versailles, and in 1903-1905 he decorated the choir of St. Paul's Church in Lyon. In all of his many ecclesiastical commissions, Borel showed himself to be an artist animated by religious feeling, always concerned with the inner life of his subjects.

Bibliography: Benezit, 1966; Lyon, 1981.

Paul-Marc-Joseph CHENAVARD
Lyon, 1807–Paris, 1895

Born into a republican, middle-class milieu, educated at a secular boarding school and at the Ecole des Beaux-Arts de Lyon, Chenavard was sent to Paris at age seventeen by his mother and stepfather (whose small fortune eventually would provide his support) to study under Louis Hersent (1777-1860). He left Hersent's studio after only a brief stay to join that of Ingres. Failing to appreciate his young pupil's gift for language, Ingres soon advised him to travel and study in Italy. This he did in 1827, but not before meeting and forming a great admiration for Delacroix. (This friendship lasted until the older man's death in 1863, yet it appears to have had no influence upon Chenavard's style.)

Chenavard's first Italian sojourn lasted a year and a half, during which time he met and formed a lifelong friendship with Corot and busily copied masterpieces in Florence, Milan, Venice, and Rome. Once back in Paris, he began shaping the positivist view of history and utopian social philosophy that he would advocate the rest of his long life. A contest on the topic, *Mirabeau apostrophant le Marquis de Dreux-Brézé*, furnished the opportunity for the politically-engaged artistic statement that Chenavard wished to make. An oil sketch on this subject constituted his debut at the Paris Salon of 1833. Shortly

afterward, Chenavard departed for a second Roman sojourn even more formative than the first.

In Rome, he met the German Nazarene painters Johann Frederick Overbeck (1789-1869) and Peter Joseph Cornelius (1783-1867) and was attracted to their coldly philosophical approach to art. They introduced him to the great philosopher Hegel, and from then on Chenavard's deliberately impersonal style seemed to reflect veneration of German philosophic art, on the one hand, and Michelangelo, on the other.

At some time in the 1840s, Chenavard began developing a scheme to decorate the interior of the Panthéon with a series of immense grisaille paintings summarizing the history of Mankind: "the march of human destiny through trial and tribulation, through alternating ruin and renaissance." The climax of the scheme was to be a giant mosaic under the Panthéon dome bearing the title "La Palingénésie Sociale (Social Rebirth)," a term that would be associated with Chenavard ever afterward. The Revolution of 1848 provided the opportunity to secure the vast commission, which, true to his utopian principles, Chenavard agreed to undertake for a derisory sum. Yet, the nomination of Chenavard was greeted with hostility from the start, and finally, at the end of 1851, Catholic opposition succeeded in convincing Napoléon III to restore the Panthéon to the Church. Chenavard's commission was abruptly cancelled. Some of the cartoons were exhibited at the Salon of 1853, and a number were shown at the Exposition Universelle of 1855. A further showing took place in 1876 in Lyon, where most of Chenavard's surviving work is preserved today, but otherwise the project was forgotten.

It may be that the artist was more skilled at expressing his ideals in conversation than on canvas. A popular member of salons and intellectual circles, his brilliant conversation won him many friends among the most influential artists and writers of his day. In the four decades that remained to him after the collapse of his dream, Chenavard's artistic output was limited to a few portraits and one last, gigantic canvas, *The Divine Tragedy*, executed in Rome for the Luxembourg Palace and exhibited at the 1869 Salon. This highly complex composition, intended as a summation of the artist's views on religion, was correctly, though unofficially, interpreted to represent the downfall of all cults. Seen thus, the painting is consistent with Chenavard's long-cherished vision of man as complete and whole unto himself, freed of all superstition and false doctrine.

Bibliography: Grunewald, 1977; Sloane, 1962; Sloane, 1973.

Michel DUMAS

Lyon, 1812–Lyon, 1885

Michel Dumas, son of a tinsmith, began his instruction at the Ecole des Beaux-Arts de Lyon at age fifteen, absorbing the principles of drawing and painting under Grobon. Later, as a student of Claude Bonnefond (1796-1860) he earned an honorable mention and a gold medal in drawing. In 1835, he succeeded in his second attempt to gain admission to the Ecole des Beaux-Arts in Paris.

In Paris, Dumas worked assiduously in the studio of Ingres for a year and won modest prizes at the Ecole. From 1834-1837, he assisted Victor Orsel and Alphonse Périn at the church of Notre-Dame de Lorette in Paris. His first Paris Salon entry, *Abraham and Agar* (1837), won critical praise and was purchased by a private collector. Though not a Prix de Rome winner, Dumas moved to Rome in 1838 to be near Ingres, and remained there fourteen years. He may have met the German painters — Koch, Overbeck, et.al. — in Rome at that time. In 1847, the painter Bodinier arranged the financing for a major composition, *Saints Peter and Paul Separating Before their Martyrdom* (Paris, Musée du Louvre), which Dumas completed in Rome to great critical acclaim. The artist was decorated by Pope Pius IX, and the painting was purchased by the state in 1854.

Dumas returned to Paris in 1852, and on the recommendation of Ingres received a commission from the government to depict the heroism of the curate of Oussoy-en-Gâtinais in the cholera epidemic of 1854. This work, *Le dévouement de l'Abbé Boulloy,* was completed in 1857. Dumas' 1859 commission for the church of Saint-Louis d'Antin (*Pilgrims of Emmaus*) was followed in 1866 by a larger commission to paint four scenes from the life of Saint Denis in the church at Clignancourt.

As early as 1850, Dumas had wished to return to Lyon as director of the Ecole des Beaux-Arts. He was unsuccessful in obtaining the appointment until 1878, but from that year until his death seven years later, he carried the torch for *Ingrisme* as director of the academy where he had received his early training.

Bibliography: Benezit, 1966; Lyon, 1981; New York, W.M. Brady & Co. Inc., 1990.

René-Auguste FLANDRIN

Lyon, 1804–Lyon, 1842

Eldest of a family of seven that included Hippolyte and Paul, Auguste entered the Ecole des Beaux-Arts de Lyon in 1817. He studied there under Alexis Grognard (1752-1840) and Fleury Richard and won prizes in 1820, 1822, and 1823. He also gave his younger brothers Hippolyte and Paul their first drawing lessons.

Auguste's early career benefited from numerous commissions from Lyon publishers for the design of lithographic prints. Meanwhile, Hippolyte and Paul had moved on to Paris and entered Ingres' studio in 1829. By 1831, Hippolyte had begun showing his master some of Auguste's landscape drawings, with the result that in January, 1833, Auguste himself arrived in Paris, where he divided his time between working under Ingres, studying in the Louvre, and supporting himself by giving drawing lessons to the Borghese family.

With Ingres' departure for Rome in 1834 and his own failure, after two attempts, to win the Prix de Rome, Auguste returned to Lyon to paint portraits and carefully-detailed genre scenes, all the while receiving entreaties from his younger brothers and from Ingres to join them at the Villa Medici in Rome, which he finally did in 1838. More than Rome, however, it was Naples that seduced him, as can be seen in two canvases (private collection) painted in the Italianate manner of Léopold-Louis Robert (1794-1835).

Upon his return from Italy, Auguste opened the studio that Louis Lamothe, Hippolyte Flandrin's future collaborator, soon joined. He began showing in the Salon de Lyon in 1838, and eventually exhibited a total of eight paintings in the Paris Salons of 1840, 1841, and 1842. His *Savanarola Preaching in San Miniato* (Lyon, Musée des Beaux-Arts) won a gold medal at the Paris Salon of 1840. An active practice as portraitist centered on a clientèle from the worlds of medicine and music; his best known portrait, *Lady in Green* (1835, Lyon, Musée des Beaux-Arts) successfully melds straightforward observation with Ingresque compositional harmony and attention to detail.

Auguste caught a chill and died in the summer of 1842, before his considerable potential could be fully realized. His brother Hippolyte, who put the final touches on Auguste's last work, *Le Père Dominique de Colonia, jésuite Lyonnais du XVIIIᵉ siècle* (Lyon, Musée des Beaux-Arts), freely admitted that his elder brother might not have been the least endowed of the Flandrin brothers.

Bibliography: Foucart (J.), 1987; Paris, Lyon, 1984-1985.

Hippolyte FLANDRIN

Lyon, 1809–Rome, 1864

Although descended from an old Lyonnais family, the Flandrin brothers spent their childhood in extremely modest circumstances. Flandrin *père* had an affinity for the arts and painted miniatures. Hippolyte received his first training from the sculptor Jean-François Legendre-Héral (1796-1851) and the landscapist and animal painter Antoine-Jean Duclaux (1783-1868). At the Ecole des Beaux-Arts de Lyon, 1827-28, he won top honors before making his way to Paris on foot accompanied by his younger brother, Paul, in 1829.

In Paris, Hippolyte and Paul enrolled in the Ecole des Beaux-Arts and joined the studio of Ingres. At first Ingres' instruction was a shock to Hippolyte, but soon the young man became his master's devoted disciple and friend. In 1832, he won the Prix de Rome with his *Theseus Recognized by his Father* (Paris, Ecole des Beaux-Arts), which he executed that year despite a life-and-death struggle with cholera.

In Rome 1833-1838 as pensioner at the Villa Medici, Hippolyte assiduously copied the Old Masters, notably Giotto, Lorenzetti, and Raphael, and upon Ingres' arrival in 1835 as director of the French Academy, he resumed a close association with his mentor. A sensitive nature combined with deep religious faith inclined him more and more toward religious painting. While in Rome, he executed a number of excellent portraits in pencil and in oil, but it was the religious paintings he sent back each year that attracted favorable critical attention and won him gold medals at the Paris Salons of 1837 and 1839. He was deemed so suited to mural painting that upon his return to France in 1838, he was awarded the succession of ecclesiastical commissions that form the basis of his reputation as one of the great religious painters of the nineteenth century. These he accomplished with the help of his brother, Paul, and several talented students, including Louis Lamothe.

Hippolyte's commissions were: the Chapel of St. John in Saint-Séverin (1839-41); the sanctuary of Saint-Germain-des-Prés (1842-46); the Chapel of the Apostles, Saint-Germain-des-Prés (1846-48); the Church of St. Paul in Nîmes (1846-49); the hundred-meter frieze in the nave of Saint-Vincent-de-Paul (1848-53), where the majesterial procession of saintly men and women became known as the *Panathanées Chrétiennes;* Saint-Martin d'Ainay in Lyon (1855); and, climactically, the nave of Saint-Germain-des-Prés (1856-63). He accomplished these impressive commissions at no apparent sacrifice of inspira-

tion for portrait painting. His *Portrait of Napoléon III* (Versailles, Musée National du Château), shown in the Paris Salon of 1863, is among two score portraits from the years 1830-63 that attest to undiminishing skill in this genre. Hippolyte was named Officer of the Legion of Honor and received as a Member of the Académie des Beaux-Arts in 1853. Ten years later, exhausted and sick, he departed for Rome with his family for a period of rest. (In 1843, he had married Aimée Ancelot, a second cousin of Ingres' close friend, Edouard Gatteaux.) He died in Rome in March, 1864.

Bibliography: Benezit, 1966; Foucart, (J.), 1987; Paris, Lyon, 1984-1985. Washington, New York, Minneapolis, Malibu, 1981-1982.

Paul FLANDRIN
Lyon, 1811–Paris, 1902

The first five decades of Paul Flandrin's life were lived in the shadow of his brother, Hippolyte, whose disciple and companion he remained until the latter's untimely death in 1864. Unlike Hippolyte, who won the Prix de Rome in 1832, Paul failed in his attempt to win that coveted award the next year. Nevertheless, he joined Hippolyte in Rome in 1834, working and travelling at his older brother's side, exposing himself to the same influences — Italian primitives and, above all, Raphael — that affected Hippolyte so profoundly. Yet, it was the Italian landscape that inspired him most and cemented his principal vocation as landscape painter.

In 1838, Paul returned to France with his brothers and joined Hippolyte in a studio in Paris. In addition to assisting with all of Hippolyte's ecclesiastical commissions, he painted many landscapes of historical, often Biblical, inspiration, and from 1839, was a frequent presence in the annual Paris Salons. Although Baudelaire lambasted his landscapes in the Salon of 1845, the State continued to acquire his work. Moreover, he remained an active portraitist in oil and (to an extent greater than Hippolyte) in pencil. He also manifested a certain talent for caricature; Ingres owned an album of his witty sketches.

Paul's visits to the coast of Normandy in the 1850s, to Fontainebleau in the 1860s, and to Pornic and the rocky coast of Brittany in the 1870s broadened his landscape repertory. In 1852, he had been named Chevalier of the Legion of Honor.

The death of Hippolyte in 1864 shocked him deeply, causing him to suspend his annual practice of submitting entries to the Paris Salons. He resumed the practice in 1865, however, and was a regular exhibitor through the 1880s. Nonetheless, by the mid-1870s, he had become dependent upon income from a drawing school for young ladies and from infrequent commissions secured through loyal friends like Philippe de Chennevières. When he died in 1902 at age ninety-one, his reputation was frozen in the art of an earlier time.

Bibliography: Benezit, 1966; Foucart, (J.), 1987; Paris, Lyon, 1984-1985.

Jean-Michel GROBON
Lyon, 1770–Lyon, 1853

Grobon was born into a typically Lyonnais milieu. His father, director of a successful ribbon and passemanterie business, enrolled him in the Ecole Central de Dessin in Lyon at fourteen, expecting that training in fabric design would serve the boy well when he succeeded to the family business.

In Grognard's class, where Grobon was placed, he won no better than second-class honors. After his father's premature death in 1786, however, he enrolled with Jean Gonichon in flower painting and began taking private lessons in Gonichon's studio. By the time he was seventeen, he also was receiving instruction in sculpture from Clément Jayet (1731-1804), another professor at the Ecole, but here again, he only took second prize. In the spring of 1789, he departed for Paris and entered the Ecole des Beaux-Arts, remaining there but six weeks. During that time, he renewed contact with Pierre-Paul Prud'hon, whom he had met in Gonichon's household, and began his earliest surviving painting, *Head of an Old Man* (Lyon, Musée des Beaux-Arts), completed in Lyon in 1795.

Two of the three paintings that comprised Grobon's 1796 début at the Paris Salon, a *Self Portrait* and *Woods at Rochecardon,* were praised for their freshness and sensibility. The third, listed as *Painting in the Flemish Style,* in fact may have been *A Young Art Student Preparing His Master's Colors* (Lyon, Musée des Beaux-Arts), signed and dated 1794. According to Fleury Richard, this work even caught the eye of Jacques-Louis David. It reveals Grobon's debt to seventeenth-century Dutch genre painting, for which he had developed an appreciation through the etchings of Jean-Jacques de Boissieu. The imprint of de Boissieu is equally evident in his 1800 Salon entry, *The Little Knife Grinder* (Lyon, Musée des Beaux-Arts), and in the six prints that he made in the years 1795-1812, all of which are based on his own painted compositions.

After 1800, Grobon's work became somewhat repetitious. He exhibited at the Paris Salon of 1806 and, for the last time, at the Salon of 1812. He associated himself closely with de Boissieu throughout the decade preceding the distinguished printmaker's death in 1810. In 1813, he was named to a new chair of principles of painting, thereby joining Grognard, Berjon and Révoil on the faculty of Ecole des Beaux-Arts de Lyon. His most remarkable student was François Bellay.

In 1840, Grobon was forced into retirement and retreated into solitude. Possessed of a fortune, not only had he no need to sell paintings, he could repurchase some of his earliest work. In his final years, he continued painting landscape views around Lyon — painting, as he dressed, in a distinctly old-fashioned manner. When he died in 1853, one obituary remarked that outside Lyon everyone thought this bachelor artist had died long ago.

Bibliography: Benezit, 1966; Grafe, 1983; Lyon, 1984; Lyon, 1989-1990; Baltimore, Boston, Minneapolis, 1984-1985.

Louis JANMOT
Lyon, 1814–Lyon, 1892

Born into a family with deep roots in textile manufacture and commerce, Louis Janmot received an excellent classical education at the Collège Royal. There he formed a strong allegiance to the Abbot Noirot — whose course in philosophy and esthetics he undoubtedly followed — but it is unclear where he first learned to draw.

Janmot enrolled in the Ecole des Beaux-Arts de Lyon in October 1831, just six months after the painter and lithographer Claude Bonnefond (1796-1860) had succeeded to the directorship vacated by Pierre Révoil. Almost immediately, he took advantage of Bonnefond's reforms, which allowed especially qualified students to bypass elementary classes. In 1832, he studied painting under Bonnefond himself and in that same year won the Laurier d'Or. Instead of proceeding immediately to Paris as laureates customarily did, however, he lingered in Lyon a year longer, only arriving in the capital in November 1833.

In Paris, Janmot joined the Lyonnais colony in the rue de Buci, where Ingres was "god." After studying briefly under Victor Orsel, who by that time was working on his large commission at Notre-Dame de Lorette, he progressed to the studio of Ingres. Despite two failed attempts to secure a place at the Ecole des Beaux-Arts in Paris, Janmot avowed to become a religious painter.

In Rome for fourteen months beginning late

in 1835, Janmot formed part of the circle around Ingres and the Flandrins. Although there is no record that he met the Nazarene painters, through Hippolyte Flandrin he could have known their art. In December 1836, he arrived back in Lyon. For two years, he shuttled back and forth between Lyon and Paris, but the death of his mother at the end of 1838 forced him, as the only son of an aging father, to settle permanently in Lyon. Determined to achieve success in Paris, however, he submitted two paintings to the Salon of 1840. One, *The Resurrection of the Son of the Widow of Naïm,* was accepted but ignored. *The Entombment of Christ,* exhibited in the Salon of 1841, fared somewhat better.

Throughout this period, Janmot was exhibiting in the Lyon Salons and accepting mural and portrait commissions. Simultaneously, he worked on his ambitious series of paintings and verses, the *Poème de l'Ame,* a project conceived as early as 1835. The eighteen paintings of the *Poème de l'Ame* were exhibited at the Exposition Universelle of 1855, thanks to the support of Delacroix.

Although in 1861 Janmot accepted a professorship at the Ecole des Beaux-Arts de Lyon, he resigned one year later in order to satisfy an ambition to execute a major commission in Paris. The triumph was short-lived, however. Janmot's sketches for the interior of the church of Saint-Augustin were deemed incompatible with the proposals of Bouguereau, with whom he shared the commission, and responsibility for the entire project was transferred to the more popular, younger artist. Janmot then received a far less important commission at Saint-Etienne-du-Mont. Although he took considerable pains over this work, he was a deeply disappointed and depressed man, and the project was not a success. In 1870, after his wife had died in childbirth, he left Paris.

The *Poème de l'Ame* was exhibited in Paris in 1876, accompanied by sixteen new drawings, and in 1879, Janmot executed a commission for the interior of a Franciscan chapel. An idealist in an age of Realism, he seemed more and more out of place, although he continued to draw and paint all the rest of his life. He resettled in Lyon in 1882, remarried in 1885, and died in 1892.

Bibliography: Benezit, 1966; Hardouin-Fugier, 1981; Lausanne, 1989; Lyon, 1981.

Louis LAMOTHE
Lyon, 1822–Paris, 1869

Lamothe is better known as an apprentice and teacher than for his own artistic accomplishment. He was first a student in Lyon of Auguste Flandrin, who after studying with Ingres 1833-34 had opened a studio with the avowed purpose of spreading the influence of Ingres in the city of Grognard and Richard. Subsequently, for almost twenty years (1840-1859), he was chief assistant to Auguste's younger brother, Hippolyte, in nearly all of Hippolyte's great decorative commissions. Then and later, Lamothe had several gifted students of his own, especially James Tissot and Edgar Degas; his influence may be seen in their early work.

Evidence of Lamothe's collaboration with Hippolyte Flandrin survives at the Château de Dampierre and at the churches of Saint Paul in Nîmes and Saint-Séverin, Saint-Vincent-de-Paul and Saint-Germain-des-Prés in Paris. His likeness can be seen in Nîmes and in Saint-Séverin and Saint-Vincent-de-Paul, where he served as model as well as assistant.

Lamothe exhibited in the Paris Salon between 1848 and 1868, receiving a third-class medal in 1863. He executed religious commissions for churches in Marseille (Chapelle Pastrée, Sainte-Clotilde), Lyon (Saint-Gaudens, Saint-Irénée) and Paris (Chapelle Saint-François Xavier).

Bibliography: Benezit, 1966; Lyon, 1989.

Laurent-Hippolyte LEYMARIE
Lyon, 1809–Saint-Rambert-en-Bugey, 1844

The gifted, well-educated son of a rich merchant, Leymarie was an artist whose inspiration suffered from a tendancy toward superficiality. Having won prizes in drawing at the Collège Royal in 1824 and 1825, he entered the Ecole des Beaux-Arts in 1826 and progressed satisfactorily until 1828, when he was expelled for drawing caricatures of one of his professors.

If Leymarie worked with Berjon, it could only have been as a private student after the flower painter's dismissal from the Ecole. It is known, however, that by 1830, he had become a student of Antoine Guindrand (1801-1843). He exhibited in the Lyon Salons of 1831, 1833, and 1836-1843. Weak health forced him to retire in 1834 to the relative quiet of Saint-Rambert-en-Bugey, where he was sighted rather too often in cafés. In 1836, he began to furnish texts and engravings for a folio, *Lyon ancien et moderne;* later, as an enthusiastic archaeologist, he would contribute to the *Revue du Lyonnais.* An article on the church of Saint-Rambert-de-Joux, a building which he helped to restore, earned Leymarie the title of Inspector of Historical Monuments.

Leymarie was one of the first artists of his time to become interested in city views. He made an important series of drawings and engravings of Lyon and monuments in the Department of the Ain. He also was an enthusiastic traveller who left charming pictorial and written accounts of his travels in Belgium, England, Scotland, and the Midi.

Critics took notice of Leymarie's work from the time of his Salon début, usually remarking upon his "marvelous facility." Often, however, his work was characterized as "excessively facile" and his landscapes were criticized for awkward foregrounds or lack of local color as often as they were praised for topographical accuracy and beautiful skies. Leymarie's health continued to deteriorate in Saint-Rambert-en-Bugey, and he died there one month after his thirty-fifth birthday.

Bibliography: Lyon, 1984.

Jean-Louis-Ernest MEISSONIER
Lyon, 1815–Paris, 1891

Although Meissonier was born in Lyon, his father, a druggist, soon installed the family in Paris, where the precocious Ernest quickly manifested a taste for art. Following a quarrel with his father, he began copying Flemish and Dutch paintings in the Louvre. Once he regained his father's support, he entered the studio of Léon Cogniet (1794-1880).

Meissonier's Paris Salon début occurred in 1834 with a genre painting, *The Visit to the Burgomeister,* which was purchased by the Société des Amis des Arts. A year later he met Paul Chenavard, and the two became friends for life. Meissonier sojourned briefly in Italy with a view toward becoming a history painter, but in 1839, Chenavard persuaded the younger artist to cultivate his talent for genre painting.

Meissonier exhibited in the Salons regularly from 1840, obtaining a third-class medal in that year, a second-class medal in 1841, and first-class medals in 1843 and 1848. In 1855, he achieved great fame with *The Brawl,* a painting that won the Grand Medal of Honor at the Salon and was bought by Napoléon III as a gift for Queen Victoria and Prince Albert on the occasion of their official visit to France.

Meissonier turned to military subjects, which he rendered with great veracity, in 1859, when, at the invitation of the emperor he accompanied the Imperial staff to record the Italian Campaign. Napoléon III recruited him again at the outbreak of the Franco-Prussian War in 1870, but Meissonier was soon so discouraged by the French defeats that he left the emperor's service and concentrated on works inspired by the era of Napoléon I. He conceived a grand Napoléonic cycle: *1796, 1807, 1810, 1814,* and *1815.* The three of these epic paintings completed before the artist's death manifest his extraordinary ob-

session with accuracy in every detail, an obsession fueled by the large collection of military paraphernalia that he amassed in his studio at 131 Boulevard Malesherbes, which, thanks to outstanding financial success, was the largest and most opulent studio in Paris. Meissonier's best known students, Alphonse de Neuville (1835-1885), Etienne Prosper Berne-Bellecour (1838-1910), and Edward Detaille (1848-1912) continued his tradition of meticulous military painting.

Bibliography: Benezit, 1966; Johnston, 1982; Milner, 1988; New York, 1977.

André-Jacques-Victor ORSEL
Oullins, 1795–Paris, 1850

A devout man born in a small town near Lyon, Orsel represents one of the main links between the teaching of Pierre Révoil at the Ecole des Beaux-Arts de Lyon and the resurgence of religious painting in mid-nineteenth-century Paris. He entered the Ecole des Beaux-Arts in 1810, won a gold medal for life drawing in 1812, enrolled in Révoil's class in 1814, and, while Révoil was away during the Hundred Days, taught the latter's modelling class. By 1815 he had resolved to dedicate himself to religious painting.

As a result of a recommendation from Révoil, Orsel studied in the studio of Pierre Guérin (1774-1833) in Paris 1817-1822. In response to his mother's death in 1819, he painted a *Prodigal Son,* which was purchased by the Society of the Friends of the Arts in Paris; his next painting, *Abraham and Hagar* (1820), was bought by the Society of the Arts in Lyon. Meanwhile, in Guérin's studio he had formed a close and lasting friendship with Alphonse Périn (1798-1874), who became his collaborator and biographer.

The Charity Hospital of Lyon commissioned a painting from Orsel in 1821. Once completed, this commission, *La Charité et ses pauvres,* was entered into the Paris Salon of 1822 and received a second-class medal. Both Orsel and Périn followed Guérin to Rome in 1822, when he took over the directorship of the Villa Medici.

In Italy, Orsel copied works of the masters, especially Raphael and Giotto. He became friends with Overbeck and other Nazarenes in Rome and was one of the French artists most responsible for transmitting Nazarene ideas to France. After sending several paintings to the Paris Salons from Rome, he began work in 1829 on *Good and Evil,* which he completed in Paris and showed at the 1833 Salon. The great success of this painting, which hangs today in the Musée des Beaux-Arts de Lyon, persuaded the Prefect of the Seine to offer Orsel and Périn commissions

in the church of Notre-Dame de Lorette. With interruptions for a mural in Notre-Dame de Fourvières in Lyon, this major work occupied the last seventeen years of Orsel's life.

Through the use of gold grounds and flat colors, Orsel emphasized the structure supporting his murals. By 1849, when he was stricken with severe rheumatism, Orsel's Paris studio had become a sort of "Lyon in Paris" on account of its attraction to such younger Lyon artists as Michel Dumas and Louis Janmot.

Bibliography: Lyon, 1981; New York, 1980.

Antoine-Claude PONTHUS-CINIER
Lyon, 1812–Lyon, 1885

Sources differ as to the early training of this prolific artist from a Lyon family engaged in manufacture of fabric trims and associated with municipal administration. His name appears on the roster of the Ecole des Beaux-Arts de Lyon for 1829, yet according to one source, he never really entered the school and instead became a student of Paul Delaroche (1797-1856) in Paris. According to others, he studied flower painting at the Ecole and competed on his own for the Grand Prix de Rome.

Either way, in 1840, Ponthus-Cinier's *The Samaritan* won second prize in the oil sketch competition. The next year, he entered the Grand Prix de Rome and by unanimous judgement won second prize with *Adam and Eve Expelled from the Garden of Eden,* a painting preserved at Lyon. Even though no financial reward accompanied this honor, his own means allowed him to sojourn in Italy for two years, 1842-1844. During this stay, he decided to forsake history painting for landscape.

Once he had returned to Lyon, Ponthus-Cinier began a productive career, exhibiting at the Lyon Salons from 1838 until his death in 1885 and at the Paris Salons from 1841 to 1867. He travelled throughout France, developing a particular preference for sites combining architectonic rock formations with bodies of water under luminous skies.

Ponthus-Cinier's unusual productivity was bound to foster jealousy; one critic claimed to perceive in his work "the small change of a talent remorselessly squandered."[1] The artist kept a *liber veritatis* in watercolor of all of his principal works. Watercolor was a technique he favored, and his gray or brown-toned washes garnered a certain following.

1. Quoted in Hardouin Fugier, *Paysagistes Lyonnais,* p. 160.

Bibliography: Lyon, 1984.

Pierre-Cécile PUVIS DE CHAVANNES
Lyon, 1824–Paris, 1898

The son of a prosperous engineer, Puvis de Chavannes was headed for an engineering career when, just before sitting for his examinations at the Ecole Polytechnique in Paris, he fell seriously ill. Forced to convalesce for two years, he developed a commitment to painting while travelling in Italy, where he particularly admired primitive fresco painting.

Once back in Paris, Puvis de Chavannes began formal training with Henri Scheffer (1798-1862), but remained with him less than a year before entering the studio of Delacroix, where he lasted only two weeks before moving on to the studio of Thomas Couture. After barely three months, he left Couture and ended his formal training. In 1848, he returned to Italy with the painter Banderon de Vermeron to study murals. A Salon début in 1850 was followed by rejection every year until 1859. Undaunted, Puvis spent the 1850s perfecting his style.

Puvis resolved to become a mural painter while decorating the dining room of his brother's new house at Le Brouchy (Saône-et-Loire) in 1854-1855. This decision received strong support from Puvis' friend, Théodore Chassériau (1819-1856), who in 1856 introduced him to the Princess Cantacuzène, who soon became his life companion and, forty-one years later, his wife.

In 1859, Puvis' *Return from the Hunt, Fragment of a Mural Painting* was accepted in the Salon. This monumental canvas, composed in a simplified Baroque manner, was a fairly literal repetition of one of the Brouchy murals, and it set the definitive course of Puvis' career. His next major paintings were *War* and *Peace* (1861). When the State acquired *Peace,* he donated *War* to go with it. Two years later, he painted *Work* and *Leisure* as companions to *War* and *Peace,* and, once the State had transferred the latter paintings to the Musée Napoléon (now the Musée de Picardie) in Amiens, he donated these additional two to the museum so that all four could be installed together on the main staircase of the building. Thus was born Puvis' first great public mural. To it he later added *Ave Picardia Nutrix* (1865) and *Ludus Pro Patria* (1880-1882).

The maturation of Puvis' mural painting style in the early 1860s fortunately coincided with burgeoning demand for decoration of new public buildings. Despite Puvis' lack of academicism, commissions poured in: the decorative ensembles for the grand staircase of the new Palais de Longchamp at Marseilles (1867-1869), pan-

els for the new city hall at Poitiers (1870-1875), murals for the Panthéon on subjects from the life of St. Geneviève (1874-1878), decorations for the private mansion of the painter Léon Bonnat (1882), murals for the grand staircase of the new wing of the Musée des Beaux-Arts de Lyon (1883-1886), a hemicycle for the amphitheatre of the Sorbonne (1886-1889), murals for the staircase of the Musée des Beaux-Arts de Rouen (1888-1891), decoration for the Hall of the Zodiac (1887-1892) and the *Escalier d'Honneur* (1892-1894) in the Paris Hôtel de Ville, and, finally, a series of murals for the staircase of the Boston Public Library (1893-96) and a further stage in the decoration of the Panthéon (1897-1898, unfinished at Puvis' death).

Puvis painted his large murals on stretched canvas in an austere hangar in Neuilly. Mostly he worked alone, without the aid of students. While executing mural commissions, he also produced a number of significant easel paintings: *Gambling* (1868); *The Beheading of St. John the Baptist* (1869, Birmingham, Barber Institute of Fine Arts); *The Balloon* (1870, New York, private collection); *The Carrier Pigeon* (1871, New York, private collection); *Hope* (1872, Baltimore, Walters Art Gallery); *Summer* (1873, Chartres, Musée des Beaux-Arts); *The Prodigal Son* (1879, Zurich, Fondation E.G. Buhrle); *Young Ladies by the Seashore* (1879, Paris, Musée du Louvre); *The Poor Fisherman* (1883, Paris, Musée du Louvre); *The Dream* (1883, Paris, Musée du Louvre), *Madame Cantacuzène* (1883, Lyon, Musée des Beaux-Arts); and *La Toilette* (1883, Paris, Musée d'Orsay). Puvis was much praised without as well as within official circles. Though he had few students, his simplified, purified renderings of traditional themes influenced painters as diverse as Toulouse-Lautrec, Seurat, Gauguin, Matisse and Picasso. His emphasis upon bare essentials and the flatness of the painted surface proclaimed a thoroughly modern esthetic.

Bibliography: Benezit, 1966; Johnston, 1982; Milner, 1988; Salinger and Sterling, 1966; Paris, Ottawa, 1976-1977.

François-Auguste RAVIER
Lyon, 1814–Morestel, 1895

Ravier received a religious education in Lyon. After passing his *baccalauréat*, he departed for Paris to prepare for a career in law. While associating in Paris 1835-1840 with other students from Lyon, he participated in the Conférence de Saint-Vincent-de-Paul and joined conservative Catholic demonstrations against the anticlericism of the July Monarchy. Once he had decided

to dedicate his life to painting, he joined the studios of the landscape painters Jules Coignet (1798-1860) and Caruelle d'Aligny. In 1839, the year he first exhibited in Paris, he met Corot at Royat. He first travelled to Rome in 1840 and went back in 1843 and 1845-1846.

After his marriage in 1853, Ravier settled in Crémieu. In 1868, he resettled permanently in Morestel, travelling occasionally to Paris, Lyon, Grenoble, and, once, it is believed, to England (1876). From 1879 until his death in 1895, he was in poor health.

From time to time, well-known landscape painters joined Ravier at Crémieu and Morestel. Paul Flandrin, Daubigny, Harpignies, Corot, and even Courbet were among those who painted at his side, along with such Lyon painters as Appian and Vernay. Ravier also was in frequent contact with Louis Janmot and his students. Michel Dumas took one of Ravier's protégés into his own studio, and it is known that Ravier had contact with Chenavard.

Ravier's early work bears the strong imprint of and is sometimes confused with that of Corot. In the 1850s, when he was settled in Crémieu, his style became freer and more individual. This is particularly evident in the later drawings.

Bibliography: Lyon, 1984.

Pierre-Henri REVOIL
Lyon, 1776–Paris, 1842

With his friend and compatriot Fleury Richard, Pierre Révoil was a leading exponent of the Troubadour style, which applied the techniques of seventeenth-century Dutch genre painting to the portrayal of anecdotes from French medieval and Renaissance history.

Anticipating a career as a silk designer, Révoil began his studies around 1791 with Alexis Grognard and Jean Gonichon. He may also have worked as a painter of allegorical figures in a wallpaper studio. In 1795, on the recommendation of Pierre Toussaint Dechazelle, he was admitted to the studio of Jacques-Louis David in Paris, where apparently he associated chiefly with a small circle consisting of the Comte de Forbin, François-Marius Granet (1774-1849) and his own boyhood companion, Fleury Richard, whose arrival in David's studio had followed his own by just a few months.

During his apprenticeship in Paris, Révoil frequently went with Fleury Richard to the Bibliothèque Nationale to copy medieval illuminations in order to develop a repertory of useful imagery. Later, he actively collected objects from the Middle Ages and the Renaissance. Later still, he would scour the Lyon region for more source

material. He is known, for example, to have based a series of watercolors on tapestries that he discovered locally and had brought to his studio.

Révoil returned to Lyon from David's studio in 1798. In 1802, he presented a large drawing in the fashionable stumping technique, *Allégorie de la Reconstruction de Lyon,* to the Minister of the Interior to commemorate Napoléon's visit to Lyon on June 29, 1800 (10 messidor, an VIII) to lay the cornerstone for the reconstruction of the Place Bellecour. A commission to create a large painting on the same subject soon followed. The resulting work constituted, in 1804, Révoil's Paris Salon début.

On the strength of these allegorical works, Révoil received the Legion of Honor and, by decree of January 25, 1807, the professorship of figure painting at the Ecole des Beaux-Arts de Lyon. Around the same time, he produced a monumental religious canvas, *Honneur au Sacré-coeur de Jésus,* in which his archaeologically precise version of the Troubadour style first emerged. At the Salon of 1810, he exhibited his first fully-developed Troubadour painting, *l'Anneau de l'Empereur Charles Quint.* Not surprisingly, the wedding ring (*anneau*) in the painting was based upon a ring in Révoil's collection.

Although successful and popular as a teacher, Révoil gave up his professorial chair in 1818 in order to travel in Provence. In 1820, however, he found himself in financial need and began a lengthy effort to reclaim his professorship, which had been filled by Fleury Richard. In 1823, with the help of François Artaud and the Comte de Forbin, he prevailed, thus ending both Richard's tenure and a lifelong friendship. By this time, Révoil had become increasingly attached to the Bourbon restoration; in the aftermath of the Revolution of 1830, he refused to pledge loyalty to the new constitution and was obliged to resign his position, this time forever. He continued exhibiting in the Salon until 1841.

Bibliography: Benezit, 1966; Lyon, 1989-1990; New York, 1985.

Fleury François RICHARD
Lyon, 1777–Ecully, 1852

Fleury Richard's training was nearly identical to that of his boyhood friend, Pierre Révoil. He entered the studio of David in 1795, thanks to a recommendation from Dechazelle, after receiving instruction from Alexis Grognard, to whom he was related, at the Ecole de Dessin de Lyon. He returned to Lyon in 1798 with Révoil. Of the two, however, Richard was the actual inventor of the Troubadour style.

After making his Paris Salon début in 1801, Richard met with great success in the 1802 Salon with *Valentina of Milan Mourning the Death of Her Husband (Valentine de Milan pleurant la mort de son époux)*. This painting was immediately seen as creating a new genre — at first called "genre anecdotique," later named "troubadour" — the novelty of which lay in both its subject matter, drawn not from classical antiquity but from the Middle Ages, and in the use of techniques derived from Dutch genre painting to portray that subject matter.

Richard often visited the Musée des Monuments Français in Paris, and his notebooks record the care with which he copied various sculptures he found there. He also accompanied Révoil on forays into the manuscript collections of the Bibliothèque Nationale. Richard paid particular attention to furniture and clothing from the Middle Ages and Renaissance, carefully sketching details for use later in paintings. Gradually, he developed a technique of placing characters and furnishings borrowed from one documentary source against architectural or scenic backdrops accurately drawn from another. For example, he used the grotto of La Balme in the Dauphiné, which he had visited in 1809, as the setting for *The Death of Saint Paul the Hermit* (Salon of 1810), and based one of the figures in the painting upon Zurbáran's *Saint Francis of Assisi*, which is in the Musée des Beaux-Arts de Lyon.

Richard was particularly inspired by events in the lives of François I^{er}, Henri IV, and Saint Louis. In the Salon of 1804, he exhibited *François I^{er} et la Reine de Navarre* (along with his self-portrait in a gothic setting, *The Artist in his Studio*). An uncompleted *Henri IV et Gabrielle d'Estrées* survives at Lyon, and *La déférence de Saint Louis pour sa mère,* exhibited in the Salon of 1808, is preserved in the Musée Napoléon at Arenberg. Another important source for Richard was contemporary historical novels.

Official favor came to Richard early in his career. In 1804, Vivant Denon, Minister of the Arts, praised the originality of his paintings, noting their success at combining the techniques of Flemish painting with the taste and propriety of the French School. The Empress Josephine and her daughter, Queen Hortense, patronized Richard regularly; it was Josephine who had purchased *Valentina of Milan* in 1802.

Richard exhibited in the Salon until 1836. He served five years, 1818-1823, as professor of figure painting at the Ecole des Beaux-Arts de Lyon, before the position was restored to his former friend, Révoil. Political and professional differences aside, the main distinction to be drawn between these rival exponents of the Troubadour style is that while Révoil sublimated emotion to archaeology and historical accuracy, Richard used historical subject matter more selectively (though no less accurately) to evoke the sentimental, melancholic mood of the mythical "Age of Chivalry." Both, in a characteristically Lyonnais manner, borrowed heavily from the techniques of Dutch genre painting.

Bibliography: Benezit, 1966; Lyon, 1989-1990.

Alexandre SEON
Chazelles-sur-Lyon 1855–Paris, 1917

After studying at the Ecole des Beaux-Arts de Lyon, Séon trained with Henri Lehmann (1814-1882), through whom he absorbed the influence of Ingres. Later, he studied with Puvis de Chavannes, whose influence was to be even more profound. Séon worked with Puvis at the Panthéon, at the Musée des Beaux-Arts de Lyon, and at the Sorbonne.

Séon made his début at the Paris Salon of 1879. In 1885, aged twenty-nine, he won the competition for the decoration of the city hall of Courbevoie. His canvases for the Courbevoie murals were exhibited at the Exposition Universelle of 1889, but the commission was to be unique in Séon's career in that efforts to obtain others failed. Three oil sketches painted in a vain attempt to secure the commission for the city hall of Montreuil in 1892 are preserved in the Petit Palais in Paris.

Along with Joséphin Pédadan and the Comte de la Rochefoucauld, Séon founded a Rosicrucian Salon, where he exhibited regularly, 1890-1897.

Bibliography: Benezit, 1966; Durey, 1988; Lausanne, 1989.

François MIEL dit VERNAY
Lyon, 1821–Lyon, 1896

Born out of wedlock and never recognized by his father, Vernay first earned his livelihood as a fabric designer. He began exhibiting landscapes at the Salon of Lyon in 1854-1855, and exhibited in Paris at least four times beginning in 1865.

Vernay affected a bohemian style of life, frequenting the cafés of Lyon and fathering six children before marrying their mother. His life was precarious and he had many detractors, but he attracted a certain critical attention during his lifetime and official recognition posthumously.

Vernay's subjects were mostly bridges, farms, country roads, and other intimate features of landscape near Lyon. Owing to the high priority he assigned to immediate sensation and rapid execution, a superficial resemblance to Impressionism is sometimes perceived in his work. The most original aspect of his art emerged in his drawings, which hint at Expressionism and Fauvism.

Bibliography: Lyon, 1984.

BOOKS AND ARTICLES

Adhémar and Cachin, 1973
J. Adhémar and F. Cachin, *Edgar Degas, gravures et monotypes,* Paris, Arts et Métiers Graphiques, 1973.

Alazard, 1950
J. Alazard, *Ingres et l'ingrisme,* Paris, Albin Michel, 1950.

Amprimoz, 1980
F.-X. Amprimoz, *Dominique Papety, ses maîtres, ses amis (1815-1849),* Ph.D Dissertation, University of Provence, 1980.

Aragon, 1952
L. Aragon, *L'Exemple de Courbet,* Paris, Cercle d'Art, 1952.

Armbruster, 1887
F. Armbruster, *Paul Chenavard et son oeuvre–Le Panthéon.* Reproduction and Publication by F. Armbruster, Lyon, Mougin-Rusand, 1887.

Aubrun, 1983
M.-M. Aubrun, "Plaidoyer pour un comparse (?). Louis Lamothe (1822-1869), chronologie, critique et aspects de son oeuvre original," *Bulletin du Musée Ingres* 51-52, December 1983, pp. 11-51.

Aubrun, 1988
M.-M. Aubrun, *Théodore Caruelle d'Aligny, 1798-1871, Catalogue raisonné de l'oeuvre peint, dessiné, gravé,* Paris, Société des Amis de Caruelle d'Aligny, 1988.

Audin and Vial, 1918-1919
M. Audin and E. Vial, *Dictionnaire des artistes et ouvriers d'art de la France. Lyonnais,* Paris, 1918-1919, 2 vol.

Baudelaire, 1962
Ch. Baudelaire, *Curiosités esthétiques,* Ed. h. Lemaître, 1962.

Bellier and Auvray, 1882
E. Bellier and L. Auvray, *Dictionnaire général des Artistes de l'Ecole française depuis l'origine des arts du dessin jusqu'à nos jours,* Paris, 1882, 3 vol.

Benedite
L. Benedite, *Meissonier,* Paris, Henri Laurens, s.d.

Benezit, 1966
E. Benezit, *Dictionnaire critique et documentaire des peintres, sculpteurs, dessinateurs et graveurs,* Paris, Librarie Gründ, 1966.

Benoist, 1932
L. Benoist, "Joseph Bernard," *Gazette des Beaux-Arts* 7, 1932, pp. 217-228.

Béraldi, 1885-1892
H. Béraldi, *Les graveurs du XIX^e siècle,* Paris, L. Conquet, 1885-1892, 12 vol.

Blanc, 1861
Ch. Blanc, "Le Salon des Arts unis," *Gazette des Beaux-Arts* 9, 1861, pp. 189-192.

Blanc, 1869
Ch. Blanc, "Galerie Delessert," *Gazette des Beaux-Arts* 1, 1869, pp. 219-222.

Blanc, 1870
Ch. Blanc, *Ingres, sa vie et ses oeuvres,* Paris, Renouard, 1870.

Borel, 1985
D. Borel, *Catalogue raisonné des dessins de Puvis de Chavannes au Musée des Beaux-Arts de Lyon,* MA Thesis, University of Lyon II, 1985.

Boucher, 1979
M.-C. Boucher, *Catalogue des dessins et peintures de Puvis de Chavannes–Musée du Petit Palais,* Paris, Musée du Petit Palais, 1979.

Bouret, 1987
J. Bouret, *Degas,* Paris, Aimery-Somogy, 1987.

Boyer d'Agen, 1909
A.-J. Boyer d'Agen, *Ingres d'après une correspondance inédite,* Paris, Daragon, 1909.

Brachlianoff, 1985
See *Exhibition,* Lyon, 1985.

Brachlianoff, 1987
D. Brachlianoff, *Matisse dans les collections du Musée des Beaux-Arts de Lyon,* Lyon, Musée des Beaux-Arts, 1987, pp. 9-27.

Brachlianoff, 1989
D. Brachlianoff, "Le portrait du Vice-Admiral Sir John Edmund Commerell par Albert Besnard," *Bulletin des Musées et Monuments Lyonnais,* 1989-4, pp 24-29.

Brilli, 1988
A. Brilli, *"Il Petit tour," itinerari minori del viaggio in Italia,* Banca Popolare di Milano, 1988.

Brown Price, 1977
A. Brown Price, "l'Allégorie réelle chez Puvis de Chavannes," *Gazette des Beaux-Arts* 89, 1977, pp. 27-40.

Bruyère, 1986
G. Bruyère, *Essai de bibliographie descriptive de François Artaud, suivi de l'inventaire de sa correspondance et d'une chronologie,* MA Thesis, University of Lyon II, 1986.

Bruyère, 1989
G. Bruyère, "Le fonds Richard au Musée des Beaux-Arts de Lyon," *Bulletin des Musées et Monuments Lyonnais,* 1989-3, pp. 4-70.

Bulletin des Musées et Monuments Lyonnais, 1989
"La chronique des musées: acquisitions du musée des Beaux-Arts entre le 1.1.1987 et le 31.12.1988," 1989-1, pp. 29-45.

Bulletin des Musées et Monuments Lyonnais, 1990
"Trois années d'acquisitions, 1990-1/2," p. 68-99.

Bundorf Canizarès, 1968
M. Bundorf Canizarès, *Essai de catalogue des peintures d'Alexandre-Gabriel Decamps,* Ph.D Dissertation, Faculté des Lettres, Paris, 1968.

Cantinelli, 1912
R. Cantinelli, *Vingt-cinq dessins de maîtres conservés à la Bibliothèque de la Ville de Lyon reproduits en fac-similés,* Lyon, Rey, 1912.

Cassou and Leymarie, 1972
J. Cassou and J. Leymarie, *Fernand Léger, dessins et gouaches,* Paris, du Chêne, 1972.

Catalogue sommaire des Musées de la Ville de Lyon, 1887
Lyon, Mougin-Rusand, 1887.

Catalogue sommaire des Musées de la Ville de Lyon, 1897
Lyon, Mougin-Rusand, 1897.

Catton Rich, 1951
D. Catton Rich, *Edgar-Hilaire-Germain Degas,* New York, Harry N. Abrams, 1951.

Chaudonneret, 1980
M.-C. Chaudonneret, *La peinture troubadour. Deux artistes lyonnais, Pierre Révoil et Fleury Richard,* Paris, Arthéna, 1980.

Chaudonneret, 1982
M.-C. Chaudonneret, *L'oeuvre d'Antoine Berjon (1754-1843) au Musée des Beaux-Arts de Lyon,* Lyon, Musée des Beaux-Arts, 1982.

Chaudonneret, 1990
M.-C. Chaudonneret, "Quelques précisions à propos du Fonds d'atelier Fleury Richard au Musée des Beaux-Arts de Lyon," *Bulletin des Musées et Monuments Lyonnais,* 1990-3, p. 18-29.

Chaumelin, 1861
M. Chaumelin, *Decamps, sa vie, son oeuvre, ses imitateurs,* Marseille, Camoin Frères, 1861.

Chesneau, 1861
E. Chesneau, *Le Mouvement moderne en peinture: Decamps,* Paris, de Panckoucke, 1861.

Chomer, 1988
G. Chomer, "Victor Orsel: deux acquisitions du Musée des Beaux-Arts de Lyon," *Bulletin des Musées et Monuments Lyonnais,* 1988-4, pp. 34-43.

Clément, 1872
Ch. Clément, *Prud'hon, sa vie, ses oeuvres, sa correspondance,* Paris, Didier et Cie, 2 Edition, 1872.

Clément, 1886
Ch. Clément, *Les Artistes célèbres, Decamps,* Paris, Rouen, 1886.

Clément, 1973
Ch. Clément, *Géricault. Etude biographique et critique avec catalogue raisonné de l'oeuvre du Maître,* Paris, Léonce Laget, 1973 (1879).

Cohn and Siegfried, 1980
M. Cohn and S. Siegfried, *Works by J.A.D. Ingres in the Collection of the Fogg Art Museum 3,* Fogg Art Museum Handbooks, Cambridge, 1980.

Colombier, 1928
P. du Colombier, *Maîtres de l'Art moderne. Decamps,* Paris, Ed. Rieder, 1928.

Coquiot, 1924
G. Coquiot, *Degas,* Paris, Ollendorff, 1924.

Couëssin, 1985
Ch. de Couëssin, "Portraits d'Ingres: examen de laboratoire," *La Revue du Louvre,* 1985-3, pp. 197-206.

Courthion, 1987
P. Courthion, *Tout l'oeuvre peint de Courbet,* Paris, Flammarion, 1987.

Custodero, 1985
J. Custodero, *Antoine Berjon, (1754-1843) peintre lyonnais,* Ph.D Dissertation, University of Lyon II, 1985.

Dargenty, 1883
Dargenty, *Le Salon national,* "Croquis d'Auguste Rodin pour la porte monumentale du Musée des Arts Décoratifs," *L'Art 35,* May 1st-June 20 1883.

Davies and Gould, 1970
M. Davies and C. Gould, *National Gallery Catalogues. French School,* London, National Gallery, 1970.

Delaborde, 1870
H. Delaborde, *Ingres, sa vie, ses travaux, sa doctrine, d'après les notes manuscrites et les lettres du maître,* Paris, Plon, 1870.

Delacroix, 1981
E. Delacroix, *Journal,* Ed. Joubin, 1981.

Delteil, 1906
L. Delteil, *Le peintre-graveur illustré, I.J.F. Millet . . . ,* Paris, 1906.

Les dessins d'Auguste Rodin, foreword by Octabe Mirbeau, Paris, Boussod, Manzi Joyant et Cie, 1897.

Dorra, 1977
H. Dorra, see *Exhibition,* Frankfurt, 1977.

Dubuisson, 1924
A. Dubuisson, *Les Echos du Bois sacré,* Paris, P.U.F., 1924.

Durafor, 1893
C. Durafor, "Jean-Michel Grobon," *La Revue du Siècle,* 1893, pp. 585-600.

Durey, 1988
Philippe Durey, *The Museum of Fine Arts, Lyons,* Paris, Musées et Monuments de France, 1988.

Eitner, 1971-1972
See *Exhibition,* Los Angeles, Detroit, Philadelphia, 1971-1972.

Elsen and Varnedoe, 1971
A. Elsen and J. Kirk T. Varnedoe, *The Drawings of Rodin,* New York, Washington, Praeger, 1972.

Faunce, 1988
See *Exhibition,* New York, 1988.

Fernier, 1969
R. Fernier (préface R. Huyghe), *Gustave Courbet peintre de l'Art vivant,* Paris, la Bibliothèque des Arts, 1969.

Flandrin, 1902
L. Flandrin, *Hippolyte Flandrin, sa vie et son oeuvre,* Paris, Laurens, 1902.

Focillon, 1927
H. Focillon, *La Peinture au XIXe siècle, le retour à l'Antique, le Romantisme,* Paris, H. Laurens, 1927.

Focillon, 1928
H. Focillon, *La Peinture au XIXe et XXe siècle, du Réalisme à nos jours,* Paris, H. Laurens, 1928.

Forges, 1973
See *Exhibition,* Paris, Louvre, 1973.

Fosca, 1921
F. Fosca, "Ingres et la Vénus à Paphos," *L'Art et les Artistes,* July 1921.

Fosca, 1930
F. Fosca, *Les Albums d'art Druet,* Paris, Librairie de France, 1930.

Foucart (B), 1987
B. Foucart, *Le Renouveau de la peinture religieuse en France (1800-1860),* Paris, Arthéna, 1987.

Foucart (J.), 1984-1985
See *Exhibition,* Paris-Lyon, 1984-1985.

Foucart (J.), 1987
Musée du Louvre. Nouvelles acquisitions du Département des Peintures (1983-1986), Paris, R.M.N., 1987.

Foucart (J.), 1987
J. Foucart, *Les oeuvres des frères Flandrin au Musée des Beaux-Arts de Lyon,* Lyon, Musée des Beaux-Arts, 1987.

Fournel, 1884
V. Fournel, *Les Artistes contemporains,* Paris, 1884.

Francia, 1983
P. de Francia, *Fernand Léger,* New Haven-London, Yale University Press, 1983.

Galichon, 1861
E. Galichon, "Description des dessins de M. Ingres exposés au Salon des Arts Unis," *Gazette des Beaux-Arts 9,* 1861, pp. 343-362.

Gatteaux, 1875
E. Gatteaux, *Collection de 120 dessins, croquis et peintures de M. Ingres . . . ,* Paris, 1875, 2 vol.

Gaubin, 1856
J. Gaubin, "Antoine Berjon, peintre de fleurs," *Revue du Lyonnais 12,* 1856, pp. 159-176.

George, 1936
W. George, "Oeuvres de vieillesse de Degas," *La Renaissance,* January-February 1936.

Georgel and Mandel, 1972
P. Georgel and G. Mandel, *Tout l'oeuvre peint de Daumier,* Paris, Flammarion, 1972.

Germain, 1907
A. Germain, "Les Arrtistes lyonnais," deuxième et troisième articles, *Gazette des Beaux-Arts 38,* 1907, pp. 166-176 and pp. 333-352.

Germain, 1911
A. Germain, *Les Artistes lyonnais des origines jusqu'à nos jours,* Lyon, Lardanchet, 1911.

Germain, 1919
A. Germain, "Un peintre provincial: Antoine Berjon," *La Renaissance de l'Art ancien et moderne,* January 1919, pp. 242-246.

Germain, 1920
A. Germain, "Les dessins du Musée de Lyon," *La Renaissance de l'art français et des industries de luxe 3,* March 1920, pp. 128-136.

Goncourt, 1876
E. de Goncourt, *Catalogue raisonné de l'oeuvre peint, dessiné et gravé de P.P. Prud'hon,* Paris, Rapilly, 1876; reprint Amsterdam: Israël, 1971.

Gordon and Forge, 1988
R. Gordon and A. Forge, *Degas,* New York, Harry N. Abrams, 1988.

Grafe, 1983
E. Grafe, *L'oeuvre de Jean-Michel Grobon (1770-1853) au Musée des Beaux-Arts de Lyon,* Lyon, Musée des Beaux-Arts, 1983.

Grappe, 1936
G. Grappe, *Edgar Degas,* Paris, Plon, 1936.

Gréard, 1897
M.O. Gréard, *Jean-Louis-Ernest Meissonier, ses souvenirs, ses entretiens, précédés d'une étude sur sa vie et son oeuvre,* Paris, Hachette, 1897.

Gros, 1902
A. Gros, *François-Louis Français. Causeries et souvenirs par un de ses élèves,* Paris, Librairies imprimeries réunies, 1902.

Grunchec, 1978
Ph. Grunchec, *Tout l'oeuvre peint de Géricault,* Paris, Flammarion, 1978.

Grunchec, 1979-1980
See *Exhibition,* Rome, 1979-1980.

Grunchec, 1985-1986
See *Exhibition,* New York, San Diego, Houston, 1985-1986.

Grunewald, 1977
M.-A. Grunewald, *Paul Chenavard et la décoration du Panthéon de Paris en 1848,* Lyon, Musée des Beaux-Arts, 1977.

Grunewald, 1985
M.-A. Grunewald, *Paul Chenavard, Lyonnais, 1807-1895. Peintre et philosophe et son environnement social,* Ph.D Dissertation, University of Paris IV, 1985.

Grunewald, 1989
M.-A. Grunewald, "Mirabeau devant Dreux-Brézé, un tableau inconnu de Paul Chenavard," *Bulletin des Musées et Monuments Lyonnais,* 1989-4, pp. 8-16.

Guiffrey, 1924
J. Guiffrey, "L'Oeuvre de Pierre-Paul Prud'hon," *Archives de l'Art Français 13,* 1924.

Guillon-Laffaille
Supplément au catalogue des dessins, gouaches et pastels de Dufy (in print).

Guilloux, 1980
Ph. Guilloux, *Meissonier, trois siècles d'histoire,* Paris, Copernic, 1980.

Hardouin-Fugier, 1975
E. Hardouin-Fugier, "Louis Janmot, élève d'Ingres, ami de Delacroix," *Bulletin du Musée Ingres,* October 1975, pp. 135-146.

Hardouin-Fugier, 1976
E. Hardouin-Fugier, *Louis Janmot. Le Poème de l'âme,* Lyon, Musée des Beaux-Arts, 1976.

Hardouin-Fugier, 1978
E. Hardouin-Fugier, *Le Poème de l'âme par Janmot,* Lyon, Presses Universitaires de Lyon, 1978.

Hardouin-Fugier, 1978
E. Hardouin-Fugier, "Fleurs du mal et Fleur des champs," *Archives de l'Art Français 25,* 1978.

Hardouin-Fugier, 1980
E. Hardouin-Fugier, *Paul Borel à l'Hôpital Saint-Luc,* 1980.

Hardouin-Fugier and Grafe, 1989
E. Hardouin-Fugier and E. Grafe, *French Flower Painters of the Nineteenth Century: A Dictionary,* Peter Mitchell, ed., London, Philip Wilson, 1989.

Hardouin-Fugier, 1984
E. Hardouin-Fugier, "Les Dessins de Paul Borel," *La Revue du Louvre,* 1984/5-6, pp. 385-390.

Haudiquet-Biard, 1983
A. Haudiquet-Biard, *Vie et oeuvre de Jean-Michel Grobon, peintre lyonnais, 1770-1853,* MA Thesis, University of Lyon II, 1983.

Hefting, 1975
V. Hefting, *Jongkind, sa vie, son oeuvre, son époque,* Paris, Arts et Métiers Graphiques, 1975.

Held, 1943
J.S. Held, "Corot in Castel Sant'Elia," *Gazette des Beaux-Arts 23* 1943, pp. 183-186.

Herbert, 1975-1976
See *Exhibition,* Paris, Grand Palais, 1975-1976.

Herbert, 1978
See *Exhibition,* Minneapolis, 1978.

Hertz, 1920
H. Hertz, *Degas,* Paris, Felix Alcan, 1920.

Hoetink, 1968
H.R. Hoetink, *Franse Tekeningen uit de 19e eeuw, catalogus van de verzameling in het Museum Boymans-van-Beuningen,* Rotterdam, 1968.

Honour, 1989
H. Honour, *L'Image du noir dans l'art occidental, de la Révolution américaine à la première guerre mondiale,* Paris, Gallimard, 1989.

Hopmans, 1987
A. Hopmans, "Delacroix's Decorations in the Palais Bourbon Library: a Classic Example of an Unacademic Approach," *Simiolus Netherlands Quarterly for the History of Art 4,* 1987, pp. 240-269.

Hoppe, 1922
R. Hoppe, *Degas och hams arbeten—Nordisk ägo,* Stockholm, P.A. Norstedt and Söner, 1922.

Hourticq, 1928
L. Hourticq, *Ingres, l'oeuvre du maître,* Paris, Hachette, 1928.

Im-Thurn, 1876
E. Im-Thurn, *Scheffer et Decamps,* Nîmes, Imprimerie de Clavel-Ballivet, 1876.

Ives, 1988
C. Ives, "French Prints in the Era of Impressionism and Symbolism," *The Metropolitan Museum of Art Bulletin 44-1,* 1988, pp. 1-56.

Jamot, 1923
P. Jamot, "Ravier en Italie. Ravier et Corot. Ravier et Carpeaux," *La Revue de l'Art Ancien et Moderne 44,* 1923, pp. 321-332.

Jamot, 1924
P. Jamot, *Degas,* Paris, éd. de la Gazette des Beaux-Arts, 1924.

Johnston, 1982
 W. R. Johnston, *The Nineteenth Century Paintings in the Walters Art Gallery,* Baltimore, Walters Art Gallery, 1982.

Joubin, 1936
 A. Joubin, "Modèles de Delacroix," *Gazette des Beaux-Arts 15,* June 1936, pp. 344-360.

Jouvenet, 1985
 O. Jouvenet, *Paul Flandrin,* Ph.D Dissertation, University of Lyon II, 1985.

Judrin, 1981-1982
 See *Exhibition,* Paris, Musée Rodin, 1981-1982.

Judrin, 1984-1987
 C. Judrin, *Musée Rodin, Inventaire des dessins,* Paris, Ed. du Musée Rodin, 1984, IV; 1985, III; 1986, II; 1987, I.

Jullian, 1954
 R. Jullian, *Le Musée de Lyon,* Collections publiques de France, Memoranda, 1954.

Jullien, 1982
 A. et R. Jullien, "Les campagnes de Corot au nord de Rome (1826-1827)," *Gazette des Beaux-Arts* 99, 1982, pp. 179-202.

Jullien, 1984
 A. et R. Jullien, "Corot dans les montagnes de la Sabine," *Gazette des Beaux-Arts* 103, 1984, pp. 179-197.

Kahn and Ecalle, 1957
 E. Kahn and M. Ecalle, "Les Demoiselles des bords de la Seine," *Les Amis de Gustave Courbet* 19, 1957.

Keyser, 1981
 E. de Keyser, *Degas, réalité et métaphore,* Publications d'histoire de l'art et d'archéologie de l'Université catholique de Lorraine, Louvain-La-Neuve, 25, 1981.

Klossowski, 1923
 E. Klossowski, *Honoré Daumier,* Munich, 1923.

Kohn, 1971
 M. Kohn, "François Ravier. A propos des oeuvres exposées au Musée des Beaux-Arts," *Bulletin des Musées et Monuments Lyonnais,* 1971-2, pp. 333-356.

Laffaille, 1972-1977
 M. Laffaille, *Raoul Dufy, catalogue raisonné de l'oeuvre peint,* Geneva, Motte, 1972, I; 1973, II; 1976, III; 1977, IV.

Lafond, 1918-1919
 P. Lafond, *Degas,* Paris, H. Floury, 1918-1919, 2 vol.

Lampert, 1986-1987
 See *Exhibition,* London, 1986-1987.

Lanvin, 1967
 Ch. Lanvin, *H. Flandrin,* Mémoire de l'Ecole du louvre, 1967, 3 vol.

Lapauze, 1903
 H. Lapauze, "Les portraits dessinés de J.-A.-D. Ingres," *Minerva,* Paris, 1903, pp. 294-317.

Lapauze, 1911
 H. Lapauze, *Ingres, sa vie, son oeuvre,* Paris, 1911.

Lassalle, 1987
 Ch. Lassalle, "La Création des musées de Nîmes," *Mémoires de l'Académie de Nîmes,* 45, 1987.

Launay
 L. de Launay, *Eugène Delacroix, reproductions de dessins et croquis,* I, s.d.

Laveissiere
 See *Exhibition,* Paris, Louvre, 1986.

Lecomte, 1905
 G. Lecomte, "Albert Besnard," premier article, *Gazette des Beaux-Arts* 33, 1905, pp. 41-56.

Léger, 1929
 Ch. Léger, *Courbet,* Paris, G. Grès & Cie, 1929.

Lem, 1962
 F.H. Lem, "Le Thème du nègre dans l'oeuvre de Géricault," *L'Arte,* January-June 1962.

Lemoisne, 1912
 P.-A. Lemoisne, *Eugène Lami 1800-1890,* Paris, Goupil & Cie, 1912.

Lemoisne, 1914
 P.-A. Lemoisne, *L'Oeuvre d'Eugène Lami (1800-1890). Essai d'un catalogue raisonné,* Paris, Champion, 1914.

Lemoisne, 1946-1949
 P.-A. Lemoisne, *Degas et son oeuvre,* Paris, Arts et Métiers Graphiques, 1946-1949.

Maison, 1956
 K.E. Maison, "Further Daumier Studies II: Preparatory Drawings for Paintings," *The Burlington Magazine* 639, June 1956, pp. 198-203.

Maison, 1968
 K.E. Maison, *Daumier, Catalogue Raisonné of the Paintings, Watercolours and Drawings,* Paris, Arts et Métiers graphiques, 1968, 2 vol.

Les Maîtres du dessin
 Les dessins français du siècle à l'Exposition Universelle de 1900, Paris, impr. Chaix, 1900.

Manson, 1927
 J.B. Manson, *The Life and Work of Edgar Degas,* London, Studio, 1927.

Mantz, 1862
 P. Mantz, "Decamps," *Gazette des Beaux-Arts* 12, 1862, pp. 98-128.

Mathey, 1955
 J. Mathey, *Ingres, dessins,* Paris, 1955.

Mathieu, 1987
 Caroline Mathieu, *Guide to the Musée d'Orsay,* Paris, Ministère de la Culture et de la Communication, Editions de la Réunion des musées nationaux, 1987.

Matisse, 1943
 H. Matisse, *Dessins, Thèmes et Variations,* Ed. by Martin Fabiani, 1943 (Foreword: "Matisse-in-France" by Aragon.)

Mauclair, 1903
 C. Mauclair, "Artistes contemporains. Edgar Degas," *Revue de l'Art Ancien et Moderne* 14, November 1903, pp. 381-398.

Mauclair, 1929
 C. Mauclair, *Les Musées d'Europe–Lyon (Le Palais Saint-Pierre),* Paris, Nilsson, 1929.

Mauclair, 1929
 C. Mauclair, "Delacroix," *L'Art et les Artistes* 17-94, February 1929, pp. 145-176.

Meier-Graefe, 1924
 J. Meier-Graefe, *Degas,* Munich, R. Piper, 1924.

Merson and Bellier, 1867
 O. Merson and E. Bellier, *Ingres, sa vie et ses oeuvres,* Paris, J. Hetzel, 1867.

Michel, 1983
 See *Exhibition,* Paris, Louvre, 1983.

Milner, 1988
 John Milner, *The Studios of Paris, the Capital of Art in the Late Nineteenth Century,* New Haven and London, Yale University Press, 1988.

Montalant, 1984
D. Montalant, *Alexandre Séon,* MA Thesis, University of Provence Aix-Marseille, 1984.

Moreau, 1869
A. Moreau, *Decamps et son oeuvre,* Paris, Jouaust, 1869.

Moreau-Nélaton, 1921
E. Moreau-Nélaton, *Millet raconté par lui-même,* Paris, H. Laurens, 1921, 3 vol.

Mosby, 1977
D.F. Mosby, *Alexandre-Gabriel Decamps, 1803-1860,* Harvard University, Garland, New York, 1977.

Mosby, 1981
D.F. Mosby, "Decamps' History of Samson"–Series in Context, *Essays in Honor of H.W. Jansen,* New York, 1981.

Le Musée des Beaux-Arts de Lyon, Paris, Musées et Monuments de France, 1988.

Naef, 1962
H. Naef, *La Famille Flandrin,* Etude dactylographiée, Paris, 1962 (Louvre, Cabinet d'art graphique).

Naef, 1977-1980
H. Naef, *Die Bildniszeichnungen von J.-A.-D. Ingres,* Bern, Benteli, 1977-1980, 5 vol.

Naef, 1979
H. Naef, "Zuwachszum Werk von Ingres," *Panthéon,* July-September 1979.

Pansu, 1980
E. Pansu, *Iconographie de l'Age d'Or ou des Quatre âges de l'Humanité,"* Ph.D Dissertation, University of Lyon II, 1980.

Parry Janis, 1967
E. Parry Janis, "The Role of the Monotype in the Working Method of Degas," *The Burlington Magazine* 767, February 1967, pp. 20-81.

Péladan, 1902
J. Péladan, "Les grands méconnus: Alexandre Séon," *La Revue Forézienne illustrée,* 1902.

Périn, 1852, 1878
A. et F. Périn, *Oeuvres diverses de Victor Orsel présentées et mises en lumière par Alphonse et Félix Périn,* Paris, 2 vol., Rapilly, 1852-1878.

Perot, 1969-1970
See *Exhibition,* Rome, 1969-1970.

Perrier, 1855
Ch. Perrier, "Exposition Universelle des Beaux-Arts, la Peinture Française, MM. Horace Vernet et Decamps," *L'Artiste* 15, June 1855.

Picon, 1980
G. Picon, *Jean-Auguste-Dominique Ingres,* Geneva, Skira, 1980.

Prat, 1977
V. Prat, *Alfred Dehodencq 1822-1882,* Mémoire de l'Ecole du Louvre, 1977.

Reff, 1977
Th. Reff, "Degas, a Master among Masters," *The Metropolitan Museum of Art Bulletin* 34-4, 1977, pp. 1-48.

Reff, 1987
Th. Reff, *Degas. The Artist's Mind,* The Belknap Press of Harvard University Press, Cambridge–Massachusetts, London, 1987.

René-Jean, 1931
René-Jean, *Raoul Dufy,* Paris, Grès, 1931.

Riat, 1906
G. Riat, *Les Maîtres de l'art moderne, Gustave Courbet peintre,* Paris, H. Floury, 1906.

Riotor, 1896
L. Riotor, "l'Art et l'Idée. Essai sur Puvis de Chavannes," *L'Artiste,* March-April-May 1896.

Rivière, 1935
G. Rivière, *Mr. Degas, bourgeois de Paris,* Paris, H. Floury, 1935.

Robaut, 1885
A. Robaut et E. Chesneau, *L'Oeuvre complet d'Eugène Delacroix, peintures, dessins, gravures, lithographies,* Paris, Chavaraz, 1885.

Robaut, 1965
A. Robaut, *L'Oeuvre de Corot, catalogue raisonné et illustré,* Paris, Léonce Laget, réed. 1965-1966, 5 vol.

Roberts, 1982
K. Roberts, *Degas,* Oxford, Phaidon, 1982.

Rocher-Jauneau
M. Rocher-Jauneau, "Un dessin de Delacroix au Musée des Beaux-Arts de Lyon," *Bulletin des Musées Lyonnais,* 1953-3, pp. 57-60.

Roger-Marx, 1930
C. Roger-Marx, "La Conquête picturale de l'Afrique du Nord. II. Alfred Dehodencq," *La Revue de l'Art Ancien et Moderne* 42, 1930, pp. 293-300.

Roquebert, 1988
A. Roquebert, *Edgar Degas,* Paris, Cercle d'Art, 1988.

Rosenthal, 1912
L. Rosenthal, "Les salons de 1912," *Gazette des Beaux-Arts* 7, 1912, pp. 450-479.

Rosenthal, 1928
L. Rosenthal, *Florilège des musées du Palais des Arts,* Paris, Albert Morancé, 1928.

Rostrup, 1938
H. Rostrup, "From the Collections of the Ny Carlsberg Glyptothek. Dessins de Rodin," 1938-II, pp. 221-226, Copenhague, Ejnar Munksgaard, 1939.

Rouveyre and Besson, 1943
A. Rouveyre and G. Besson, "Marquet, dessins," *Le Point* 27, December 1943.

Salinger and Sterling, 1966
M. Salinger and C. Sterling, *French Paintings, A Catalogue of the Collection of the Metropolitan Museum of Art,* Vol. II, New York, Metropolitan Museum of Art, 1966.

Schlenoff, 1956
N. Schlenoff, *Ingres, ses sources littéraires,* Paris, P.U.F., 1956.

Shuster, 1978-1979
See *Exhibition,* Hamburg, Frankfurt, 1978-1979.

Séailles, 1910
G. Séailles, *Alfred Dehodencq. L'homme et l'artiste,* Paris, Société de propagation des livres d'art, 1910.

Sérullaz, 1963
See *Exhibition,* Paris, Louvre, 1963.

Sérullaz, 1984
M. Sérullaz, *Musée du Louvre–Cabinet des Dessins–Inventaire général des dessins Ecole Française–Dessins d'Eugène Delacroix,* Paris, RMN, 1984, 2 vol.

Shapiro, 1980
M. Shapiro, "Degas and the Siamese twins of the Café-Concert: the Ambassadeurs and the Alcazar d'été," *Gazette des Beaux-Arts* 95, 1980, pp. 153-164.

Silvestre
T. Silvestre, *Histoire des artistes vivants,* Paris, Blanchard, s.d.

Sloane, 1962
J. C. Sloane, *Paul Marc Joseph Chenavard, Artist of 1848*, Chapel Hill, The University of North Carolina Press, 1962.

Sloane, 1973
J. C. Sloane, *French Painting Between the Past and the Present, Artists, Critics, and Traditions, from 1848 to 1870*, Second Hardcover Printing, Princeton, Princeton University Press, 1973.

Spencer, 1973
Ch. Spencer, *Léon Bakst*, London, Academy Eds., 1973.

Stern Shapiro, 1978
B. Stern Shapiro, *A Note on Two Degas Drawings*, Fenway Court, Isabella Stewart, Gardner Museum, 1978.

Storck, 1889
A. Storck and H. Martin, *Lyon à l'exposition universelle de 1889*, Lyon, Storck, s.d., 2 vol.

Stuffmann, 1978-1979
See *Exhibition*, Hamburg, Frankfurt, 1978-1979.

Sutton, 1986
D. Sutton, *Degas, vie et oeuvre*, Fribourg, Office du Livre, 1986.

Symmons, 1979
S. Symmons, *Daumier*, London, Oreskobooks Ltd, 1979.

Ternois, 1962
D. Ternois, "Lettres inédites d'Ingres à Hippolyte Flandrin," *Bulletin du Musée Ingres* 11, July 1962, pp. 5-26.

Ternois, 1967-1968
See *Exhibition*, Paris, Petit Palais, 1967-1968.

Ternois, 1980
D. Ternois, *Ingres*, Paris, Nathan, 1980.

Ternois and Camesasca, 1971
D. Ternois and E. Camesasca, *Tout l'oeuvre peint d'Ingres*, Paris, Flammarion, 1971.

Thiollier (F.)
F. Thiollier, *Paul Borel peintre et graveur lyonnais, 1828-1913*, Lyon, Lardanchet, s.d.

Thiollier (F.), 1888
F. Thiollier, *Soixante dessins de F. Auguste Ravier, 1814-1895*, 1888, Ed. Saint-Etienne, 1981.

Thiollier (H.), 1987
H. Thiollier, *Peintres lyonnais intimistes, Guiguet, Garraud, Degabriel, J. Bardey amie de Rodin*, Lyon, Musée des Beaux-Arts, 1987.

Toussaint, 1977-1978
See *Exhibition*, Paris, Grand Palais, 1977-1978.

Toussaint, 1986
H. Toussaint, "Ingres et la Fornarina," Actes du Colloque "Ingres et Rome," *Bulletin du Musée Ingres*, September 1986, pp. 63-74.

Vachon, 1895
M. Vachon, *Puvis de Chavannes*, Paris, Braun, Clément Cie, 1895.

Vial, 1905
E. Vial, *Dessins de 30 artistes lyonnais du XIXᵉ*, Lyon, Rey & Cie, 1905.

Vincent, 1956
M. Vincent, "Les oeuvres de Fernand Léger au Musées des Beaux-Arts de Lyon," *Bulletin des Musées Lyonnais*, 1956-3, pp. 49-54.

Vollard, 1914
A. Vollard, *Degas. Quatre-vingt-dix-huit reproductions signées par Degas*, Paris Vollard, 1914.

Warnod, 1981
J. Warnod, *Suzanne Valadon*, Paris, Flammarion, 1981.

Weston, 1975
H. Weston, "Prud'hon: Justice and Vengeance," *The Burlington Magazine* 876, June 1975, pp. 353-363.

EXHIBITION CATALOGUES

Arles, 1949
Dessins et aquarelles du XXᵉ siècle, Arles, Musée Réattu, 1949.

Baden-Baden, Zürich, 1984
Les voyages secrets de Monsieur Courbet, Baden-Baden, Staatliche Kunsthalle, Zürich, Kunsthalle, 1984.

Baltimore, Boston, Minneapolis, 1984-1985
Regency to Empire, French Printmaking 1715-1814, Baltimore, The Baltimore Museum of Art; Boston, Museum of Fine Arts; Minneapolis, The Minneapolis Institute of Arts, 1984-1985.

Bordeaux, 1963
Delacroix, ses maîtres, ses amis, ses élèves, Bordeaux, Musée des Beaux-Arts, 1963.

Bordeaux, 1985
Odilon Redon 1840-1916, Bordeaux, Musée des Beaux-Arts, 1985.

Bordeaux, Paris, 1975-1976
Albert Marquet, Bordeaux, Musée des Beaux-Arts; Paris, Musée de l'Orangerie, 1975-1976.

Boston, Philadelphia, 1984
Edgar Degas. The Painter as Printmaker, Boston, Museum of Fine Arts; Philadelphia Museum of Art, 1984.

Brême, 1969
Dessins français des maîtres du XIXᵉ de Delacroix à Maillol, Brême, Kunsthalle, 1969.

Charleroi, 1962-1963
Géricault, un réaliste romantique, Charleroi, Palais des Beaux-Arts, 1962-1963.

Charleroi, Luxembourg, 1965
Maîtres lyonnais du XIXᵉ siècle, Charleroi, Palais des Beaux-Arts; Luxembourg, Musée d'Histoire et d'Art, 1965.

Cleveland, Brooklyn, St. Louis, Glasgow, 1980-1982
The Realist Tradition: French Painting and Drawing 1830-1900, Cleveland, The Cleveland Museum of Art; Brooklyn, The Brooklyn Museum; St. Louis, The St. Louis Art Museum; Glasgow (Kelvingrove), Glasgow Art Gallery and Museum, 1980-1982.

Florence, 1989
Arti del Medio Evo e del Rinascimento. Omaggio ai Carrand, Florence, Bargello, 1989.

Frankfurt, 1977
Die Nazarener, Frankfurt, Städtische Galerie im Städelschen Kunstinstitut, 1977.

Geneva, 1951
De Watteau à Cézanne, Geneva, Musée d'Art et d'Histoire, 1951.

Gifu, Ibaraki, Hiroshima, 1990
La gloire de Lyon. La peinture lyonnaise du XIXᵉ siècle, Gifu, The Museum of Fine Arts; Ibaraki, Tsukuba Museum of Arts; Hiroshima, The Fukuyama Museum of Art, 1990.

Givors, 1963
Exposition artistique et culturelle, Givors, 1963.

Hamburg, Frankfurt, 1978-1979
Courbet und Deutschland, Hamburg, Kunsthalle; Städtische Galerie im Städelschen Kunstinstitut, Frankfurt, 1978-1979.

Jerusalem, 1981
Jean-Auguste Dominique Ingres, 53 dessins sur le vif du Musée Ingres et du Musée du Louvre, Jerusalem, Musée d'Israël, 1981.

Lausanne Fondation de l'Hermitage, 1989
Chefs-d'oeuvre du Musée de Lyon, Lausanne, Fondation de l'Hermitage, 1989.

Lille, 1866
Exposition des Beaux-Arts, Lille, 1866.

London, 1964
Delacroix, London, Royal Academy of Arts, 1964.

London, 1986-1987
Rodin Sculpture and Drawings, London, Hayward Gallery, 1986-1987.

Los Angeles, Detroit, Philadelphia, 1971-1972
Géricault, Los Angeles County Museum of Art, The Detroit Institute of Arts, Philadelphia Museum of Art, 1971-1972.

Lyon, 1904
Exposition rétrospective des artistes lyonnais peintres et sculpteurs, Lyon, Palais Municipal des Expositions, 1904.

Lyon, 1911
Cent dessins, Lyon, Hôtel de Ville, 1911.

Lyon, 1946
Exposition rétrospective de François Vernay, Lyon, Musée des Beaux-Arts, 1946.

Lyon, 1948
Oeuvres italiennes de Bouguereau, Lyon, Musée des Beaux-Arts, 1948.

Lyon, 1950
Le poème de l'âme de Janmot, Lyon, Musée des Beaux-Arts, 1950.

Lyon, 1952
Bourdelle, Lyon, Musée des Beaux-Arts, 1952.

Lyon, 1954
Courbet, Lyon, Musée des Beaux-Arts, 1954.

Lyon, 1955
Fernand Léger, Lyon, Musée des Beaux-Arts, 1955.

Lyon, 1962
Marquet, Lyon, Musée des Beaux-Arts, 1962.

Lyon, 1981
Les peintres de l'âme–Art lyonnais du XIXᵉ siècle, Lyon, Musée des Beaux-Arts, 1981.

Lyon, 1982
Fleurs de Lyon, Lyon, Musée des Beaux-Arts, 1982.

Lyon, 1984
Paysagistes lyonnais 1800-1900, Lyon, Musée des Beaux-Arts, 1984.

Lyon, 1985
Pierre Combet-Descombes 1885-1966, Lyon, Musée des Beaux-Arts, 1985.

Lyon, 1986
Portraitistes lyonnais 1800-1914, Lyon, Musée des Beaux-Arts, 1986.

Lyon, 1987
Matisse, l'art du livre, Lyon, Musée des Beaux-Arts, 1987.

Lyon, 1987
Quattrocento, Italie 1350-1523, Peintres et sculpteurs du Musée des Beaux-Arts de Lyon, Lyon, Musée des Beaux-Arts, 1987.

Lyon, 1989
De Géricault à Léger, Dessins français des XIXᵉ et XXᵉ siècles dans les collections du Musée des Beaux-Arts de Lyon, Lyon, Musée des Beaux-Arts, 1989.

Lyon, 1989-1990
Les Muses de Messidor, Peintres et sculpteurs lyonnais de la Révolution à l'Empire, Lyon, Musée des Beaux-Arts, 1989-1990.

Lyon, 1990
Une femme, deux fleurs, un lion. Allégories et symboles relatifs à la ville de Lyon depuis sa fondation jusqu'à nos jours, Palais Saint Jean, Lyon, 1990.

Minneapolis, 1978
Millet's Gleaners, The Minneapolis Institute of Arts, 1978.

Montauban, 1980
Ingres et sa postérité jusqu'à Matisse et Picasso, Montauban, Musée Ingres, 1980.

Munich, Paris, 1968
Edouard Vuillard, K.-X. Roussel, Haus der Kunst, Munich, Paris, Musée de l'Orangerie, 1968.

New York, New York Cultural Center, 1977
War à la Mode, Military Pictures by Meissonier, Detaille, de Neuville and Berne-Bellecour from the FORBES Magazine Collection, New York, New York Cultural Center, 1977.

New York, Shepherd Gallery, 1980
Christian Imagery in French Nineteenth Century Art 1789-1906, New York, Shepherd Gallery, 1980.

New York, Colnaghi, 1985
French Drawings, 1760-1880, New York, Colnaghi USA Ltd., 1985.

New York, Brooklyn Museum, 1988
Courbet Reconsidered, New York, The Brooklyn Museum, 1988.

New York, San Diego, Houston, 1985-1986
Master Drawings by Géricault, The Pierpont Morgan Library New York, San Diego Museum of Art, The Museum of Fine Arts, Houston, 1985-1986.

New York, W.M. Brady & Co. Inc., 1990
Master Drawings: 1760-1880, New York, W.M. Brady & Co. Inc., 1990.

New York, Colnaghi, 1990
Claude to Corot, The Development of Landscape Painting in France, New York, Colnaghi USA Ltd., 1990.

New York, Fort Worth, Pittsburgh, Ottawa, 1990-1991
Masterful Studies, Three Centuries of French Drawings from the Prat Collection, New York, National Academy of Design; Fort Worth, Kimbell Art Museum; Pittsburgh, The Frick Art Museum; Ottawa, National Gallery of Canada, 1990-1991.

Orléans, Rennes, Dunkerque, 1979
Théodore Caruelle d'Aligny et ses compagnons, Orléans, Musée des Beaux-Arts; Rennes, Musée des Beaux-Arts; Dunkerque, Musée des Beaux-Arts, 1979.

Paris, 1845
Salon de 1845, Paris, Musée Royal.

Paris, 1855
Exposition universelle de 1855, Paris, 1855.

Paris, Champs-Elysées, 1855
Exposition et vente de 40 tableaux et 4 dessins de l'oeuvre de M. Gustave Courbet, Paris, avenue Montaigne, 7, Champs-Elysées, 1955.

Paris, 1861
Salon des Arts Unis, Paris, 1861.

Paris, Champs-Elysées, 1861
Salon de 1861, Paris, Palais des Champs-Elysées.

Paris, 1867
Exposition Universelle, Paris, 1867.

184

Paris, Champs-Élysées, 1867
Exposition des oeuvres de M. G. Courbet, Paris, Rond-Point du Pont de l'Alma, Champs-Élysées, 1867.

Paris, Ecole des Beaux-Arts, 1867
Exposition des tableaux, études peintes, dessins et croquis de J.-A.-D. Ingres, Paris, Ecole Impériale des Beaux-Arts, 1867.

Paris, 1868
Salon de 1868, Paris, Palais des Champs-Elysées.

Paris, 1877
Catalogue de la 3ᵉ exposition de peinture par MM. Caillebotte, Cals, Cézanne. Rue le Peletier, Paris, 1877.

Paris, Corps législatif, 1878
Explication des ouvrages de Peinture exposés au profit de la colonisation de l'Algérie par les Alsaciens-Lorrains, Paris, Palais de la Présidence du Corps législatif, 1878.

Paris, Ecole des Beaux-Arts, 1884
Dessins de l'Ecole moderne, Paris, Ecole Nationale des Beaux-Arts, 1884.

Paris, 1889
Exposition Universelle, Paris, 1889.

Paris, 1900
Exposition Centennale de l'Art français, Paris, 1900.

Paris, Galerie Georges Petit, 1901
Exposition des oeuvres d'Alexandre Séon, Paris, Galerie Georges Petit, 1901.

Paris, Grand Palais, 1905
Salon d'Automne, Paris, Grand Palais, 1905.

Paris, Arts Décoratifs, 1910
Exposition des cartons, esquisses, dessins pour l'oeuvre décorative d'Albert Besnard, Paris, Musée des Arts Décoratifs, 1910.

Paris, Chambre Syndicale, 1921
Ingres, Paris, Chambre Syndicale de la Curiosité et des Beaux-Arts, Association franco-américaine d'expositions de peintres et de sculpteurs, 1921.

Paris, 1924
Salon de la Société Nationale des Beaux-Arts. Centenaire Puvis de Chavannes, Paris, 1924.

Paris, Galerie Georges Petit, 1924
Exposition Degas, Paris, Galerie Georges Petit, 1924.

Paris, Orangerie, 1932
Joseph Bernard, Paris, Musée de l'Orangerie, 1932.

Paris, Orangerie, 1934
Daumier. Peintres, aquarelles, dessins, Paris, Musée de l'Orangerie, 1934.

Paris, Orangerie, 1937
Degas, Paris, Musée de l'Orangerie, 1937.

Paris, Galerie Cailleux, 1951
Le dessin français de Watteau à Prud'hon, Paris, Galerie Cailleux, 1951.

Paris, Louvre, 1963
Mémorial de l'exposition Eugène Delacroix, Paris, Musée du Louvre, 1963.

Paris, Louvre, 1967-1968
Théodore Rousseau, 1812-1867, Paris, Musée du Louvre, 1967-1968.

Paris, Petit Palais, 1967-1968
Ingres, Paris, Petit Palais, 1967-1968.

Paris, Louvre, 1973
Autoportraits de Courbet, Paris, Musée du Louvre, Les Dossiers du Département des Peintures, 1973.

Paris, Musée Rodin, 1973
Joseph Bernard, Paris, Musée Rodin, 1973.

Paris, Galerie du Fleuve, 1974
Aspects du paysage néoclassique en France de 1790 à 1855, Paris, Galerie du Fleuve, 1974.

Paris, Grand Palais, 1974
De David à Delacroix. La peintre française de 1774 à 1830, Paris, Grand Palais, 1974.

Paris, Orangerie, 1975
Hommage à Corot, Paris, Musée de l'Orangerie, 1975.

Paris, Grand Palais, 1975-1976
Jean-François Millet, Paris, Grand Palais, 1975-1976.

Paris, Grand Palais, 1977-1978
Gustave Courbet, Paris, Grand Palais, 1977-1978.

Paris, Grand Palais, 1979
L'Art en France sous le Second Empire, Paris, Grand Palais, 1979.

Paris, Louvre, 1979
Dessins français du XIXᵉ siècle du Musée Bonnat à Bayonne, Paris, Musée du Louvre, Cabinet des dessins, 1979.

Paris, Musée Rodin, 1981-1982
Les Centaures, Paris, Musée Rodin, Cabinet des Dessins, Dossier 1, 1981-1982.

Paris, Louvre, 1983
L'aquarelle en France au XIXᵉ siècle. Dessins du Musée du Louvre, Paris, Musée du Louvre, Cabinet des Dessins, 1983.

Paris, Musée Rodin, 1983-1984
Dante et Virgile aux Enfers, Paris, Musée Rodin, Cabinet des Dessins, Dossier 3, 1983-1984.

Paris, Palais de Tokyo, 1984-1985
La donation Arï et Suzanne Redon au Musée du Louvre, Paris, Palais de Tokyo, 1984-1985.

Paris, Louvre, 1986
Prud'hon. La Justice et la Vengeance divine poursuivant le crime, Paris, Musée du Louvre, les Dossiers du département des Peintures 32, 1986.

Paris, Grand Palais, 1988
Degas, Paris, Grand Palais, 1988.

Paris, Lyon, 1984-1985
Hippolyte, Auguste et Paul Flandrin. Une fraternité picturale au XIXᵉ siècle, Paris, Musée du Luxembourg; Lyon, Musée des Beaux-Arts, 1984-1985.

Paris, Ottawa, 1976-1977
Puvis de Chavannes, 1824-1898, Paris, Grand Palais; Ottawa, Galerie nationale du Canada, 1976-1977.

Recklinghausen, 1962
Idee une Vollendung, Recklinghausen, Städtische Kunsthalle, 1962.

Rome, 1969-1970
Gustave Courbet, Rome, Académie de France à Rome, Villa Medici, 1969-1970.

Rome, 1979-1980
Géricault, Rome, Académie de France à Rome, Villa Medici, 1979-1980.

San Francisco, 1977
Four Centuries of French Drawings, San Francisco, Fine Arts Museum, 1977.

Tübingen, Berlin, 1984
Edgar Degas, Tübingen, Kunsthalle; Berlin, National Galerie, 1984.

Washington, New York, Minneapolis, Malibu, 1981-1982
French Master Drawings from the Rouen Museum: From Caron to Delacroix, Washington, D.C., National Gallery of Art; New York, National Academy of Design; Minneapolis, The Minneapolis Institute of Arts; Malibu, J. Paul Getty Museum, 1981-1982.

Winterthur, 1953
Théodore Géricault, 1791-1824, Winterthur, Kunstmuseum, 1953.

Zürich, 1987
Eugène Delacroix, Zürich, Kunsthaus, 1987.

ARTISTS IN THE EXHIBITION